Analyzing Children's Art

Rhoda Kellogg

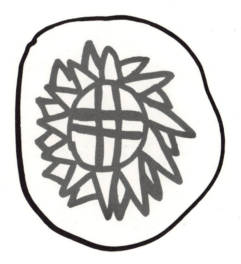

Mayfield Publishing Company/285 Hamilton Avenue/Palo Alto/California 94301

Contents

"A work of art is an artifact considered with respect to its design."
JOSEPH MARGOLIS, *The Language of Art and Art Criticism*

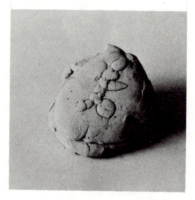

Introduction

This book describes the mental development of children that takes place as they work in art. The developmental story begins with children as young as twenty-four months, whose scribbling is considered by many adults to be a meaningless result of muscular activity, and continues through children of eight years, whose art is commonly viewed as a striving to depict the persons and things around them.

It is easy and plausible to dismiss early scribbling as meaningless activity or to treat the art of older children as an imperfect record of their surroundings. However, neither approach does justice to the actual work of children. I will attempt to render a realistic account of children's art by describing in detail what children produce when they work with crayons, paint, clay, or other art materials, and then I will try to show why their art develops as it does from the first scribble through early pictures.

My investigation of the *what* of children's art focuses on the characteristics of line formations, particularly in scribblings and drawings. Line formations also exist in children's paintings and clay work, as shown in the following pages, but most of the art that I have collected and examined has been done with crayon or pencil on paper. I do not consider the use of color in children's art because

choice of colors is limited to what is made available by adults. By restricting my investigation to the characteristics of line formations, I am able to compare the work of children from many lands and times, as a record of their free choice of line constructions.

The best introduction to the main points of my research is provided by Herbert Read:

> It has been shown by several investigators, but most effectively by Mrs. Rhoda Kellogg of San Francisco, that the expressive gestures of the infant, from the moment that they can be recorded by a crayon or pencil, evolve from certain basic scribbles towards consistent symbols. Over several years of development such basic patterns gradually become the conscious representation of objects perceived: the substitutive sign becomes a visual image. Scientists may object that the analysis of this process has not been carried far enough to justify a generalization, but we have an hypothesis that should hold the field until it has proved to be false. According to this hypothesis every child, in its discovery of a mode of symbolization, follows the same graphic evolution. Out of the amorphous scribblings of the infant emerge, first certain basic forms, the circle, the upright cross, the diagonal cross, the rectangle, etc., and then two or more of these basic forms are combined into that comprehensive symbol known as the *mandala*, a circle divided into quarters by a cross. Let us ignore for the present the general psychological significance of the process: I merely want you to observe that it is universal and is found, not only in the scribblings of children but everywhere where the making of signs has had a symbolizing purpose—which is from the Neolithic Age onwards. [Read, 1963, p. 4.]

Much of this book is devoted to documenting and defining the process outlined above, following which the "general psychological significance" is discussed. Through analysis of the development of the art produced by children, I will try to demonstrate that art plays an important role in children's over-all mental development.

It is a truism that better understanding of the child mind is an urgent need if society is to protect itself from the waste and destruction caused by miseducation, but the statement needs repetition. Child art can be a valuable key to adult understanding of the mental growth and educational needs of children. In pursuing the *what* and the *why* of children's

art, this book touches on important educational issues, and practical judgments are implicit in many of the book's conclusions.

The basis of the investigation that follows is my examination of approximately a million drawings done by young children. More than half of these drawings are filed in the Rhoda Kellogg Child Art Collection of the Golden Gate Kindergarten Association, housed at 1315 Ellis Street, San Francisco. This collection is accessible by appointment to professionals and to persons interested in children's art. Of these half-million and more drawings, some 8,000 are generally available, in microfiche form, from Microcard Editions, Inc., 901 26th Street N.W., Washington, D.C. 20037. The microfiche system, a variation of microfilming, permits twenty-nine drawings, plus an identifying label, to be reproduced on a sheet of film three inches by five inches. The drawings are enlarged when the film is inserted in a special reading machine, which projects the film image on a ground-glass viewing screen or on a wall screen.

More than 250 paintings and drawings, selected as outstanding examples of children's work, are reproduced in full color in *The Psychology of Children's Art* (Kellogg and O'Dell, 1967). Like the microfiche cards, this book provides a view of a portion of the material that I have collected.

The drawings that I have examined as a basis for this book come chiefly from children enrolled in the Golden Gate Kindergarten Association's nursery schools in San Francisco. From 1948 through 1966, the Association administered classes for approximately 2,000 children of ages two, three, and four. (Despite its name, the Golden Gate Kindergarten Association is now mainly concerned with nursery education.) In 1966, all of the classes administered by the Association were moved into a new, model building that contains a nursery school for ninety children and additional classrooms where older children —aged four to fourteen—attend art classes. This building is known as the Phoebe A. Hearst Preschool Learning Center, and this is where the work of collecting child art proceeds.

Of the drawings done by children in the Association's nursery schools, 200,000 have been filed under the children's names, with the date of each drawing, a sequence number, and the child's age in months

recorded on the back. This method of filing lends itself to the study of the individual child's development, a work partially done. Another 100,000 preschool drawings are not classified. (Older children who attend art classes in the Center have not yet produced a great quantity of drawings, and so their work does not happen to form a significant basis for this book. These children come from the neighborhood of the new Center. They are given access to art material rather than any formal instruction, they are treated as guests, and their attendance is entirely voluntary.)

The nursery schools administered by the Golden Gate Kindergarten Association have consistently enrolled children of varied backgrounds, both racial and cultural. As a consequence, the drawings on which this book is based were done by youngsters of diverse home environments.

In addition to the 300,000 drawings by nursery school children, the Rhoda Kellogg Child Art Collection contains approximately 200,000 drawings that I obtained from 1953 through 1960, when I taught courses dealing with the developmental sequence of children's art for the University of California Extension Division. Most of my students were teachers in child care centers and public elementary schools in the Bay Area of California, and they brought the drawings to me to be examined and analyzed. These drawings represent the work of an estimated 10,000 children aged four to eight. The majority of these drawings are filed by subject matter: designs, scenes, people, houses, vegetation, etc.

A third source of the art in my collection is the various countries I visited in 1954, 1960, and 1961. I was privileged to lecture on child art in schools and universities in London, Paris, Amsterdam, Göteberg, Stockholm, Copenhagen, Munich, Zurich, Cairo, Athens, Teheran, Beirut, New Delhi, Bombay, Katmandu, Tokyo, Nagasaki, Osaka, Hong Kong, Manila, and Bangkok. Through these lectures I received some 5,000 drawings and paintings from thirty countries. Other examples of child art in the collection come from a variety of friends and interested persons.

The quantity of drawings that I have examined during my years

of teaching far exceeds the number that I have been able to save and house, but the Collection alone seems ample evidence for the conclusions that I have formed. In fact, the Collection appears large enough for statistical analysis (see pages 192 and 193, for instance). I regret that the limited space available in a book restricts the number of drawings and other kinds of children's art that can be displayed. The illustrations that follow are typical of the work that I have seen, and the reader may find many additional examples of children's art in homes and schools.

Some of the illustrations are author's sketches of children's work, used for the sake of clarity. They are identified as such. The illustrations of the works of children have not been changed in any way except when the mark of a light crayon had to be strengthened to show the line formation in the original drawing.

The reader who is familiar with the precursor of this book, titled *What Children Scribble and Why* and published in 1955, may be interested to know that nothing stated there is negated by my present findings. Rather, my intervening study has extended the scope of my conclusions. Particularly, in 1955 I did not recognize the developmental meaning to be seen in the scribblings of two-year-olds. The fact that the Golden Gate Kindergarten Association has for twenty years conducted classes for children as young as twenty-four months has allowed me to consider large quantities of very early work. The current book also extends the analysis of child art to age eight, though the previous book did not go beyond age four. The classifications I employ here are similarly extended to supplement the ones formerly used.

I wish to dedicate this book to the many teachers of young children who helped to make the material available for study. The analysis and classification are my own work, and any errors or faulty interpretations are my own responsibility.

I am, however, greatly indebted to several other persons—Malka Haas in Israel, Professor Max Knoll in Germany, Harry Baker, M.D., in Canada, Dr. Desmond Morris in England, Professor Naohiko Fukada in Japan, and Nicolas Charney, editor and publisher of *Psychology Today*—for their professional interest in my theories and findings. I

owe special thanks to my husband, Murray Gitlin, for his unfailing assistance; to Ruth Lissauer, Phyllis Smart, and Cecily Bricca, for their editorial and typing services; to the members of the Board of Directors of the Golden Gate Kindergarten Association for their cooperation in this work; to Robert Overstreet for photographs of children; to Ralph Putzker for photographs of clay; to Palmer W. Pinney of the National Press for editing this work; and to the Press for publishing *What Children Scribble and Why* in 1959, after the author's edition was exhausted. Finally, I am indebted to Mr. Albert Diaz of Microcard Editions for allowing me to print drawings from the microfiche and material from the *Handbook for Microfiche*.

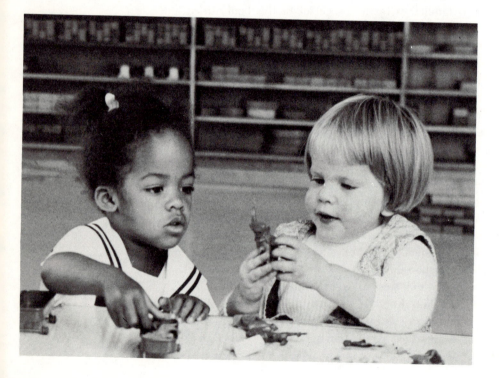

1. Seeing Is Believing

It has long been assumed that the primary pleasure young children derive from scribbling is that of movement, or "motor pleasure." It could equally well be assumed that visual pleasure is primary. Why does a child bother to mark paper or to make lines in dust? Why does he soon stop his scribbling motions if they do not produce marks—if, for instance, his crayon breaks into unusable pieces? Why is a steamy window attractive only as long as the steam lasts to show the lines the child's finger traces? The answer is that visual interest is an essential component of scribbling, whether or not it is primary.

The visual stimulation of scribbling goes beyond eyesight and lighting. In day-to-day activities, we are seldom conscious of the fact that were it not for the brain, we could not, in spite of good retinas and good light, see an object. A blind person does not see because his retinas cannot transmit adequate nerve impulses to his brain, even though his brain may otherwise be normal. Yet a person with a defective brain and normal retinas may not perceive an object, since both eyes and brain are needed for this function. As Gregory (1966, p. 46) states, "the retina is actually a specialized part of the surface of the brain which has budded out and is sensitive to light." A stimulus of light on the retina causes nerve impulses to reach the cells in the

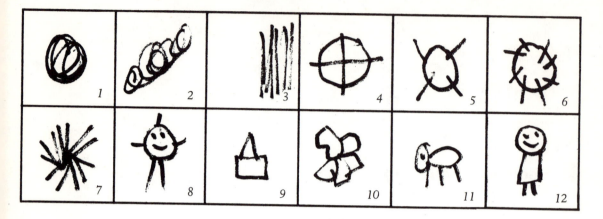

occipital area of the cortex. "What the eyes do is to feed the brain with information coded into neural activity" (Gregory, 1966, p. 7).

The brain acts on this incoming neural activity by selecting and organizing it according to the maturity, experience, and expectations of the individual. What he perceives is in part the consequence of what he expects to perceive and what he is used to perceiving.

To illustrate the role of experience and expectation in seeing, twelve drawings are presented in the boxes here. The drawings are author's sketches of line formations that children commonly make. What are they? What can be said of them? The reader will probably find his answers affected by two prevalent beliefs: the scribbling of young children is meaningless, and the scribbling of older children is an attempt to show reality. The reader's answers may also be affected by whatever recollections he has of his own childhood scribbling, by his current familiarity with the works of children, and by the fact that he has been alerted to look anew at "meaningless scribbles."

In any case, the reader may find it interesting to assign labels to the drawings now, to review the labels after he has read this book, and then to examine the descriptions on page 279.

Seeing is believing, according to the adage. When a Missourian says, "Show me," he demands the direct confirmation that vision seems to provide. But believing is also seeing. If the Missourian or any other skeptic is told, "You're looking right at it," he may remain skeptical because his perceptions are not the same as those of another observer. The statements and conclusions in the following pages are the result of my seeing, and the reader may ask what expectations and beliefs I brought to my examination of child art.

Although I had seen many examples of children's scribbling in the years before, it was not until 1945 that I perceived that three-year-olds were drawing the dominant religious symbol of the Eastern world, the mandala. I do not mean that the symbol had religious significance

for the children or that some mysterious force was at work. I merely observed that a design which had been given religious significance by a large number of people in the East was being made spontaneously by very young children in the West.

This perception led me to look for similar designs and structures in children's work and to attempt to classify those that I found. I attached no special significance to unusual instances of structure. It is possible to discover some sort of shape or design in almost any markings on paper. What I sought were shapes and designs that occur regularly and quite clearly in the drawings of many children. For

five days a week over a period of twenty years, I watched young children in the act of scribbling, and I examined their completed work.

I would be reluctant to advance my observations of children's art except for another sort of observation I have made: almost invariably, a person responds to my findings according to the implications they hold for his profession. For instance, my observations suggest that basic artistic talent is commonplace rather than a gift accorded a lucky few, and it is this statement that engages the attention of a professional artist. My observations also support an increase in the role of spontaneous art in public schools, and it is this conclusion that interests a teacher.

A psychologist focuses on the fact that my investigation accords with Gestalt theory, which stresses pattern and organization in perception. "Gestalt" means form, and Gestalt theory states that when a child looks at his scribblings, the retinas of his eyes see millions of dots reflected from the lines and the paper. The child's brain must organize these dots into meaningful Gestalts, that is, into shapes that "make sense." Gestalt theory also emphasizes the physiologic basis of perception. Perceptual organization is something that originates as a physiologic characteristic of the nervous system, in the view of this theory.

To a Jungian psychoanalyst, my investigation is significant because the recurring designs I find in preschool art may be considered archetypal symbols. To an archaeologist, my study is noteworthy because it suggests an explanation of the forms of primitive and prehistoric art. And so on. Scarcely anyone shows enough concern for direct observation of the spontaneous work of children.

The point is that every educated adult has some highly developed patterns of thought that help him to deal with the preoccupations and responsibilities of his mental life. Because of the specialized ideas which persons acquire through higher education and through professional duties, a vast no-man's-land tends to separate one profession from another. This separation, which might be termed a "mind-gap," is not easy to overcome in these days of specialization. (I recall the director of a foundation to whom I applied for funds. He leafed through

my book, *What Children Scribble and Why*, and announced, "You have made no graphs, so the work is not scientific and would not command our support.")

To bridge the gap that exists between my experience with children's art and the reader's concerns, I present first the line formations that I have seen. I hope that the reader will share my perceptions. In any case, I have tried not to distract him with extended discussions of theory in this part of the book. Children's art has major significance for psychology, education, and esthetics, and important implications for sociology, anthropology, and other areas of study. It is easy to make children's art a controversial subject. In the early chapters, though, I try to let the reader see what I have seen.

Though they lack the excitement of controversy, the observations described in the early chapters have their own interest. They cover a large number of the scribblings of two-year-olds, whose work has seldom if ever been collected in quantity elsewhere. Further, the observations encompass more than a million examples of children's art produced over a period of twenty years, and the art comes from a wide variety of sources—from children of all economic and social groups and from many parts of the world.

If the observations I have made lead to increased study of children's art, I shall be delighted. I am aware that one set of facts may be used to support different theories, and that my conclusions are subject to dispute. I am also aware that my observations may be improved and modified by other investigators. My abiding wish is that this book may help to close the immense mind-gap between adults and children. It is easy for adults to measure certain kinds of child behavior in laboratory situations, but it is impossible for adults to experience again the outlook and expectations of two-, three-, or four-year-olds. Scribblings, as a record of the seeing and acting of young humans, offer a way to discern more clearly children's developing vision and mental processes, and perhaps to work a reformation in early childhood education.

2. The Basic Scribbles

The Basic Scribbles are twenty kinds of markings that are made by two-year-olds and by even younger children. These movements show variations of muscular tension that do not require visual guidance: two-year-olds can make all the Scribbles without eye control, and babies waving their arms would make these Scribbles if an instrument could record where and how their fingertips move through the air. Blind children can make them, but of course they derive no visual satisfaction from the results of the motion and they have no stimulus to combine the Scribbles.

The Basic Scribbles help us to see that drawing capacity of a fundamental sort is natural in very young humans. Animals, too, can scratch lines on a surface, but none can make all the Scribbles. Human neural and muscular systems are required for making them, and so the capacity for forming all the Scribbles is not one recently acquired by the species. A child who cannot make them must therefore be seriously disabled, mentally or physically. On the other hand, skill at combining the Scribbles into art or into language symbols varies greatly in the species in time and place.

It may seem academic to describe these Scribbles in detail, and it may seem arbitrary to look for them in children's art. The Scribbles

are such elementary line formations that they may be found in any drawing, and so what significance can they have? The answer is that the Twenty Basic Scribbles are the building blocks of art, and they are important because they permit a detailed and comprehensive description of the work of young children. The complete list of Scribbles follows (the order in which they are listed is not meant to have developmental significance).

THE BASIC SCRIBBLES

Scribble 1		Dot
Scribble 2		Single vertical line
Scribble 3		Single horizontal line
Scribble 4		Single diagonal line
Scribble 5		Single curved line
Scribble 6		Multiple vertical line
Scribble 7		Multiple horizontal line
Scribble 8		Multiple diagonal line
Scribble 9		Multiple curved line
Scribble 10		Roving open line
Scribble 11		Roving enclosing line
Scribble 12		Zigzag or waving line
Scribble 13		Single loop line
Scribble 14		Multiple loop line
Scribble 15		Spiral line
Scribble 16		Multiple-line overlaid circle
Scribble 17		Multiple-line circumference circle
Scribble 18		Circular line spread out
Scribble 19		Single crossed circle
Scribble 20		Imperfect circle

The marks most easily made, with crayon or with fingers, seem to be Scribbles 6, 7, 8, and 9, the multiple ones resulting from rapid back-and-forth movement. The single-line versions, Scribbles 2, 3, 4, and 5, are also readily made.

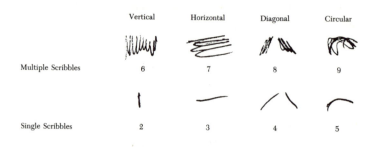

	Vertical	Horizontal	Diagonal	Circular
Multiple Scribbles	6	7	8	9
Single Scribbles	2	3	4	5

Whether the single or the multiple Scribbles are the first ones to be made by the child I do not know. To my knowledge, no adequate study of this behavior has ever been undertaken. I do know that both the single and the multiple lines are made at age two, and that they are used later for purposes of art. The adult artist uses the multiple lines for shading, and the child uses them to fill in coloring books and his own drawn areas. Both adult artists and children use the single lines for outlining shapes. (See Appendix A.)

Scribble 9 made by a boy with sand as the art medium (photograph courtesy of Malka Haas)

Movements that pound the paper with a crayon leave a record of dots. A dot, which is Scribble 1, may have the shape of a period, a comma, or a very short line, depending on the force and angle of the pounding movement.

Scribble 12 is an undulating line which may be wavy or zigzag. The two variations might be viewed as separate Scribbles, but they are combined here because they flow so often from one to the other in the work of children that they are practically inseparable. The difference reflects a slight variation in muscle tension.

Scribble 11 is a roving line that doubles back on itself and thus spontaneously makes one or more enclosed areas. The other roving line, Scribble 10, does not cross back on itself but simply meanders, leaving a record of alternating directional movement which is different from that of the other Scribbles. The single loop, Scribble 13, often suggests a poor oval, but the multiple loop, Scribble 14, has a distinctly different look. Scribble 20 is a small, imperfect circle, made frequently after the child has learned to make a large circle, but seldom before.

For purposes of analysis, the Basic Scribbles can be grouped into six categories on the basis of their over-all direction.

DIRECTION OF LINE MOVEMENT	SCRIBBLES
Vertical	2, 6
Horizontal	3, 7
Diagonal	4, 8
Circular	5, 9, 15, 16, 17, 18, 19, 20
Alternating	10, 11, 12, 13, 14
No line movement	1

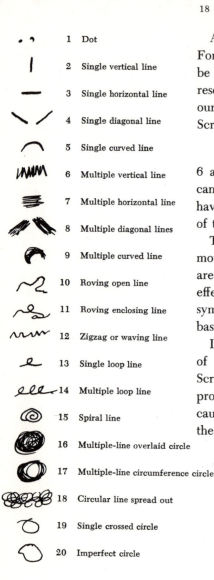

	1	Dot
	2	Single vertical line
	3	Single horizontal line
	4	Single diagonal line
	5	Single curved line
	6	Multiple vertical line
	7	Multiple horizontal line
	8	Multiple diagonal lines
	9	Multiple curved line
	10	Roving open line
	11	Roving enclosing line
	12	Zigzag or waving line
	13	Single loop line
	14	Multiple loop line
	15	Spiral line
	16	Multiple-line overlaid circle
	17	Multiple-line circumference circle
	18	Circular line spread out
	19	Single crossed circle
	20	Imperfect circle

Actual line formations may not fall neatly into these categories. For example, Scribble 8 may curve slightly, though not enough to be called Scribble 9. Or Scribbles 6 and 9 may open so wide as to resemble a huge Scribble 12. These irregular markings need not hinder our discussion because they can be treated as variations of the Basic Scribbles. As an instance, the marking shown here begins as Scribble

6 and merges into Scribble 12. The middle section of the marking can be considered either Scribble 6 or 12. The Twenty Basic Scribbles have provided an adequate system of classification for the hundreds of thousands of drawings that I have examined.

The Scribbles comprise all the marks that are made by spontaneous movement with or without the control of the eyes. When Scribbles are made with eye control, they yield an immense range of visual effects, but every drawing, pattern, shape, design, pictorial, or language symbol can be broken down into Scribble components, that is, into basic line elements.

It is difficult to find clear-cut examples of each Scribble in the work of young two-year-olds. At this age, the child usually places one Scribble over another. He changes his hand direction frequently, probably to prevent muscle fatigue, and changes of direction usually cause changes in the form of scribbling. At ages three and four years, the child often puts a single type of Scribble on one piece of paper.

Drawing made of Scribbles 1, 2, 3, and 4 (age seven years)

Drawing made of Scribbles 2, 3, 4, 5, 12, and 16 (five years)

Language symbols constructed of Scribbles 2, 3, 4, and 5 (from Botsford, 1911, p. 41)

Phoenician	Archaic Greek	Later Greek	English
⟡ ⟡	Λ ΛΛΛ	A Λ	A
�	ᙖ ᙖ	B	B
⋀ ⋀	∧ ⋀ ∧ C	Γ	G
⊿ ⊲	△ ▽ ₽	△	D
⊒	⊒⊒ ⊧⊒⊧	E Є	E
⟍	⟍ F	F	F
Z	⟊ Z I	Z	Z

The ancestors of some of the letters of our alphabet

The Scribbles may appear in clear-cut form in finger painting as well as in work with paper and crayon, as the illustrations in this chapter show. These finger paintings were done by children of ages two through four. An example of complicated scribbling is shown on page 21. There, a structured drawing of a man, one characteristic of child art, is overlaid by markings. Had I not seen the child draw a face and then scribble over it, I could not have seen that organized work was present. The piece of paper that a child has marked with pencil or crayon may contain many layers of line formations, and a finger painting may represent the last arrangement of many. Or the paper may show partial work, incomplete because the child was distracted. If a movie camera could be set up so that it would not interfere with the spontaneity of child art, it could yield a record of hand-eye coordination and of all the successive line formations made on each piece of paper.

1 Dot

2 Single vertical line

3 Single horizontal line

4 Single diagonal line

5 Single curved line

6 Multiple vertical line

7 Multiple horizontal line

8 Multiple diagonal lines

9 Multiple curved line

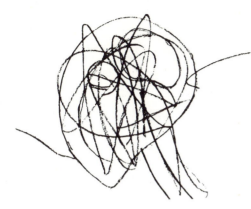

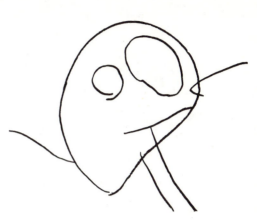

Scribbled-over image of a Human (three years)

Tracing of the Human beneath the scribbling

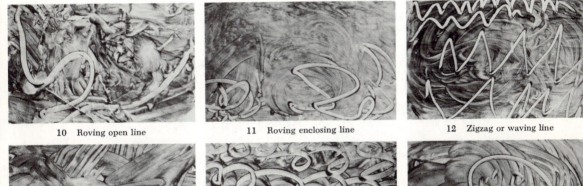

10 Roving open line

11 Roving enclosing line

12 Zigzag or waving line

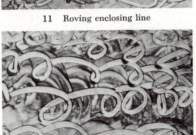

13 Single loop line

14 Multiple loop line

15 Spiral line

16 Multiple-line overlaid circle

17 Multiple-line circumference circle

18 Circular line spread out

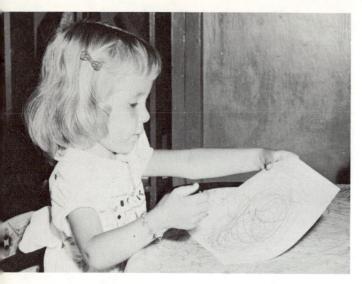

At age two, the girl in the photograph did the scribbling visible there. Two years later, she made the drawing below (shown in half size)

3. The Placement Patterns

Any drawing may be analyzed into Basic Scribbles. The same drawing may also lend itself to a different sort of analysis, that of the placement of markings on the sheet of paper regarded as an area to be marked.

A pattern analysis cannot be applied as widely as an analysis into Basic Scribbles. The Scribbles apply to all line formations in any medium, but a Placement Pattern requires a well-defined perimeter, a "frame" of some kind. Further, line formations within a frame do not always show definite patterning. Another difference between Basic Scribbles and Placement Patterns is that the Scribbles do not require eye control. They can be made whether or not the child's eye is guiding his hand. In fact, they can be made whether or not the child can see. Placement Patterns, though, require both seeing and the eye's guidance of the hand.

Two-year-olds who are unable to make clear-cut outlines nevertheless have enough eye-hand coordination to control the general area of their scribblings. This control need not be a product of forethought. As the child scribbles on a blank paper, the paper yields a new visual stimulus. As he continues to scribble, the total image—blank spaces as well as markings—continues to change, and the child responds to the new configuration as he draws. If a pattern is suggested by the lines and spaces before him, he may complete it.

The child may, of course, use forethought and place lines quite deliberately on a page. On the other hand, his perception of lines

P1. Over-all. The entire paper is covered, and there may or may not be emphasis of corner or edge markings.

P2. Centered. The scribblings are centered on the paper, and they may be large or small.

P3. Spaced border. The scribblings are not necessarily centered, but there is an absence of lines along the perimeter.

P4. Vertical half. The scribblings are confined to one vertical half of the paper.

P5. Horizontal half. The scribblings are confined to one horizontal half of the paper.

P6. Two-sided balance. The scribblings are placed on one vertical or horizontal section of the paper to balance scribbles on the other side, with space between.

P7. Diagonal half. The scribblings are confined to one diagonal half of the paper.

P8. Extended diagonal half. The scribblings spill over somewhat beyond the diagonal half.

P9. Diagonal axis. The scribblings are evenly distributed on a diagonal axis so that two corners are filled and two are left empty.

Author's sketches

P10. Two-thirds division. The scribblings are confined to about two-thirds of the paper, or the markings on two-thirds are distinctly separated from those on the other third, or they have different characteristics of line or color.

P10

P11. Quarter page. The scribblings are confined to a quarter of the paper.

P11

P12. One-corner fan. The scribblings flare out from one corner over the center, leaving the other three corners empty.

P12

P13. Two-corner arch. The scribblings cover one of the wide edges of the page and much of the page itself, but leave two corners empty, and so the total markings give a half-circle or arch effect.

P13

P14. Three-corner arc. The scribblings leave only one corner of the paper unmarked.

P14

P15. Two-corner pyramid. The scribblings cover one of the narrow edges of the paper and converge toward the center of the edge opposite, leaving two corners empty and making a pyramidal shape.

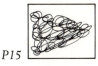

P15

P16. Across the paper. The scribblings go from one edge to the edge opposite.

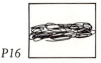

P16

P17. Base-line fan. The scribblings flare up from one edge and move toward one or both of the adjoining edges.

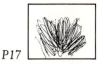

P17

and spaces, of figure-ground relationships, may not operate at all. The child may be so engrossed in forming a line that he ignores the totality of the paper. However, there is strong evidence that the child frequently sees the paper as a unit and reacts to it. An instance is the series of photographs on pages 30 and 31. The young artist there deliberately restricts her marks to one side of the paper. Similar evidence is provided by the many children I have observed in the act of patterning their scribbling.

The Patterns themselves are good evidence, particularly when many lines show a relatively precise limit of placement. The frequency of figure-ground perception is suggested by the regularity with which Placement Patterns occur in the children's art that I have observed. (See page 192 for a preliminary report.) Several experiments support my observation, among them the intriguing work that Desmond Morris has done with chimpanzees (Morris, 1962).

I have detected seventeen Placement Patterns in children's art, and there may be others that occur with some frequency. Which ones are made first and which ones are made most often is a problem yet to be studied. The numbers I have given the Patterns are a descriptive convenience, with no necessary developmental meaning. Examples of patterned scribbling by children may be seen throughout this book.

These seventeen Placement Patterns can be assigned to drawings without knowledge of the orientation of the paper to the child. It does not matter which edge of the paper was used as a base line, in this analysis. Thus P4, the vertical half, is vertical in relation to the proportions of the paper, and a line going from one long side of the paper to the side opposite is always classified as a vertical. In my experience, children prefer to place the paper so that one of the longer edges is toward them and the paper is wider than high. An analysis of children at work might take account of the base line actually used by each child. This, of course, would call for a more detailed system of classification.

Each of the Placement Patterns offers evidence of the perception that accompanies scribbling: P2, the centered marking, shows that the eye is aware of the center of the paper; P3, the spaced border,

shows that the eye perceives perimeter space. The other Patterns give further evidence of the way in which the child sees the relation of his markings to the paper.

The importance of the Placement Patterns lies in the developmental sequence that follows from them. The Patterns are the earliest evidence I have discerned of controlled shaping in children's work. The Basic Scribbles themselves suggest shapes, mainly circles, but also rectangles and triangles. However, the Scribbles do not necessarily indicate eye control of hand movement. The Placement Patterns suggest purposeful half-circles, quarter-circles, rectangles, triangles, arches, and various odd shapes.

PLACEMENT PATTERN
ILLUSTRATIONS

P1, over-all (32 months)

P2, centered (30 months)

P3, spaced border (30 months)

P4, *vertical half* (26 months)

P5, *horizontal half* (age unknown)

P6, *two-sided balance* (age unknown)

P7, *diagonal half* (27 months)

P8, *extended diagonal half* (29 months)

P9, *diagonal axis* (33 months)

P10, two-thirds division (28 months)

P11, quarter page (31 months)

P12, one-corner fan (28 months)

P13, two-corner arch (32 months)

P14, three-corner arc (31 months)

P15, two-corner pyramid (30 months)

P16, *across the paper (33 months)*

P17, *base-line fan (29 months)*

Photographs of a girl (21 months) as she scribbles in Placement
Pattern 4, the vertical half (photographs courtesy of Malka Haas)

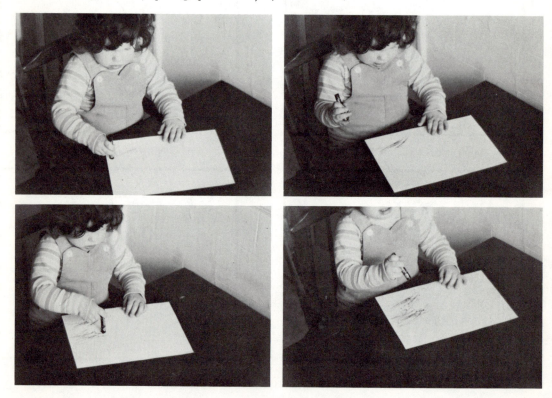

If my observations are correct, children as young as twenty-four months often guide their scribbling movements so that the marks fall into distinct Patterns. These Patterns are made spontaneously, without coaching or copying, and they are frequently made in response to the visual stimulus of the scribbling process. The Patterns suggest shapes that the child will make later by filling in an area or by drawing an outline.

What accounts for the prevalence of shapes in children's art? Here observation ends and theory begins. I do not have to advance very far into theory, however, to say that children perceive and remember those scribbles that suggest shapes; scribbles that do not suggest shapes are not so easily recalled. The shapes to be found in children's art evolve from the children's perceptions of their own scribbling.

Of course, children find ovals and rectangles in the world around them. The moon, human faces and bodies, tree trunks, cloud formations, and circular or rectangular house structures are part of the experiences

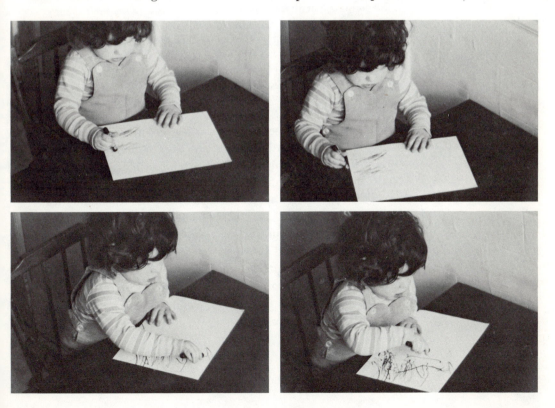

of nearly every child. However, the general evolution of shapes in children's art suggests that the process is largely independent of such observation. (Children's drawings of humans illustrate this point particularly well.) In any case, the shape-making tendency of children is so strong and pervasive that it seems to be innate, whether or not it is brought out by experiences other than scribbling.

Because scribbling entails perception and perception entails the brain, comprehensive theories about children's art must sooner or later consider the brain's functioning. The Gestalt psychologist W. Kohler (in Vernon, 1962, p. 52) has hypothesized that certain physiological functions of the brain are responsible for the tendency to organize visual data into pleasing or "good" shapes, that is, shapes which have symmetry, simplicity, and regularity. How the "good" shapes to be seen in scribbling are remembered is suggested by the words of Penfield and Roberts:

> One must assume that there are specialized areas in the brain where the patterns of passage of nerve impulses may be stored. The pattern of passage of electrical potentials through certain neurons (nerve cells) and over their connecting fibers forms a unit. . . . Each passage of a stream of neural impulses leaves behind it a persisting facilitation, so that impulses may pass that way again with greater ease. This is, in general, the neuronal basis of memory. [Penfield and Roberts, 1959, pp. 245-246.]

Speculations such as these may one day lead to proof that in earliest scribblings we have a record of mental processes natural to the species. Meanwhile, much work remains to be done with scribblings themselves. I wish to mention the exhibition of the scribblings of very young Israeli children that was staged by Malka Haas. The exhibition, made especially for her students at the State Teachers Training College of Collective Settlements in Tel Aviv, showed Placement Patterns of Israeli children of Middle Eastern as well as European origin.

Similar exhibits or collections could be made in many countries, and they could be subjected to intensive analysis. At present, the work of two-year-olds is seldom available in quantity, and significant observations are still to be made.

4. The Emergent Diagram Shapes

By the age of two, children generally put some of their scribblings into definite Placement Patterns, with the markings positioned in relation to the edges of the paper. By the age of three, children make Diagrams, with single lines employed to form crosses and to outline circles, triangles, and other shapes. Formations that may be called Emergent Diagram Shapes precede the Diagrams.

Left: E1, multiple line crossings which could have been made without lifting the crayon (26 months)

Right: E2, multiple line crosses which could only have been made by lifting the crayon (25 months)

Left: E3, small crossings. Short lines cross other lines (27 months)

Right: E3, small crossings. Many small lines appear here (30 months)

E3, small crossings, placed on the periphery (29 months)

E4, crisscrossing lines, giving cross images (26 months)

E4, crisscrossing lines, with distinct crosses (31 months)

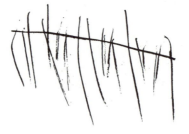

E5, parallel line crosses, at approximate parallels (36 months)

E6, multicrossed line and T-cross images (43 months)

E7, added line crossings, put on Scribble 17 (33 months)

E7, added line crossings, on circular scribbles (28 months)

E7, added line crossings, on varied scribbling (25 months)

E8, squares constructed from crossing lines (32 months)

The Emergent Diagrams do not rely on the edges of the paper for their definition, nor do they present clear shapes. Instead, they suggest the Diagrams, as shown here.

For purposes of classification, I distinguish seventeen Emergent Diagram Shapes. Each of the seventeen is shown in at least one illustration in this chapter, and a complete listing of the Emergent Diagrams is given in Chapter 18. Again let me caution that my classification is a descriptive convenience and not a hypothetical sequence of development.

Emergent Diagrams 1 through 9 all present crossing lines. Visually, these line formations are forerunners of the Greek cross and the diagonal cross that are commonly made by the time children are three. Emergent crosses may all be made under the control of the eye, though E5, parallel line crosses, may also be the result of rhythmic movements without eye control.

The remaining Emergent Diagrams suggest shapes other than crosses. In E10, lines near the perimeter of the paper are visual forerunners of the border, base, and sky lines in the art of older children. Children who make E10 scribblings use the edges of the paper as guides. A set of scribblings that nearly touches the edges of the paper on all sides, as shown in the illustration for E11, implies a rectangle. If a line is drawn around the outermost markings, a rectangle results. Again, the edges are guides, but the implied rectangle would exist without them. A number

E8, squares constructed from crossing lines (32 months)

E9, ladder cross squares (made by children of three and four)

E10, border, base, or sky lines, producing squares (32 months)

E11, implied square shape (28 months)

E14, concentric markings (42 months)

E12, centeredness markings,
in circular lines (26 months)

E12, centeredness markings,
with crossing line (28 months)

of E11 scribblings imply a rectangle that is well within the perimeter of the paper.

Markings in the center of a scribble, as in E12, and concentric markings, E14, suggest oval or circular Diagrams. In E13, E15, and E16, Diagrams are implied by the limits of the markings. A line drawn around E13 scribblings results in an oval or circle. In similar fashion, E15 yields an odd shape and E16 yields a triangle. Classification E17 is something of a catchall. I use it for scribblings in which a roving line takes in large areas. These scribblings show careful movement of the sort used in forming shapes, but no definite single shape is separately outlined.

The skeptical reader may have particular reservations about the implied shapes that I find in scribblings. If a child's paper shows a single circle made with a single line and there are no other markings on the paper, he has certainly perceived a circle, but why assume that he perceives circularity when his markings happen to fit inside a circle? Observations of children at work form one part of my answer. I have many times seen a child lift his crayon and place a final mark which shapes out a whole. Another part is the entire development of children's art as described in this book. The Basic Scribbles, the

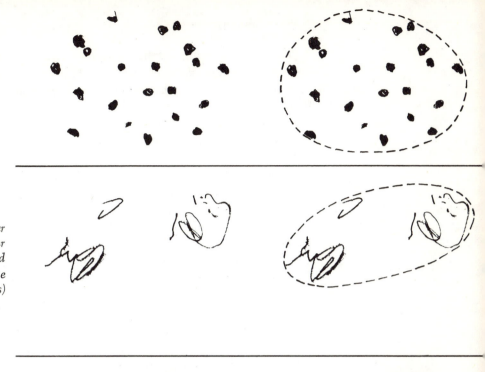

E13, implied circular shapes, as shown by four drawings. Each implied shape is outlined at the right (two to three years)

Placement Patterns, and the Emergent Diagrams all testify to the child's perception of shapes. Evidence of this perception is strengthened when a child uses circular scribbling in a centered Placement Pattern and adds a centeredness marking in the middle of the scribbling. Similarly, a number of circular scribblings may be spaced out in an implied circle. The notion of implied shapes gains credibility from the appearance of these shapes in Scribbles, Placement Patterns, and all subsequent work.

Although I see compelling evidence that children deliberately place markings so that the *total* configuration implies a shape, I see no such evidence in the parts of scribblings. Many shapes may be found within the scribblings of very young children, and yet these shapes do not necessarily recur in any deliberate form later. Diamonds, for instance, abound as small parts of the scribblings of very young children, but I have not observed a young child draw one deliberately in spontaneous art, nor have I seen diamonds as important shapes in later work. Apparently, diamonds are not "good" shapes to a child, even though they have the symmetry, simplicity, and regularity that W. Kohler (in Vernon, 1962, p. 52) attributes to pleasing shapes.

That total configurations are a clue to children's perception of shape though small parts of drawings are not is explained by D. O. Hebb (1961). He states that parts and wholes are perceived through different mental processes. The capacity to see a whole, a Gestalt, is innate, but

E14, concentric marks (38 months)

the capacity to see parts must be developed through much activity of the eye and brain. Whatever the explanation, children's perception of the over-all shapes implied by their scribblings seems to be a fact. Long before children can draw an outline of an oval, a triangle, or any other Diagram, they make combinations of Basic Scribbles within such implied areas, and these drawings are not rare, but commonplace.

The Emergent Diagram Shapes provide a transition between the first two of the general stages that I discern in self-taught art. During the pattern stage, the child makes the Basic Scribbles and draws some of them in Placement Patterns. This stage begins as early as age two and perhaps earlier.

Following the pattern stage in the child's development in art is the shape stage. This stage includes Diagrams—definite shapes drawn in outline form—as well as the Emergent Diagram Shapes that precede the Diagrams. The child usually enters the shape stage between the ages of two and three.

Soon after he begins to make Diagrams, the child elaborates them into what I term Combines (units of two Diagrams) or Aggregates (units of three or more Diagrams). These units are characteristic of the design stage of self-taught art, a stage that tends to occur when the child is between three and four years old. During the design stage, the child ordinarily begins to make the balanced line formations that I designate as Mandalas, Suns, and Radials. Following the design stage, the child does

E15, implied odd shape, and outline (39 months)

E15, implied odd shape, and the outline of the shape (39 months)

pictorial work. He draws representations of humans, animals, buildings, vegetation, and other subjects. He is likely to enter the pictorial stage at about age four.

In whatever stage the child is, his work will tend to fall into the familiar Placement Patterns, and often his drawings will imply the outlines of shapes. As the child develops in art, he will make new varieties of line formations, but he also will maintain many of the characteristics of his earlier drawings.

The four stages cover the time from the child's first scribbling until approximately age five, a time at which children often are taught

E16, implied triangular shape, and the outlined shape (32 months)

E16, implied triangular shape, and its outline (37 months)

to copy the schemas favored by society. The outline of a three-dimensional frame house is an example of such a schema. Prior to that, each child attains successive stages—patterns, shapes, designs, and pictorials—through his own activities and perceptions.

The developmental stages that emerge from my classifications lead to several puzzling questions: Is development in scribbling related significantly to development in art? Is scribbling itself truly art? The phrase "child art" has become commonplace, though it is an offensive misnomer to many art critics, and especially to those who refuse to review any exhibition of children's work. Traditionally, adults have

E16, implied triangular shape, and its outline (29 months)

dismissed the work of children, and children have been conditioned at school to denigrate their early tastes and abilities and to consider scribbling a waste of time, if not a misdemeanor. Only in the last few decades has anyone taken the work of children seriously *as art*.

What continuities link children's drawings with adult art? There are several important ones, whether art is approached from the standpoint of the artist and his talent, the viewer and his reaction, or the work itself.

The child gains control of the normal human arm movements that are the source of the Basic Scribbles as well as all later line formations. At the same time, he sees and remembers basic esthetic forms that are utilized by every adult artist. The increasing number of adults

E16, implied triangular shape, and its outline (36 months)

E17, pre-Diagram (34 months)

who "begin" to paint and draw as an avocation and who do well in art testify to the continuity of esthetic vision over the years. Similarly, in my experience children who are termed "creative" or "gifted" in art have done much early scribbling that was appreciated by parents and teachers. A number of discontinuities exist, of course. Most children stop all spontaneous art activity by the age of eight or so, and those who go on usually study and practice intensively to master the techniques of various media. Although a number of adults take up art as a hobby, a larger number do not resume any artistic activity. Yet the capacity to make abstract line formations and simple pictorials surely exists in all adults.

As I have noted, an adult who views children's work may well consider it worthless. I suspect that adult reaction would change if child art were commonly displayed. I hope that the book *The Psychology of Children's Art* (Kellogg and O'Dell, 1967) will prove an instrument of change. The reader who examines the color reproductions of drawings and paintings there will probably experience the same pleasure that he finds in adult art. Predicting the reactions of others is a hazardous business, but my own feelings and the comments I have heard encourage me to believe that children's work is just as artistically pleasing as the work of adults.

Important continuities also exist when art is considered from the standpoint of the work itself. Placement Patterns, implied shapes, Diagrams, and the Basic Scribbles themselves are common to the work of adults and children. These formations are, in fact, observable in the drawing and painting of all cultures. Adult art differs from child art in those art styles and formulas that are taught to older children in each culture and that help to distinguish one culture from another. In some cultures, the special styles and formulas require considerable technique. When technique departs too far from basic esthetic forms, however, it seems to lose vitality, as the history of academic painting clearly suggests.

I certainly do not wish to underestimate the variety or value of cultural elements in art. Instead, I wish to stress that the basic line formation and motifs that are appealing in child art are also to be

found in the art of adults. This is particularly clear in the work of artists like Kandinsky, Miro, and Klee. Modern abstractionists rely on childlike designs not because of personal regressiveness, but because child art contains the esthetic forms most commonly used in all art, including representational work. Herbert Read (1960c) says, "A comparison of abstract art with children's scribbles does not make abstract art ridiculous; on the contrary, it connects it organically with the beginnings of all visual symbols."

Perhaps a distinction should be made between the spontaneous art of all children and the work of older children who incorporate cultural formulas into their natural line formations. However, I believe that both sorts of work deserve to be known as art. The Diagrams, described in the next chapter, underscore the presence of basic esthetic forms in the art of all children.

5. The Diagrams

Children's art may be analyzed in terms of six Diagrams. Five of them are geometrically regular: the rectangle (including the square), the oval (including the circle), the triangle, the Greek cross, and the diagonal cross. Although children's versions of these five lack geometrical precision, the Diagrams are made quite clearly, often with single, unbroken lines. The sixth Diagram, the odd shape, serves as a catchall classification for any deliberate line formation that encloses an irregular area.

The Diagrams are easy to separate from other line formations in analysis, but they are not often found separately in children's work. Instead, they are either combined with Scribbles or with other Diagrams or both. When Scribbles are added to a Diagram, the resulting configuration is frequently a Placement Pattern or the implied shape of another Diagram. When Diagrams are added to each other, the result is what I term a Combine (a unit of two Diagrams) or an Aggregate (a unit of three or more). Diagrams, Combines, and Aggregates appear almost simultaneously in the development of children's art, and they might be grouped together in this book. However, the classifications based on them are more readily understood if considered one at a time, and so I devote separate chapters to the Combines and the Aggregates.

Visually, the Diagrams are similar to a number of the Placement Patterns and Emergent Diagram Shapes that have gone before. Developmentally, the Diagrams indicate an increasing ability to make a controlled use of lines and to employ memory.

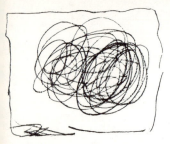

An image of a rectangle, made by lines that are close to the paper's perimeter (31 months)

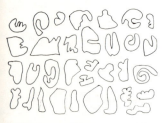

Odd shape Diagrams, without added lines (about three years)

Rectangular Diagrams, showing added lines (about three years)

During the pattern stage and early in the shape stage, the child responds to the visual stimulation of his own scribbling. As he gains eye control over the Basic Scribbles, he is able to use them to complete Placement Patterns and Emergent Diagram Shapes that are suggested by his scribblings. The formations that he makes are spontaneous, a result of the interplay of his scribbling motions and his predisposition to like certain shapes. (As noted in Chapter 3, this predisposition seems based in the physiology of the brain.) The interplay goes on through the child's coordination of eye and hand. None of the line formations of this stage need to be kept in mind beforehand. Rather, they may emerge naturally in the course of the child's scribbling.

In contrast, the Diagrams give evidence of planning and deliberation. It is possible that some Diagrams are made from a random beginning, just as it is a fact that some of the earlier markings are completely deliberate. For example, a Greek cross may result from a random vertical stroke followed by a deliberate horizontal to form the cross, or an Emergent Diagram Shape such as the border lines, E10, may be totally intentional. Unsteady lines in the work of a young child may show unsure coordination of a planned movement. However, planning is not easy to detect in early scribbling unless the child produces definite duplicates of some Gestalts. The Diagrams, though, provide clear evidence of forethought in child art.

The operation of memory is also indicated by the Diagrams. It is likely that the child who makes the Diagrams recollects similar shapes in his previous scribbling, and that these shapes come to mind when he uses paper and crayon. At least, there are ample visual sources for

Left: Diagrams and Scribbles

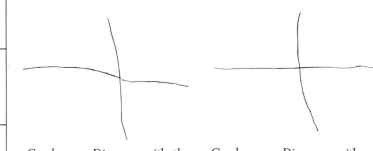

Greek cross Diagram, with the vertical cut evenly (36 months)

Greek cross Diagram, with a centered crossing (36 months)

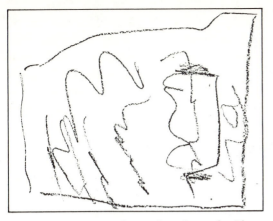

Rectangular Diagram distorted so that it fits Place-
ment Pattern 14, the three-corner arc (five years)

Odd shape Diagram located on the paper to fit
within Pattern 7, the diagonal half (five years)

the Diagrams. Rectangles may be remembered from P1, P3, P10, E10,
and E11. Ovals have visual analogues in Scribbles 16, 17, 19, and 20,
and sometimes in P2, P3, P13 (half-circle), P14 (quarter-circle), E12,
E13, and E14.

The child who makes a triangle in clear outline may remember this
shape from P7, P8, P15, or E16. The Greek cross may derive from E1,
E2, E3, E4, and E6 when made in upright balance, and the diagonal
cross may derive from Emergent Diagram Shapes E1 through E8 when
they are made in diagonal balance. The odd shape may mirror P9, P12,
and E15.

What role does memory play in the child's early scribbling? I suspect
that the role is a large one, although some of my evidence is
inconclusive. Similar patterns made by one child may reflect the child's
predisposition to see and complete certain line formations rather than
his memory of previous scribbling. However, the young two-year-old
can make duplicate drawings in one sitting without copying his own
work, and these duplicates show both foresight and memory. If he is ca-
pable of making duplicates through memory, he also should be capable
of remembering general patterns, at least for short spans of time.
Further, the child's patterns carry over into his later work. By the time
he can make Diagrams, the role of memory and the forethought based on
memory is clear.

6. The Combines

When two of the Diagrams are put together, they form what I term a Combine. Theoretically, there are twenty-one possible pairs of Diagrams, including the pairing of a Diagram with itself. Or, if a Combine is defined according to which part is dominant—if an oval within an odd shape, for example, is distinguished from an odd shape within an oval—then there are thirty-six possible Combines. If equality between the parts of a Combine is also recognized as a possibility, then the number of theoretic Combines becomes fifty-seven. Categories of separated, overlapping, and containing, illustrated on the opposite page, produce sixty-six possible Combines.

Further distinctions might be made. Consider the ways in which an oval and a rectangle may be put together on a page. The oval may be centered or off center inside the rectangle. If the oval is off center, it may be to the top or bottom, the left or right. In any position inside the rectangle, the oval may be relatively large or small. Or the oval and the rectangle may overlap, with the oval's center at any of the various "o'clock" positions relative to the rectangle. Further, the comparative size of the overlapping figures may differ. Or the oval may be separate from the rectangle at various distances, in various directions, and with various dimensions, though the two figures are visually related. Finally, instead of being inside, overlapping, or separate, the oval may contain the rectangle.

With distinctions like these, categories may be piled on categories,

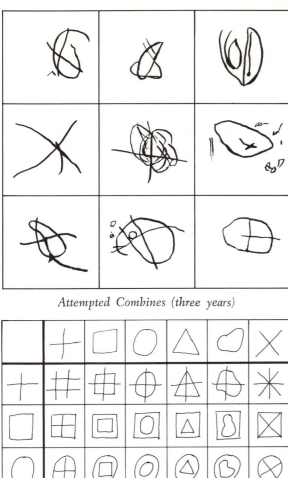

Attempted Combines (three years)

Thirty-six possible Combines (author's sketches)

Pairs	Separate	Overlapping	Containing
Rectangle and rectangle			
Rectangle and oval			
Rectangle and triangle			
Rectangle and odd shape			
Rectangle and Greek cross			
Rectangle and diagonal cross			
Oval and oval			
Oval and triangle			
Oval and odd shape			
Oval and Greek cross			
Oval and diagonal cross			
Triangle and triangle			
Triangle and odd shape			
Triangle and Greek cross			
Triangle and diagonal cross			
Odd shape and odd shape			
Odd shape and Greek cross			
Odd shape and diagonal cross			
Greek cross and Greek cross			
Greek cross and diagonal cross			
Diagonal cross and diagonal cross			

Sixty-six possible Combines (author's sketches)

Combine constructed of odd shapes (35 months)

Combines of odd shapes (three and four years)

and the possibilities of analysis soon outstrip any likely developmental significance. Perhaps a computer could be programmed to classify the line formations in children's art in an exhaustive manner. Nevertheless, the programmer's definitions would have to be arbitrary, and the results of the computation would deserve to be treated with some caution. Categories of line formations provide a way to approach the actual development of children's art, but the categories and the development are not the same.

I have found that certain Combines are commonly made, and others are made rarely if at all. The Combines favored by children include

Combine of touching squares (35 months)

Combine of joined squares (35 months)

Combine of separate squares (35 months)

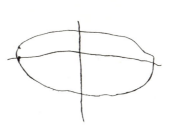

Combine of overlapping odd shapes (35 months)

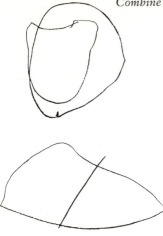

Combine of a Greek cross with-in an oval Diagram (40 months)

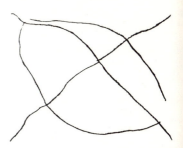

Combine of a diagonal cross and a circular formation (47 months)

Combine made by dividing an odd shape (37 months)

the Greek cross joined with the diagonal cross, and either cross joined with a rectangle, oval, or odd shape. Two ovals are also commonly put together, as are two rectangles. Other favored Combines are listed in Chapter 18.

A separate category might be reserved for attempted Combines. In these line formations, a child has put together two figures, though one of them is not a distinct Diagram. Attempted Combines indicate that the child is experimenting with the joining of two figures.

The examples of Combines shown here occurred in drawings in which extraneous scribbling was not added, and so the delineation of the line formations is clearly visible. It is notable that a Combine may be formed so that it implies a Diagram, and, too, it may fall within a Placement Pattern.

As each child proceeds in self-taught art, he gradually accumulates a visually logical system of line formations. The system is logical in the sense that one sort of line formation leads to another. Whenever he uses art materials without the constraint of adult direction, the child remembers and employs as much of the system as he has taught himself. Combines as defined here offer a designation for a significant part of the process of self-taught art.

Two odd shapes and a line in Pattern 12, the one-corner fan. They imply a triangle in Pattern 9, the diagonal axis (37 months)

Two odd shapes in a one-corner fan imply one large odd shape that itself falls on the diagonal axis of the paper (48 months)

7. The Aggregates

When he begins to form Aggregates—units of three or more Diagrams—the child functions as an artist with a repertory of visual ideas. The number of possible Aggregates is infinite, and the child who has an opportunity to scribble freely and often between the ages of two and three customarily will make many complex Aggregates between the ages of three and four. He will develop a personal style of constructing them, and a teacher or parent frequently will be able to recognize his work among drawings by other children.

Personal style has to do with the way the child draws the universally similar Basic Scribbles, shapes, designs, and pictorials. Variations of muscle pressure and eye attention cause weak or strong lines and neat or indefinite connections between lines. In addition, the child's span of attention determines whether his execution of a line formation is bold or subtle, simple or intricate, large or small.

Every child's work exhibits such extremes at one time or another. However, each child's drawing develops a prevailing style. As the child teaches himself to draw—unless adults interfere—he learns which muscle pressures produce the effects he likes best, and he learns which are the easiest to use. Eventually, he develops a style in drawing that adults can recognize much as they recognize an individual's handwriting, which is also a product of habitual muscle coordination. Their recognition depends on their seeing a number of the child's works and on their awareness of subtle differences. Most of the drawings that the child

makes before the pictorial stage are not readily distinguishable from the drawings of other children.

Aggregates constitute the bulk of child art between ages three and five. Children never tire of making them. What keeps the Aggregates from becoming hodgepodges of forms is the child's seemingly inborn preference for balance and regularity.

The Aggregates that are commonly produced continue to reflect the general shaping tendencies discernible in previous work. Twenty-two Aggregate classifications are listed in Chapter 18. Of these, classifications A10 through A13 represent over-all configurations that imply one or another of the Diagrams, and classifications A14 through A22 represent Aggregates that fall within Placement Patterns.

Those Aggregates that imply a rectangle, oval, or triangle, and those that fall into Placement Patterns 1, 2, 3, 6, 13, or 15 have balance of one kind or another. Three kinds of balance can be distinguished: top-bottom, left-right, and over-all. In top-bottom balance, most markings at

A2, Aggregate made of rectangles (37 months)

A2, Aggregate made of rectangles (41 months)

A8, multicrossed Aggregate area (48 months)

A9, formation of three Diagrams (37 months)

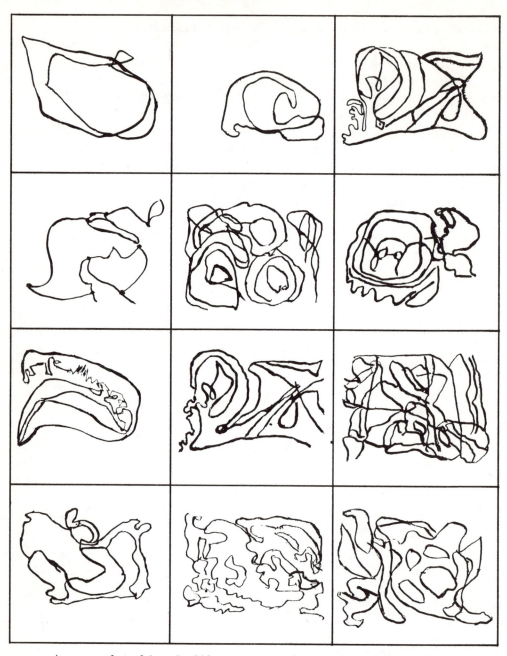

Aggregates derived from Scribble 11, roving enclosing line (three and four years)

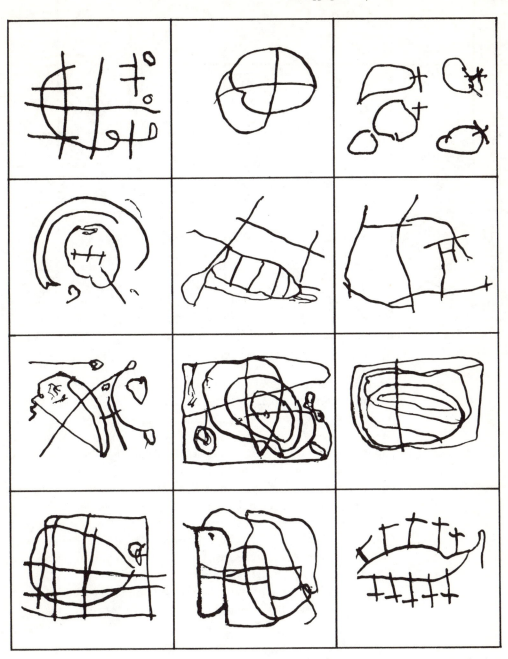

Aggregates formed of odd shapes and Greek or diagonal crosses (three and four years)

Author's sketches of Combines and Aggregates from finger paintings (three and four years)

the top of the configuration are balanced by similar markings at the bottom. In left-right balance, most markings at the left are matched by markings at the right. Over-all balance, as in a rectangle or oval, is a combination of the other two kinds of balance. When using drawing paper, the child usually keeps one of the longer edges toward him, and this orientation may be taken for granted when the child cannot be observed directly. (I find that balance in child art usually is artistically satisfying whichever edge of the paper is toward the viewer.)

An Aggregate may be balanced even though it does not imply a Diagram or fall into a Placement Pattern. Three odd shapes, for instance, may be positioned so that they have top-bottom balance although they are quite irregular in other respects.

Balance has developmental significance because the child seems to perceive and remember balanced line formations more easily than other

formations. And, as indicated in the chapters on Mandalas, Suns, and Radials, the child seems to prefer over-all balance to top-bottom or left-right balance.

During the design stage—the stage that includes work done from the Combines and Aggregates to the pictorials—the child makes drawings that are always abstract and frequently balanced. Does it make sense to speak of the child as an abstractionist or to treat some of his work as design? The question leads into consideration of the continuities between child art and adult art, a subject treated briefly in Chapter 4.

Gaitskell (1958) enumerates several elements of design. They are balance, line, mass and space, light and shade, texture, color, rhythms, movement, unity, and center of interest. All of these elements, except texture and light and shade, appear early in child art. Texture is used by the age of four or five. Light and shade do not appear in self-taught art. Not all designs by adults have light and shade, though, and so some child art would seem to qualify as design.

However, Gaitskell does not accept this conclusion. He shifts his attention from the elements to be found in drawings to the qualities within supposed artists, and he decides that young children are too

Author's sketches of Combines and Aggregates from easel paintings (three and four years)

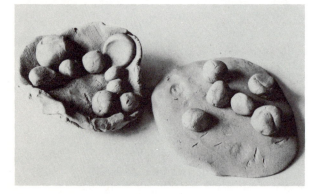

Aggregates in clay
(three and four years)

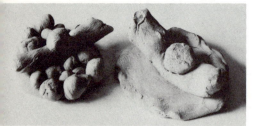

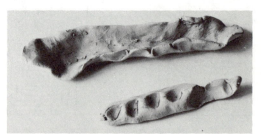

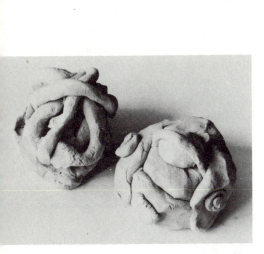

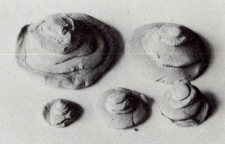

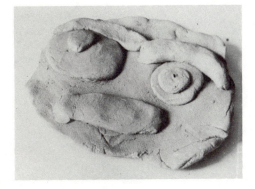

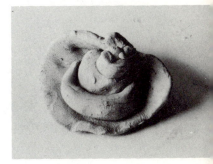

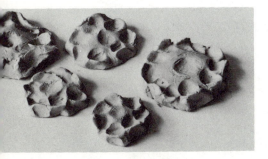

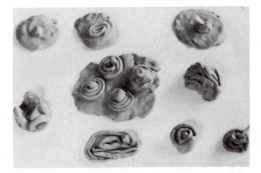

immature to be taught designs and that consequently the word should not be applied to their work. This conclusion amounts to saying that the child cannot produce valid art until adults have taught him how. Two drawings may be virtually identical, and they may contain nearly every element of design, yet in Gaitskell's view one of them is spurious if it is the work of a preschool child. This criterion is difficult to apply because a viewer must go beyond the drawing and ask about its source before making a judgment. The criterion also ignores the entire process of self-taught art, which yields work that has shape, balance, complexity, and other basic elements of art.

Whether the child is an abstractionist is a question that can be pursued through the child's drawings or through his capabilities and actions as an artist. When drawings are the prime concern, there are clear contin-

Aggregates in finger paintings (three and four years)

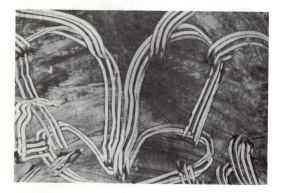
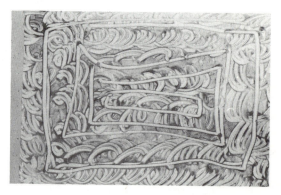
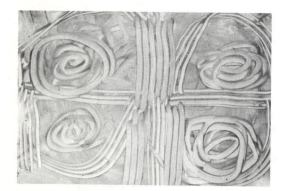
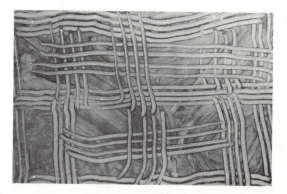

uities between child and adult work. By a dictionary definition, an abstraction is "a work of art using lines, shapes, and colors without reference to natural objects." Drawings produced in both the shape stage and the design stage are certainly abstract according to this standard of abstraction.

When attention shifts from the drawings themselves to the child's capabilities and actions, there is much more room for controversy. As an example, Arnheim (1954, p. 129) says, "There is no certain evidence that young children possess the rather advanced intellectual concepts necessary to think abstractly of symmetry, proportion, or rectangularity." He adds that children work "largely within the perceptual sphere itself rather than at the level of intellectual abstractions."

If abstract concepts are a condition of abstract art, then the child is not an abstractionist. However, I doubt that adult abstractionists spend much time in this sort of conceptualizing. Instead, I believe that they employ "visual conceiving." This phrase comes from Schaefer-Simmern (1948, p. 13), who states that a primary visual order exists in every human mind. It exists apart from rational thinking, language development, or emotional states, and it is expressed in Gestalt formations. These formations need not be pictorial and they need not provide emotional release except in the sense that they nourish the human spirit.

I believe that all art can be understood in terms of a visual order that has its own existence. Concepts and emotional states may be

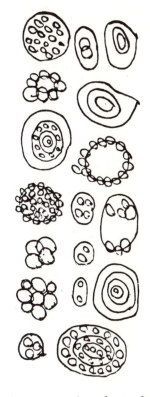

Aggregates of ovals in balance (three and four years)

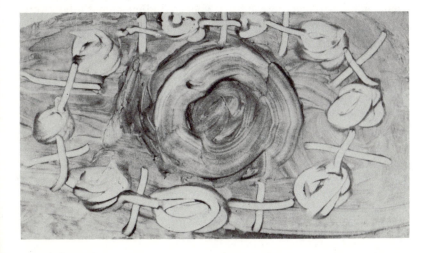

Aggregate of alternate ovals and crossed lines (four years)

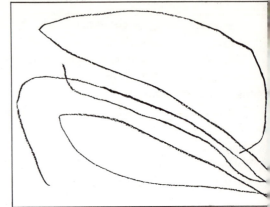

Aggregate of various shapes that falls into Placement Pattern 14, the three-corner arc (five years)

Aggregate of three odd shapes in Placement Pattern 9, the diagonal axis (four years)

applied to art, but art may not require them. The child who perceives circularity in his own scribbling and who repeats his perception in an oval Diagram has made an abstraction even though he has not conceptualized the process. The abstracting is part of the process itself.

The continuities between the artistic capabilities and actions of children and those of adults are thus based in visual thinking. Both children and adults see and produce esthetic forms without reference to natural objects. Some forms—the diamond and the pentagon, for instance—are not made by children prior to the pictorial stage, and many formal techniques of art are beyond children's abilities. But even though adult artists act in ways that young children cannot follow, primary visual conceiving is similar for children and adults.

Buckminster Fuller describes basic human powers of visualization: "I am astonished at how accurately and quickly the eye can see balance between mass and verticality. Most men's eyes can read what engineers call slenderness ratio in construction: the ratio of cross section to length in, for example, a column. . . . This ability is built into the eye; it isn't something taught to humans by other humans" (in Taubman, 1967).

Friedrich Froebel, the founder of kindergarten education, recognized the links between child and adult artists more than a hundred years ago.

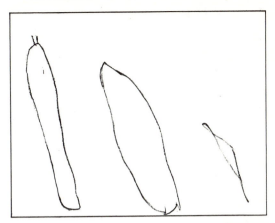

Aggregate of varied forms within Placement Pattern 14, the three-corner arc (five years)

Aggregate of shapes that together form Placement Pattern 8, the extended diagonal half (three years)

He stated (in Murray, 1914, p. 105), "Art and appreciation of art constitute a general capacity or talent of man, and should be cared for early, at latest in boyhood." Of drawing he said (p. 104), "Much is developed by this action, more than is possible to express—a clear comprehension of form, the possibility of representing the form separate from the object, the possibility of retaining the form as such, and the strengthening and fitting of the hand and arm for free representation of form."

Froebel stressed the importance of play, and it is significant that he defined play (in Murray, 1914, p. 141) as "spontaneous self-instruction."

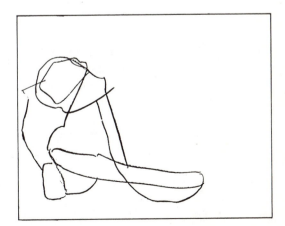

Aggregate that implies a triangle within Placement Pattern 7, the diagonal half (four years)

8. The Mandalas

"Mandala" is the Sanskrit word for circle. The word is applied in Eastern religion to various line formations, chiefly geometric shapes in a concentric organization. The same sort of line formations occur spontaneously in the art of children. Mandalas made by children are often Combines, formed of a circle or a square divided into quarters by a Greek cross or a diagonal cross, or Aggregates, formed of a circle or a square divided into eighths by the two crosses together. Concentric circles or squares also are Mandalas.

In the next chapters, two similar sorts of line formations are treated: the Suns and the Radials. (I use capital letters to distinguish the formations in children's art from all other drawings.) Suns are not Combines or Aggregates because they lack crossing lines in the center. Instead, Suns are generally formed of an oval (circle) or a rectangle (square) with short lines that cross the perimeter. Sometimes the lines start at the perimeter and extend outside; occasionally they start at the perimeter and extend inside the circle or square. Radials may be Combines, formed of the two crosses, or Aggregates, formed of many crosses centered on the same point, but Radials may also be composed of straight or curved lines that diverge from a small area rather than a single point.

Unlike Suns, Mandalas are divided by one or more crosses, and unlike Radials, Mandalas have an enclosing perimeter. All three formations are important as aids to the analysis of child art.

Some visual sources of the over-all Mandala configuration are indicated by classifications M1 through M5, presented in Chapter 18. These

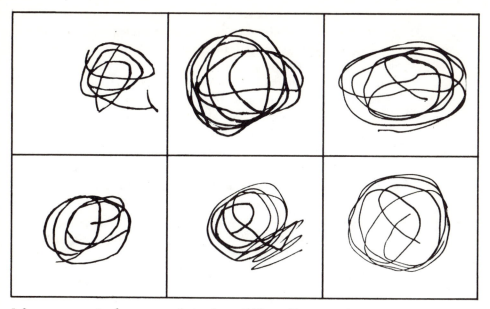

Inherent crosses in the centers of circular scribblings (three years)

classifications include inherent Mandalas and "Mandaloid" formations, and they provide evidence that Mandalas are perceived by children long before the first Diagrams are made. The remaining classifications, through M13, accommodate clear-cut line formations.

If my observations are correct, Mandalas are a key part of the sequence that leads from abstract work to pictorials. The child proceeds from Mandalas to Suns to Humans. As he goes from one step to the next, he incorporates many features of his previous spontaneous art into his new drawings. This visually logical system of development accounts for the over-all shape of the first Humans drawn by the child, a shape that usually seems distorted, crude, and inartistic to adults.

In fact, the Mandaloid shape of the first Humans is a sign of the child's essential artistry. Mandalas are significant not only as a part of the sequence of child art development, but also as a link between the art of children and the art of adults.

The most obvious evidence of the link is the prevalence of mandalas in art. Squares or circles divided by one or more crosses abound both in adult and child art. As the last chapter showed, however, art objects themselves are not enough to convince investigators that there is significant continuity between the work of children and adults. Gaitskell refuses to consider children's work design, even though it looks like design, and Arnheim does not think that children are abstractionists, despite the fact that their work has no reference to natural objects. Both consider art from the standpoint of the adult artist.

Mandalas offer proof that adults share the esthetic vision of child artists. The mandala Gestalt is one to which both children and adults

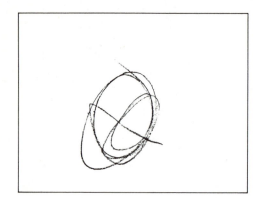

"Inherent" Mandala. The image might have appeared without eye control when the child stopped the crayon's circular motion and his hand made a crossing line as a preliminary to lifting the crayon. The child can see the crossed circle effect whether or not he meant to produce the image (36 months)

M1, inherent one-line center crossing, within multiple circular scribbling (37 months)

M2, inherent multilined half crossings that go across circular scribbling (25 months)

M2, *inherent multilined half crossings, on
circular scribbling of a few lines (34 months)*

M3, *inherent multilined crossings, with a
full cross on circular scribbling (40 months)*

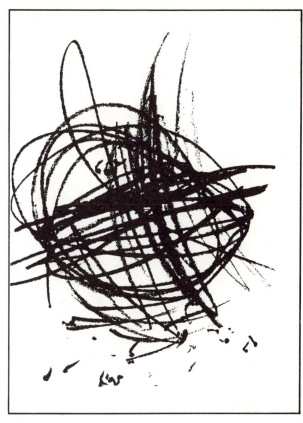

M3, *inherent multilined crossings, along with heavy
circular lines and dots in several places (28 months)*

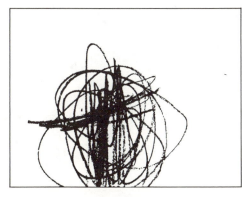

M3, *inherent multilined crossings, made
with heavy vertical scribbling (28 months)*

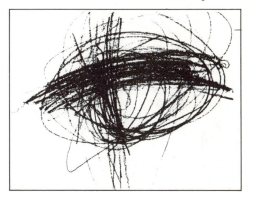

M4, *Mandaloid scribblings, showing control
of line and increased clarity (38 months)*

react favorably. Why is the mandala so appealing? One reason is its over-all balance. Arnheim (1954) has drawn a "structural map" of the location of marks on a paper that have the greatest "stability," and the map itself is a mandala, although Arnheim does not call it that.

In Oriental religion, the mandala is regarded as a symbol of the cosmos. In Jungian psychology, the mandala is representative of the unity of the psyche with the collective unconscious, which is "simply the psychic expression of identity of brain structure irrespective of all racial differences," as Jung has phrased it (1932, p. 83). I do not believe that the mandala has religious significance for nursery school children, and my study is not based on Jungian psychology, but I welcome both interpretations as testimony to the mandala's basic appeal.

Unfortunately, parents and educators are so accustomed to regarding self-taught art as inferior that they do not appreciate the simple Mandalas that the child makes. The appeal of these line formations is masked by prejudice, and many delightful drawings are thrown in wastebaskets. Few adults overcome the assumption that child art is always poor art.

The prejudice against child art is part of the larger prejudice against the mind of the child. Each adult can recall his own schooling, when he was made very aware of his inadequate (though potentially adequate) physical and mental capacities. In later years, it is difficult for him to respect the activities or art products of any child.

Mandalas offer a bridge across this prejudice. They are easy to recognize and essentially pleasing. By discovering them in child art, an adult may appreciate the artistic sense of children. The adult may also per-

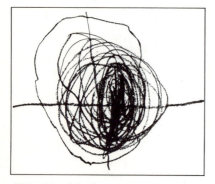

M5, Mandaloid structuring, formed here with a filled-in oval (41 months)

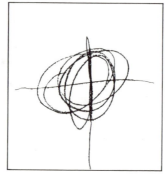

M5, Mandaloid structuring, on a multiple oval (46 months)

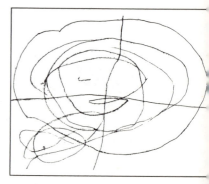

M5, Mandaloid structuring, here made of some concentric ovals (40 month

ceive the distinction between *childish* behavior, which is immature and limited to youngsters, and *childlike* behavior, which children and adults share. Painting or drawing that produces simple, basic designs is childlike, not childish. An increasing number of adults are working in art with childlike enjoyment. More adults would seek relaxation in this way if they did not fear criticism based on prejudice against anything that children do.

A large mandala carved in stone is not considered childish because only an adult could make it. The same line formation, drawn on paper by a three-year-old, is commonly considered to be immature and unimportant. Adults who acknowledge the worth of children in other respects may still demean spontaneous art. Maria Montessori urged well-planned and supervised training of the sense organs of the young, but she did not approve of free art (Montessori, 1912).

Children, like adults, may be denied enjoyment because their childlike work is deemed immature. When children work with art materials under favorable conditions, they are calm, self-controlled, and satisfied. The one drawback to their satisfaction is fear of adult disdain. Parents and educators should not apply arbitrary standards to self-taught art. The value of art activity is in the doing of it. To look for steady progression is unrealistic. The child will repeat familiar Gestalts, experiment with new ones, and produce "uneven" work for a variety of reasons. When adults have a consistently approving reaction to all the work made, without overemphasizing appreciation of what they like best, the child functions best in art.

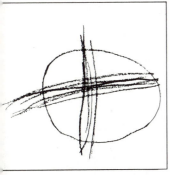

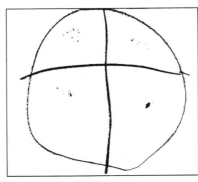

M5, Mandaloid structuring, with ne oval and crosses (37 months)

M8, cross and oval Mandala, a formation of two Diagrams (37 months)

M8, cross and oval Mandala, with an odd shape surrounding it (37 months)

M7, Mandalas of crosses and squares (four years)

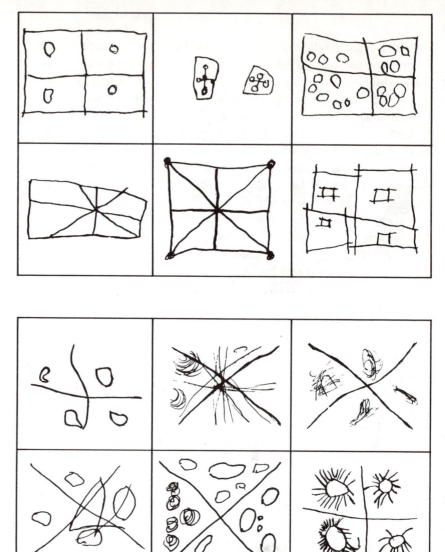

M6, crosses plus implied perimeters (four years)

*Mandala design containing flowers
or flower-like Humans (six years)*

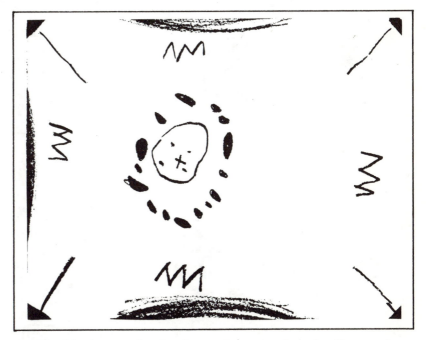

M9, Mandala of cross and oval and rectangle positioned together (four years)

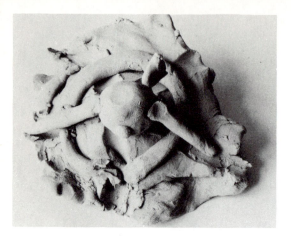

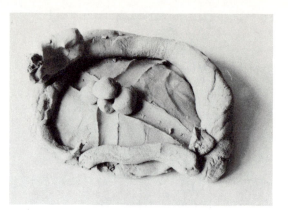

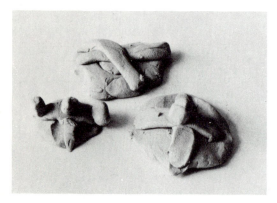

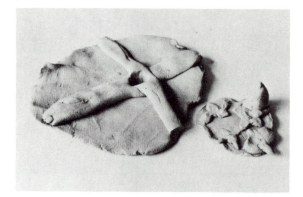

Mandalas in clay (three and four years)

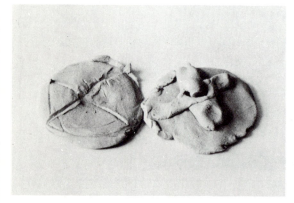

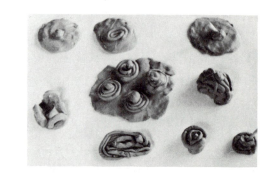

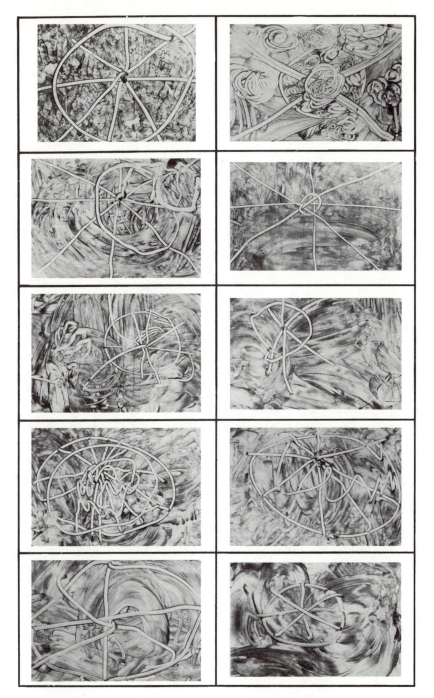

M8, Mandalas of crosses and ovals, in finger paintings (three and four years)

9. The Suns

In early scribbling, the child's coordination of hand, eye, and brain often results in markings that have over-all implied shape. In following work, the child draws a variety of such shapes and combines them into organized, nonpictorial Gestalts. When these Gestalts are made of separate lines, as in basic Diagrams, Combines, Aggregates, and Mandalas, the child has produced structured work.

The structures that the child makes show a developmental sequence, but it is not a mere progression from simple to complex line formations. The Sun is a very simple structure, yet it does not appear before the child has drawn complex Aggregates. Every two-year-old draws curved and straight lines, the components of the Sun. Nevertheless, the child rarely makes a circle with lines crossing the perimeter before age three.

What accounts for the relatively late appearance of the Sun? My explanation begins by stressing that young children get their "ideas" for structures mainly from their own scribblings rather than from drawings by adults or from objects that have visual impact as Gestalts. (The child's first Sun is not a representation of the solar sun, but it may be so labeled by an adult in hope that the child at last is able to "draw something.")

Author's sketch

The child's first structures derive from the shapes of his early scribbling. Although some of these shapes suggest the Sun, they do not seem to provide enough stimulus for the Sun until after the Mandala is made as shown here. The lines intersecting the circle are suggestive, and, since one image leads to another in child art, such a Mandala probably inspires the Sun. I have observed the sequence from Mandala to Sun often enough to believe that it is the prevailing order in child art. However, no statistical study has yet been made to confirm or deny this observation. One difficulty with such a study is that it would require the collection and dating of *all* the scribblings done by a large number of young children over some months of time. Because children make scribblings at home, in school, while visiting friends, etc., few parents or teachers could save and date every drawing in the time span that includes the first Mandala and the first Sun. Further, the loss of a few drawings might be critical; children may gain the stimulus for the Sun from only one or two Mandala formations. The multilined Diagram illustrated here is another likely stimulus.

In any case, both the Mandala and the Sun are favorite Gestalts and both are used nonpictorially more often than pictorially in art in general. Like the Mandala, the Sun Gestalt has a long and glorious

Author's sketch

Author's sketch

S1, pre-Sun scribbling—suggesting the Sun image—made of many crossed lines (32 months)

S1, pre-Sun scribbling, composed of Basic Scribbles 1, 2, 3, 4, 5, and 16 (32 months)

S3, *Sun with center marks, here verticals (45 months)* S3, *Sun with center marks, showing dots (43 months)*

S3, *Sun with center marks, including dot and oval (41 months)*

history in art, including the prehistoric art studied by archaeologists, and the Sun provides another link between adult and child art.

The Gestalts in early scribbling that are similar to the Sun include pre-Sun scribblings (S1) and the attempted Suns (S2), as listed in Chapter 18. These Suns, with the Mandala, appear to offer the visual stimulus for structured Suns.

It is interesting to note that the classification of Suns with center marks (S3) contains drawings that usually precede clear-center Suns (S4). Apparently, the formation of Suns with clear centers means a break from Mandalas and from certain circle Aggregates. Such a break seems to require time and "thought," in the sense of the visual thinking mentioned in Chapter 7. The system of child art is visually logical because the child proceeds step by step. He produces variations of known Gestalts and these, in turn, suggest new Gestalts. He will progress spontaneously in art if he is free to make variations, for it is the new Gestalts that stimulate him and hold his interest.

S3, *Sun with center marks, including some ovals (37 months)*

The uniformity of child art throughout the world leads me to believe that the human mind is predisposed to remember—that is, to like—certain variations and to discard others. The discarded ones are those that are either too complicated to take in at a glance or too difficult to repeat often enough to have them become fixed in the mind. Neurologists investigate the question of how much "old" and how much "new" stimulus the nervous system demands to function in balance; child art seems to be a balanced, self-regulated source of stimulus, at least until adults attempt to guide it.

S3, Sun with center marks of lines (38 months)

S3, Sun with center marks extended (39 months)

S3, Sun with center marks of ovals (43 months)

S4, clear-center Sun, rays to border (41 months)

Within the self-regulated system of child art, the Mandala and the Sun appear to provide stimulus for the child's first drawings of a Human. (The child's first Human should not be labeled a "man," for it has neither age nor sex characteristics.) The stimulus is especially clear in drawings of the Sun face (S5), which is a unit of the Sun and circle Aggregates, and in drawings of the Sun Human (S6), which is influenced more by the Sun than by the Mandala, as seen in Chapter 11. The labels of "hair" or "whiskers" or "eyelashes" on a Sun Human stem from the minds of adults. In the progression of child art, the lines to which these labels are applied are not pictorial. If they were, they would appear frequently on the Humans made later, and they do not. Instead, the lines show that the child has been stimulated by his own earlier drawings of the Sun.

S4, clear-center Suns, with lines crossing the perimeters of varied Diagrams (three and four years)

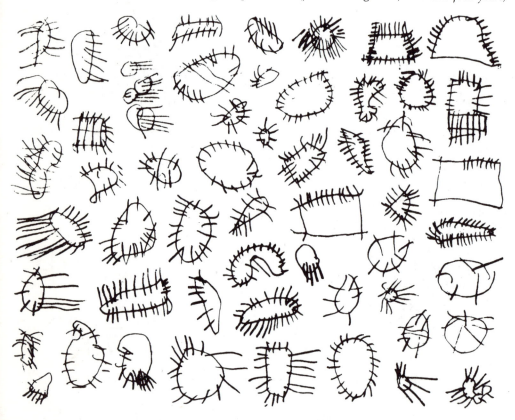

S4, clear-center Suns, with lines crossing the perimeters of oval Diagrams (three and four years)

Only in later work, after the child has drawn the Human with definite lines, is the Sun made with a variety of rays, as illustrated here. The addition of these rays makes some of the perennial designs of human art, including the flower symbol. However, the Human comes first in the prevailing sequence of child art.

Suns made with rays that return to the circumference of the central figure, resulting in varied images. These Suns are a relatively late development in children's art: they customarily appear after the Humans (author's sketches)

Waving scribble

Loop scribble

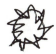
Zigzag scribble

Added loops

Added circles

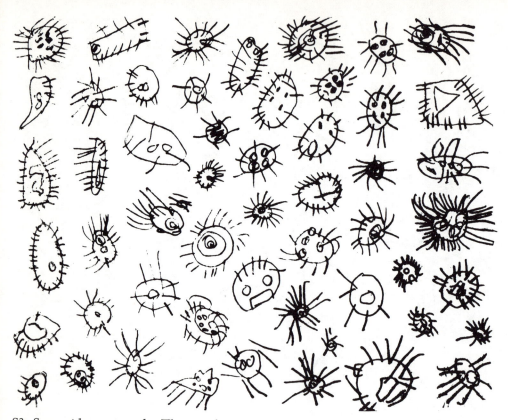

S3, Suns with center marks. These marks are fore-
runners of the Sun faces, S5 (three and four years)

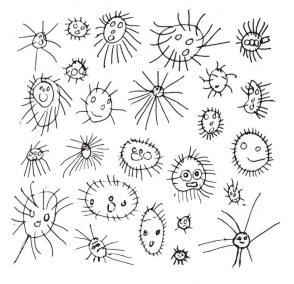

S5, Sun faces, including ovals (three and four years)

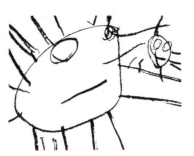
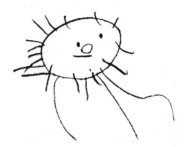

S5, Sun face image (42 months) *S5, two Sun faces (42 months)* *S6, Sun Human form (39 months)*

S6, Sun Humans, with faces, arms, and legs (three and four years)

Lined Diagram with horizontals and, at right, a Sun Human made on the same day by the same child (37 months)

S10, Sun design, with crosses and ovals (48 months) *An S3 Sun with unusual center markings (40 months)*

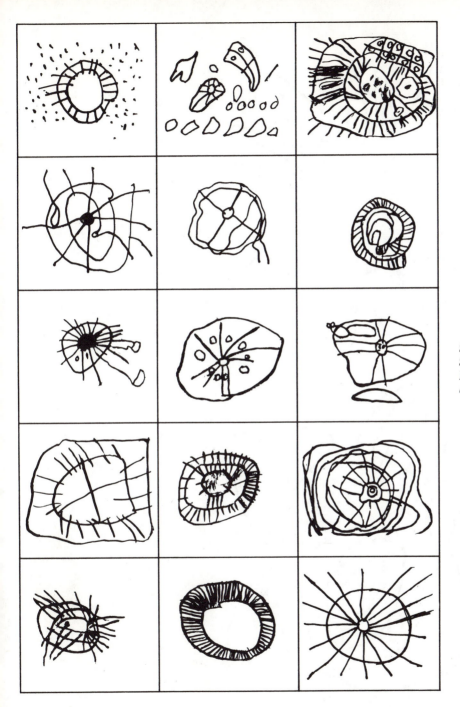

S11, enclosed Suns, and some Radials (three and four years)

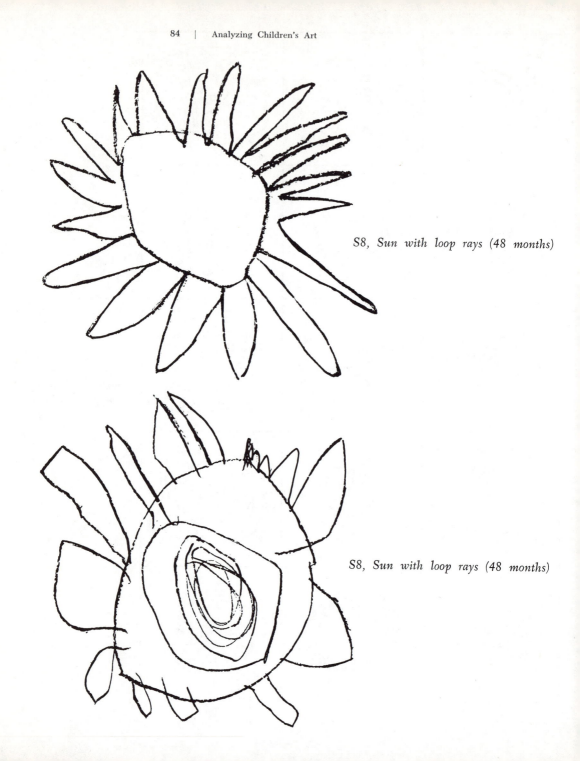

S8, Sun with loop rays (48 months)

S8, Sun with loop rays (48 months)

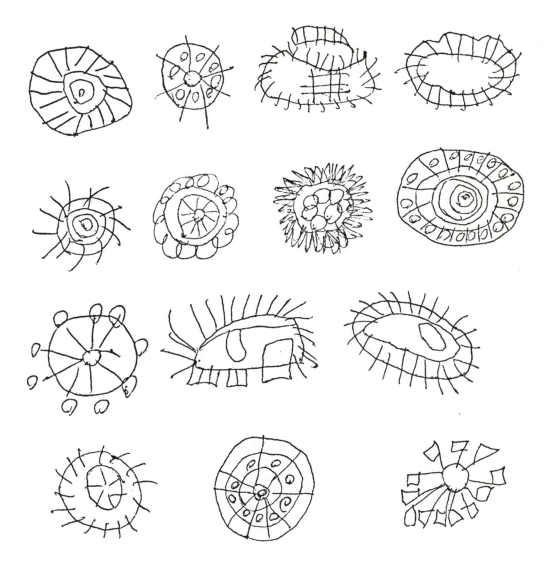

S10, Sun designs, showing great variation (about four years)

10. The Radials

One more abstract or nonpictorial Gestalt needs special description before an analysis of the Humans in child art: the Radials. They are part of many designs, and they influence the placement of arms and legs on Humans.

A Radial formation is one with lines that radiate from a point or a small area. The Combine of a Greek cross with a diagonal cross is one Radial, and the Mandala shown here includes the same Radial. It is tempting to look for a neat developmental sequence from the Radial made of crosses to the Mandala and then to the Sun. Actually, the Radial made of crosses is a special case; it resembles other Radials, but it does not have the same visual origin. It derives from the Diagrams, but the Radials commonly made in child art come from scribbling with rhythmic movements that do not require eye control. For example, the inherent Radial (classification R1 as listed in Chapter 18) can be made spontaneously by normal movements, with or without eye control. Rhythmic crisscrossing lines (R2) can be made without much eye control on the part of the child.

Child art is so rich and varied that no meaningful classification system can be absolutely precise. An interesting puzzle is offered by R3 drawings, circumference marks on circular scribbling. Are these marks stimulated by the need to complete an implied shape or to fill out a Placement Pattern, or do the marks represent a deliberate attempt to form a Radial Gestalt? Direct observation of the child at work might provide

Author's sketches

Multiple crisscrossing lines that give the effect of radiating from a central black area (18 months)

the answer, but inspection of drawings alone does not. In any case, these markings appear to have visual meaning for the child, as does every scribbling he makes; even the lines made without eye control yield some visual stimulation. Complete Radials (R5), on the other hand, show definite formation of Radial Gestalts. Like Mandalas and Suns, R5 Radials have over-all balance.

One source of Radial formations is Placement Pattern 17, the base-line fan. It contains lines that radiate out from one edge of the paper to cover an area near the center of the paper. Direct observation of the child as he draws this image shows how easily it comes from Scribbles 8 and 9. When the child is right-handed, he raises his right elbow to make radiating marks toward the left side of the paper. He brings his elbow in close to his body to make marks toward the right side. The left-handed child makes equivalent marks.

Scribbling in Placement Pattern 17, the base-line fan

(34 months) *(34 months)* *(33 months)*

Gestalts from the drawings of chimpanzees. These line formations are the same as base-line fans produced by children (author's sketches)

R1, inherent Radial in circular scribbling made of Scribbles 1, 16, and 18 (32 months)

Chimpanzees make the same movements when they paint with a brush. Desmond Morris (1962) describes the art of primates in a most interesting book, *The Biology of Art.* Compared to the child, the chimp's achievements in art are quite limited. Chimps do not make a complete radial formation, nor do they ever reach work as advanced as the Aggregates of child art. The most advanced work known to have been done by a chimpanzee is a poor oval Diagram containing two short crossing lines (Morris, 1962, p. 136).

The Radial-like formation of the base-line fan is not the only characteristic that child art has in common with the art of chimpanzees. The work of chimps shows that they use balance, and so they seem capable

R1, inherent Radial formation (47 months)

R1, inherent Radial formation (42 months)

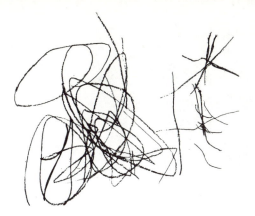

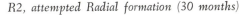

R2, attempted Radial formation (42 months) *R2, attempted Radial formation (30 months)*

of making marks with eye control. Apparently, though, they cannot remember esthetic images, or at least they cannot reproduce them at will, and so they do not progress in art as do children. The fact that both lower primates and children favor balance indicates that the tendency to make and to like balanced line formations is inborn. Morris's study and Rensch (1965) point to the conclusion that esthetic response to balance is a natural, biological capacity of all primates.

In several other respects, Morris reaches conclusions that do not accord with my observations of child art. It is worth making a small digression here to consider his beliefs, because they have implications for the entire development of the esthetic sense in childhood.

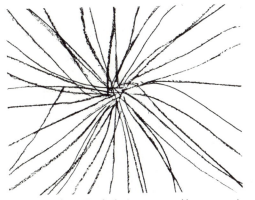

R5, complete Radial formation (four years) *R5, complete Radial image (five years)*

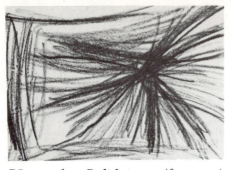
R5, complete Radial image (five years)

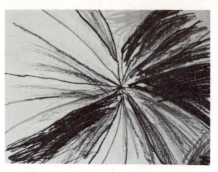
R5, based on cross (five years)

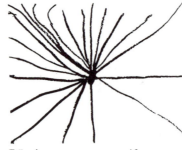
R5, from two crosses (five years)

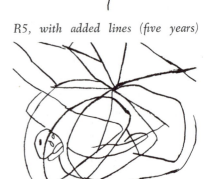
R5, with added lines (five years)

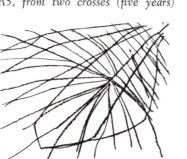
R7, Radial design (five years)

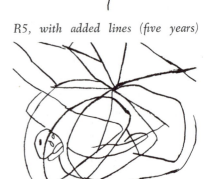
R7, design with face (five years)

R7, Radial design similar to the design of a spider web (four years)

R7, Radial design giving distinct indication of a spider web (five years)

Morris (1962) says that origins of picture-making are unknown. He thinks that art is the result of surplus energy being released in a self-rewarding activity, and that art once served three purposes: to communicate facts about hunting techniques, to further religious or magical purposes, and to bring esthetic satisfaction to the artists. When men developed writing, picture-making lost one major function, and even more so when photography developed. Religious use of art also declined, leaving the esthetic reason as the main one for doing art.

Morris lists six biological principles of picture-making, a term he uses to cover abstract art as well as pictorial work. These principles are: self-rewarding activation, compositional control, calligraphic differentiation, thematic variation, optimum heterogeneity, and universal imagery. All these principles can be applied to ape art and to human art. He thinks that the differences between the child brain and the ape brain have only an indirect effect on the differences between ape art and child art. My comment is that apes, with full brain growth, only do some of the art which the two-year-old child produces with incomplete brain growth, and so the differences in art and in brain growth are significant. The three interrelated factors underlying all art he gives as the muscular, the visual, and the psychological. "As soon as the child has portrayed a specific person or a specific place, there will be strong psychological undercurrents controlling the exact way in which it is presented in the picture" (p. 136). A question not answered by Morris is: When does the child draw a specific person or place? Certainly not until he has studied culture-approved ways of doing so. Therefore, the "psychological" factor, as he uses the term, is not a factor in the art of young children. Morris is quite wrong to say that children prefer "calligraphy over composition" (p. 158) and that apes are better at composition. The scribblings of two-year-olds are well organized into shaped areas that apes cannot produce. The lower primates do produce certain of the Placement Patterns and they react to balance in line formations, as already noted.

That apes as well as humans have esthetic need is shown by Morris, but what he fails to see is that this need may be the main one which accounts for art activities, and that picture-making for communication

about daily activity (such as hunting) or about religious emotions may be secondary. Many of the art forms to which Morris and archaeologists attribute a religious significance are made by children for esthetic reasons. To say, for example, that the drawing of the sun image by prehistoric man proves he was a sun worshiper is valid only if we say that sun worship is characteristic of all children, judging by their art. Unless we take the position that children's art expresses religious feelings, we must admit that the symbols which adults use for religious purposes may be chosen simply because they are esthetically good. In that case, esthetics antedates religion in the human mind.

Expert opinion on prehistoric communication may easily overlook the esthetic factor. The archaeologist, says Curt Ducasse (1948, p. 111), is regarded "as an authority, not only on the history, but also on the aesthetic merits of the statues or other objects he digs up. Yet he may, in fact, be less capable of aesthetic response to them than was perhaps one of the laborers hired by him to do the digging." Ducasse also says that the "discipline which fits one for intellectual enjoyment not only does not automatically develop one's capacity for aesthetic appreciation, but rather tends to inhibit and displace it" (p. 110).

The importance of the esthetic factor, in contrast to the factor of communication, is underscored by the relation between child art and calligraphy. The lines employed for both occur in the Basic Scribbles, but the use of these lines differs. In child art, the lines are used entirely to make self-taught formations. The formations are not learned from adults. Each generation starts from scratch, and each child teaches himself the basics of drawing before age six. (Incidentally, I detect no difference between males and females in the capacity to use the Basic Scribbles until approximately age five, when cultural influences frequently affect a child's choice of subject matter as "masculine" or "feminine.") Language symbols, however, have been passed on from generation to generation within the limits set by particular cultures. Each child learns these symbols from adults, and each child is well advanced in esthetic development before he begins to master the line combinations of written communication.

Many line combinations of adult art also are taught to children, at

home or in school. When the child proceeds from abstract formations such as Radials to pictorial work, the biological esthetic taste that he has developed for himself often is in conflict with the wishes and expectations of the adults around him. This biological taste applies to spontaneous pictorial work as well as to abstract formations. The early Humans owe more to previous structures in self-taught art than they do to the child's observations of human beings.

The conflict between cultural taste, which is acquired from adults, and the biological taste of self-taught art is particularly clear when the child tries to learn the schemas transmitted by the culture. If the schemas happen to coincide with formations of self-taught art, as in the case of radial lines used to indicate a halo in adult drawing, the conflict is minimized. Often, though, cultural schemas are strange to the child. They seem less definite than the formations of his own art, and they are hard to learn. The conflict occurs so often because adult schemas are largely based on the visual Gestalts of objects, but the schemas of child art result from Gestalts based on line balance, proportion, and shaping. The drawings of Humans illustrate these three factors.

R5, complete Radial image (five years) *R7, Radial image of many lines (five years)*

11. The Humans

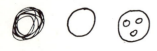

Author's sketches

Basic Scribbles

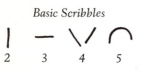

The origin of the child's first drawing of a Human may be traced to Scribble 17, which becomes the oval Diagram, which in turn becomes the "face" Aggregate, as shown. The body parts that customarily accompany this Aggregate are traceable to Scribbles 2, 3, 4, and 5, and to all of the Diagrams. It is the way in which the child combines the Scribbles and the Diagrams that gives a particular appearance to the Human and to all subsequent pictorialism. When the first Human is made, the child joins the face Aggregate with body parts that form a modified Mandala.

H1, face Aggregate, showing separate markings (37 months)

Aggregate that is a forerunner of the face image (37 months)

H1, face Aggregate, with markings that overlap (36 months)

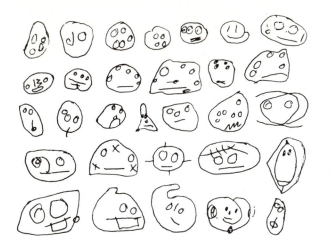

H1, face Aggregates (three and four years)

In the development of some children, I have observed a preliminary period, after the Sun is drawn and before the Human appears, when the child draws an area with a few rays extending from it (classification H2 as listed in Chapter 18). Although an H2 drawing resembles an incomplete Sun or a Human without a face, it is neither, because it occurs after the child draws the Sun and the face Aggregate quite well. Probably, the H2 structure is the product of the child's inventive mind as he seeks to make new Gestalts out of Suns, Mandalas, and various Aggregates. The H2 structure itself lacks only center markings and possibly a leg to become a Human.

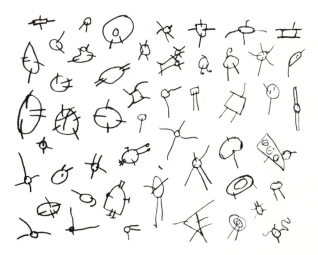

H2, areas with a few rays (three and four years)

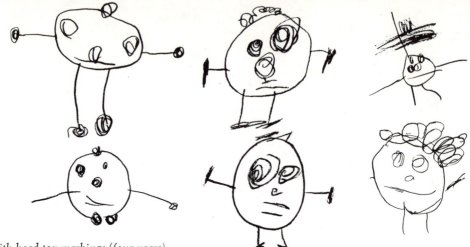

H3, Humans with head-top markings (four years)

The first Human (termed "Human with Head-top Markings" and classified as category H3 in Chapter 18) shows signs of its origin. The head-top markings give Mandala balance to the figure, the same sort of balance that is cherished in former work. The Human has arms extending from the head, and these, with the head-top markings (labeled "hat" in my book *What Children Scribble and Why*), increase the figure's Mandaloid appearance. Further, almost all the Humans that children draw spontaneously are made to fit into an implied Diagram, usually an oval, and many of the Humans fall into Placement Patterns as well.

I find it very difficult to convince adults that the child's early pictorials are not mainly based on observations of objects and persons in the child's environment. Before showing other variations of Humans, I wish to point out some reasons for the usual attitude of adults. In doing this, I hope to convince the reader that the attitude is wrong and that the Humans are esthetic compositions evolved out of earlier work.

When an adult calls one of the Humans a "man" or "mama" or "lady" or "daddy" or any other name denoting an actual person, he is accepting a long-standing assumption about child art. These labels and similar ones have been applied to child art for at least a hundred years, as some of the first books about the subject demonstrate, and probably for much

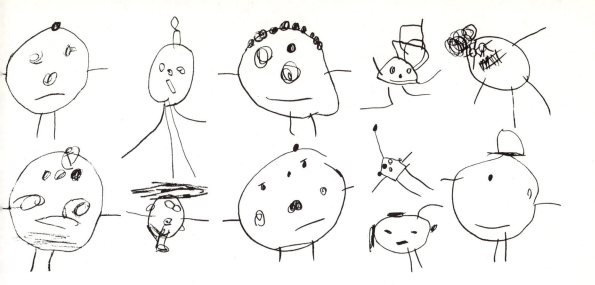

longer. An adult who employs such labels—rather than alternative words like "formula," "schema," or "symbol"—acts in a long tradition.

The child often encourages this tradition. He labels his Scribbles, Patterns, and Aggregates as persons and things owing to his realization that adults wish for evidence of general pictorial meaning in child work. The child may be laughed at because his work is not at all like his label, or, if the adults around him have a tolerant attitude toward scribbling and go along with the child's mislabels, he may be confused. The child knows that his scribblings are not pictorial Gestalts, as are photographs and much of the adult art that he can see, but he accepts the adults' tolerance of his labels as a familiar inconsistency of the adult mind.

The tradition of pictorial labels also is strengthened by the lack of words to describe particular aspects of child art. Adults who wish to talk about the child's work find it convenient to use the same words that they apply to everyday objects. One aim of this book is to supply descriptive terms that do not have pictorial connotations. (In the case of the Humans, which are only partly pictorial, I have retained ordinary anatomical labels such as "armless" and "with ears." I would rather use esthetic terms to reflect the abstract component of these drawings, but no useful terms exist.)

Another source of the usual attitude adults have toward child art is the adults' faint or clear recollection of parental dismissal of their own scribbling in childhood. This recollection contributes to the general prejudice against child art and the mind of the child, as described in Chapter 8.

The general belief that child art is worthless unless it is realistic causes two common mistakes. One is to teach the child to copy realistic work. Actually, when the child is prematurely taught to draw a face, that face is not retained for very long, or else it is repeated as a mere stereotype and the child loses interest in more varied scribbling. For this reason, an adult should never draw pictures for a young child to copy, and, if possible, the child should not draw while sitting next to another child whose work is more advanced and more appreciated by adults. A child should "copy" another child's work only if both are in approximately the same phase of development. There is no harm in this kind of "copywork," for the child's natural growth in art is not impeded by it.

The other common mistake is to prevent the child's scribbling, so far as possible. Some adults remember being punished in childhood for scribbling destructively on walls, floors, and furniture. It is not surprising that these adults have mixed feelings about letting their own children scribble at any time. Other adults feel that the activity is worthless, if not destructive, or they fear that the child who becomes too absorbed in it may be headed for failure in reading or a career in art, a future they do not approve of.

Adult opposition to scribbling cannot prevent a child from doing some work, if only with his fingers on dusty or frosty surfaces or with a marking instrument on walls and sidewalks, in sandpiles, and so forth. Such scribbling movements stimulate the child's eye and mind, and the child who has never used paper and crayons nevertheless learns some of the imagery that he has drawn elsewhere. This development despite restrictions was shown by the children in Nepal to whom I gave the first paper and crayons that they had held. A few of the children had had access to a slate and a slate pencil kept by a Buddhist monk who was trying to teach them to read, but they all showed development in scribbling the Gestalts of self-taught art.

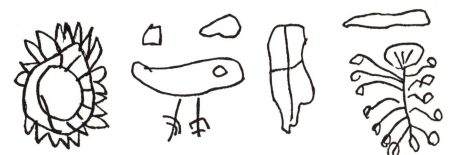

Drawings made by the boy in Nepal shown in the photograph above. He had never used paper or crayons before, but his drawings reflect experience in scribbling with his fingers or a stick in dust or snow (age unknown)

Adults who encourage copywork and who forbid spontaneous scribbling may harm the child's development in learning as well as in art. My observations of children suggest that the child who has frequent opportunity to draw without adult interference learns faster and increases his cognitive ability more than he would if he were denied the opportunity.

The prevailing attitude toward child art also has theoretical consequences. Helga Eng's (1931) detailed study of one child's work, for example, was influenced by her conviction that all children wish to pictorialize, and she saw a "man" where I see a cross Diagram and a few Scribbles. The evidence, including the vast number of drawings I have examined, most of them done by children who were allowed to scribble freely in nursery schools, seems clear. Consider the drawings that follow. These Humans were made by normal children. Who, for one moment, can think that they look much like human beings? Yet young children indicate to us in other ways that they know about human anatomy, including sexuality (see, for instance, Kellogg, 1953, p. 98). They know that arms are not attached to the head. The adult belief that child art has significance only insofar as it is pictorial art is a misconception that hinders the study of child development.

My analysis indicates that child art has its own discipline, controlled in the child mind by perceptions quite different from those that enable the child to recognize men, women, children, costumes, and various human characteristics. For adults and for young children, the Gestalts that permit recognition of a living human probably are quite similar. The Gestalts for the drawing of a human are very different, though, because adults have learned formulas for art that the children have not yet learned.

The following categories are not mutually exclusive; any one drawing may illustrate more than one category. The categories illustrate the main ways in which the child treats the "anatomy" of the Human, ways that lead to meaningful esthetic wholes. My taxonomical approach is not mathematically neat, but it allows description of significant parts of the work of children.

The Human *without* head-top markings (classification H4 in Chapter

18) may not be Mandaloid, but its arms and legs usually will be drawn in lengths that insure an implied Diagram.

I once thought that the armless Human (H5) was the result of the child's trying to elongate the figure to make it more realistic. After observing many such drawings, I know that this is not true and that the armless Human is drawn as an implied Diagram and, often, as a Placement Pattern. Lowenfeld (1954, p. 21) considers the same figure to be an expression of an individualistic emotional state. However, all children make the armless Human, and they do so *after* they make the Human with arms. The reason for omitting the arms is not immaturity or forgetfulness. It is simply that such a Human looks better to the child when the figure lacks arms, once the child has made the head and legs in certain proportions.

H4, Humans without head-top markings (four years)

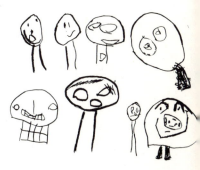

H5, armless Humans, here shown with head-top markings (four years)

H5, armless Humans, with torsos defined by horizontals (four years)

H5, armless Humans, here without any head-top markings (four years)

The legless Human (H6) is relatively rare. Some drawings of this sort may be incomplete work, though the legs seem to be omitted for esthetic reasons in most of the H6 drawings I have examined.

The humanoid Aggregate (H7) is one that contains a face. In addition, certain aspects of the Aggregate suggest a torso and limbs. Such an Aggregate is not in the mainstream of the developmental sequence of Humans, nor is it frequently drawn.

H6, legless Human, with arms on the head (four years) *H7, **humanoid Aggregates, with faces** (four years)*

H8, Humans in Aggregates that resemble torsos (four years)

H9, Human with ears. Feet and hair also appear on this version of a Human in category H9 (38 months)

Several weeks before making the Human at left, the same child produced the Aggregate above (37 months)

The Human in an Aggregate (H8) is the typical Human incorporated into an Aggregate which is otherwise nonpictorial. This Human shows that the child sees the figure as an esthetic unit incorporated into the whole of his drawing.

The Human with ears (H9) has markings on either side of a face that merit the label "ears." They fall into the places where the first arms were once attached. Sometimes ears and arms both are attached to a face. They complete the implied esthetic composition of the shape as a Mandala. They are not renditions, either in size or in shape, of ear anatomy as known to the child.

The Human with a big head (H10) and the Human with a small head (H11) are commonly found in adult art—the former in comic books, the latter in advertising for women's clothing shown on models standing with feet far apart. The big head gives top-bottom balance to the drawing. The small head gives an over-all triangular effect.

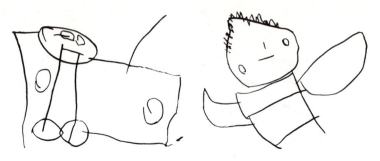

H12, Humans with wing arms (four years)

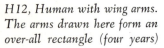

H12, Human with wing arms. The arms drawn here form an over-all rectangle (four years)

The Human with wing arms (H12) is commonplace. The only reason the markings are here called "arms" is that they relate to head and torso in a position that justifies the label. The markings are made for an over-all effect in art.

The categories of hands and feet and of hair (H13 and H14) show clearly that esthetics wins out over realism in child art. These features are a pure delight to look at. They tell their own story.

H13, hands and feet. Such Gestalts are used from four to eight years (author's sketches)

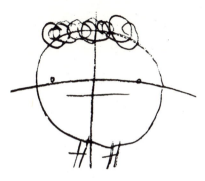
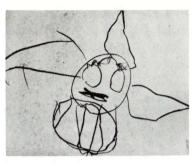

H15, Mandaloid Humans (three years)

The Mandaloid Human (H15) is one that fits neatly into a crossed circle, with head, arms, and legs falling in balance on the cross, and with the whole fitting into a circle or oval. When the Mandaloid Human is based on the diagonal cross, it often is called a "dancer" or a person in distress by adults who do not know the "etymology" of child art. Such a figure does *not* indicate an emotional state calling for psychiatric attention.

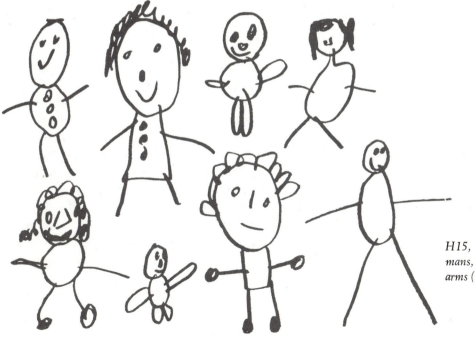

H15, Mandaloid Humans, showing balanced arms (four and five years)

The Radial Human (H16) has drooping arms which suggest the Sun, but more so the Radial. The arms may express "fatigue" or "sadness" to adults, but these limbs are drawn in lengths which make an esthetic shape of the whole.

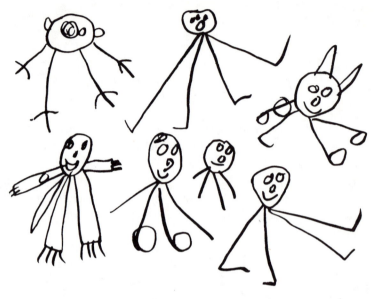

H16, Radial Humans, limbs diverging (four and five years)

Humans in pairs (H17) may look alike or have differentiations which lead adults to call the figures "boy" and "girl." Which sex is being portrayed is sometimes hard to determine, for women wear pants in many parts of the world and men may wear flowing robes. The female Human is customarily identified by long hair, whereas the male's hair is short. Breasts and phallus are so rarely drawn before age six that they cannot be indigenous to child art. Their absence is due not only to the adult's taboo but also to the fact that the child is not interested in drawing realistic anatomy—sexual or otherwise. Each child develops individual varieties of typical Humans, all in basic formulas. The child does not lose interest in earlier formulas as he develops more complex ones, and for this reason one drawing of a Human does not necessarily reflect his ability to draw them.

Humans in groups (H18) are made either in one size or in graded sizes, the latter often being called "a family" group. Similarity of the figures in these groups is often greater than any differentiations, other than size, which would connote the age or sex of family members.

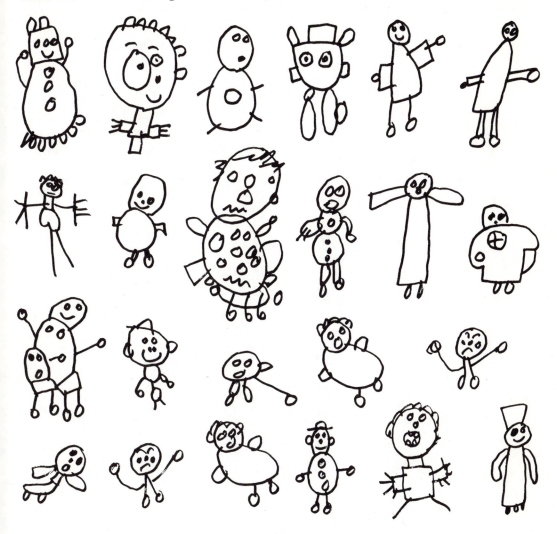

Sexless Humans. Like many of the Humans of spontaneous art, these figures offer little evidence of concern for realistic anatomy (five to seven years)

The stick man (H19), contrary to popular estimate, is not an early version of a Human, nor is it a popular one. I think it is learned at age five or six by copying the work of adults or of other children who have learned it from adults. The stick man might be a spontaneous "reduction" or "abstraction" of the many Humans known to the child. Only in this case is it an important Gestalt in child art. I have not seen it often enough in preschool work to form a judgment.

Humans are the favored subject matter of child art, and a separate book would be needed to display and discuss them adequately. To repeat, the Humans are not drawn from life, nor are they crude, immature, stumbling efforts in art. They represent an advanced stage of the child's evolving mental capacity to create complex Gestalts of great interest to the human eye. Evidence of high intelligence is presented by the

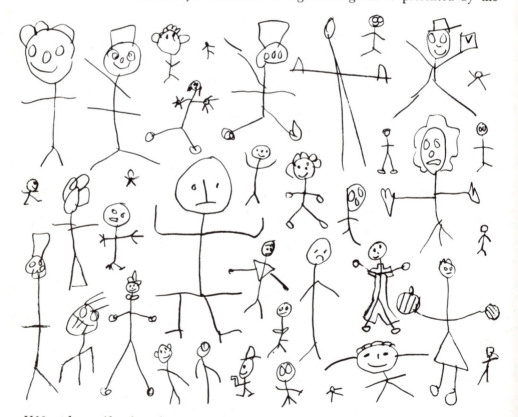

H19, stick men (five through seven years)

Going from bottom to top, these Gestalts represent the probable evolution of Humans from earlier scribbling. The Basic Scribbles at the bottom lead to (2) Diagrams and Combines; (3) Aggregates; (4) Suns; (5) Sun faces and figures; (6) Humans with head-top markings and with arms attached to the head; (7) Humans without head-top markings; (8) armless Humans; (9) Humans with varied torsos; (10) Humans with arms attached to the torso; and (11) relatively complete Human images (author's sketches)

Not all of these evolutionary steps may appear in the work of every child. Each drawing made by the child over a three-year period would be needed to determine the point. However, the steps apply well to large quantities of work by many children. Similar steps apply to the evolution of other pictorial items

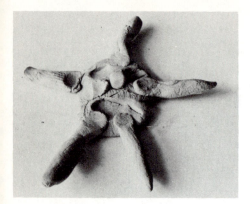

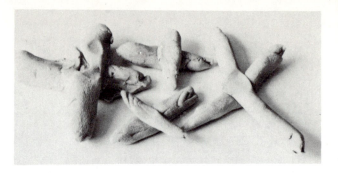

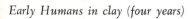
Early Humans in clay (four years)

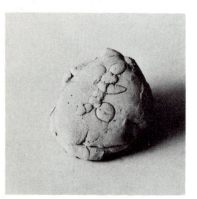

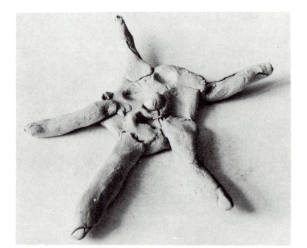

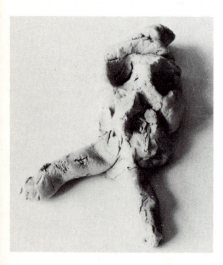

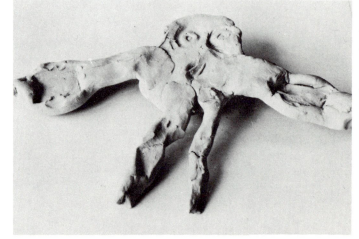

Humans, and the child who can draw them in great variety, but cannot learn to read, surely is not lacking brain capacity to do so. Something else is wrong. To conclude this chapter, various illustrations of Humans are shown in different media (other examples may be seen in Kellogg, 1958), all of which convince me of the lasting influence that first scribblings have on the mind as it works in art. That the human mind is predisposed to see and to retain throughout life certain abstract Gestalts produced by spontaneous scribbling movements in childhood is a hypothesis worth further study.

In this and in subsequent chapters, works of children of ages six through eight are included to indicate the carry-over of spontaneous preschool work. However, no attempt is made to show the full variety or capacity of older children's work. The reader may refer to my presentation on microfiche (Kellogg, 1967a) for more complete documentation.

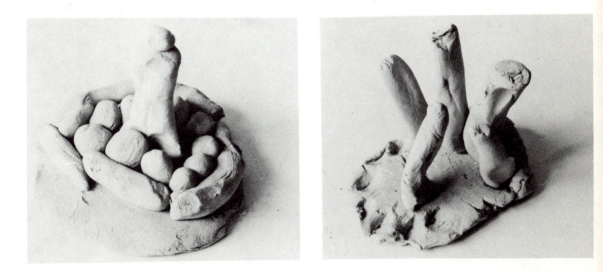

Two Mandalas made in clay (four years)

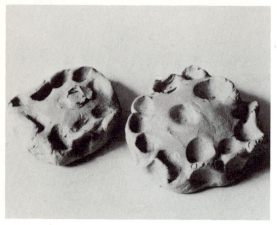

Oval Aggregate (four years)

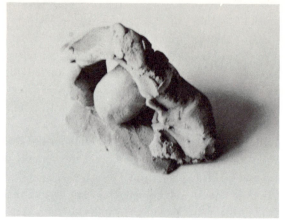

Combine (four years)

Left-right balance in clay (four years)

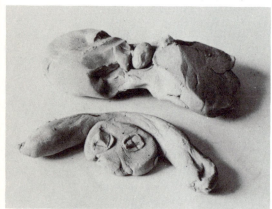

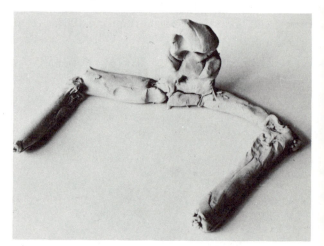

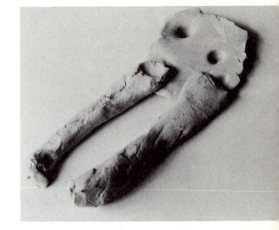

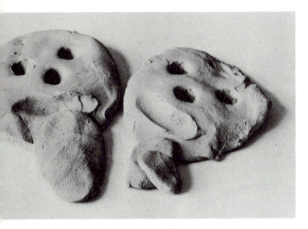

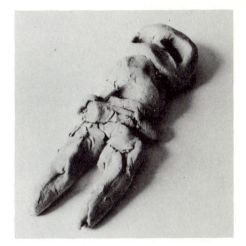

Below left and on this page: Humans in clay. Many lack arms, legs, or torso, but all have face marks (four years)

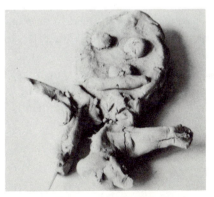

12. Early Pictorialism

Aside from the Humans, the early pictorialism of child art may be grouped under the following headings: Animals, Buildings, Vegetation, and Transportation. As before, I use capital letters to show that these words are being applied to the art of children.

The child's first efforts to draw Animals may produce Gestalts that are hard to distinguish from Humans. For example, a Human schema made with ears on the top of the head becomes a "rabbit" or a "bear." An Animal in this schema has a vertical torso and is drawn in a front view. An Animal that is given a horizontal torso is drawn from a side view. Such an Animal may or may not have ears. By changing the position of the face features in relation to the torso of a Human, the child suggests the image of a horizontal Animal. However, the arms and legs of this horizontal Gestalt need to be rearranged, as illustrated here, to become a true Animal, one that is clearly distinguishable from a Human Gestalt.

The transfiguration of the Human into the horizontal Animal is not too difficult for the child of age four or five. My observations indicate that the child of this age has the mental capacity to see readily what

Author's sketches

Humans or Animals? (four years)

Creature with a horizontal torso and ears on top of the head. Is it a Human or an Animal? (five years)

Humans or Animals? (five years)

simple changes are required to differentiate the Human from the Animal. He may be aided by the fact that adult schemas for animals, as seen in publications and in the sketches of parents, are similar to his own Animal schemas.

Few Animals are drawn by the child until about age five, when the kindergarten influences his work. Therefore, child art available for study of the Animals is not as "pure" as is the work of nursery school children who are allowed to scribble freely.

Creatures with top ears and vertical torsos (four and five years)

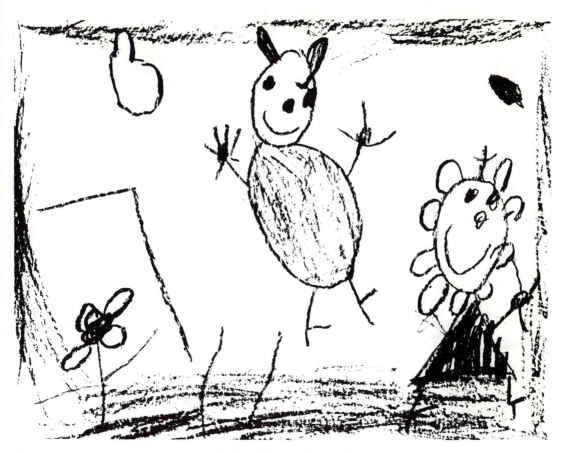

Two figures, one suggesting an Animal, the other a Human (five years)

Age five is often a time of crisis in child art. The child's spontaneous art is seldom appreciated by kindergarten teachers who are unfamiliar with preschool work. They give the child formulas to copy. Textbooks and flash cards for cognition of word Gestalts along with cultural art Gestalts may cause confusion and turmoil. The child's self-taught system differs too widely from that of adults. (Although child art and cultural

Two figures that could be termed either Humans or Animals (four years)

Gestalts are in conflict, one indicates capacity for the other, as I mentioned in Chapter 11. I believe that the child's art in kindergarten and first grade can be used as a guide for deciding whether or not the child has the mental development needed for learning to read.) Some children in the pictorial stage of art continue to thrive both in their drawing and in the Three R's, but many I have known abandoned art in the elementary school because lack of teacher approval for their natural child art was taken by them as a personal affront.

Animal in a finger painting. Note the placement of the torso and legs (four years)

Human and Animals in a finger painting. The head-top markings differ (four years)

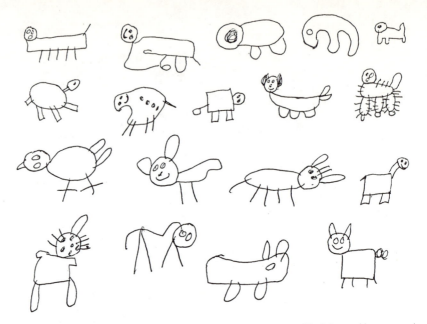

Animals with varied heads, legs, and tails, with few added lines (four years)

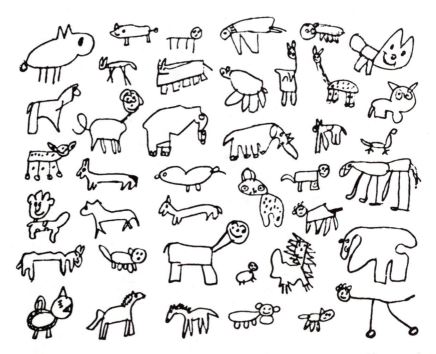

Animals, several with added dots or features, of uncertain species (five years)

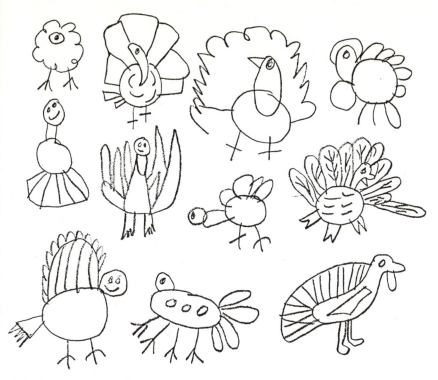

"Turkeys" that include designs learned from teachers (five to seven years)

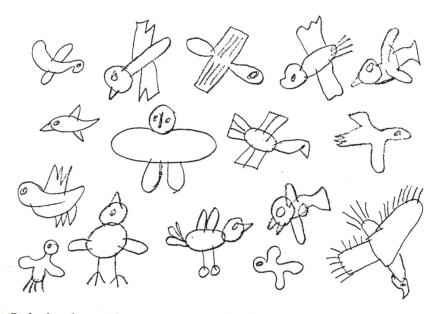

Birds that fit into the cross image of spontaneous art (five to seven years)

Delightful Animals
(five to seven years)

Animals made with a wide variety of
leg formations (five to seven years)

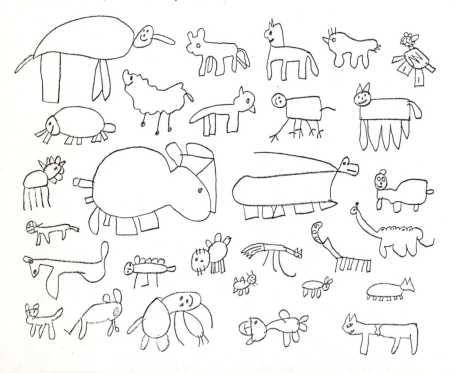

Buildings are drawn by combining Diagrams in various ways, not as a result of observing houses on the street. The child artist handles all subject matter by making units of the Diagrams, the archetypal or universal shapes indigenous to child art. Schools in every land make an effort to have the child copy the art that adults prefer as typical of the local culture. However, the Buildings or "houses" which children make are drawn alike all over the world (see Chapter 15). Those seen here are done by children living in California's Bay Area.

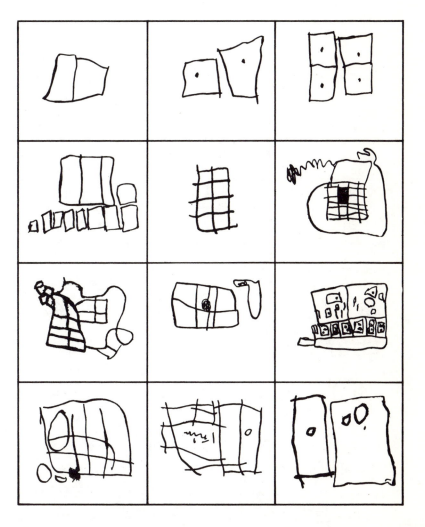

Combines and Aggregates that are forerunners of the buildings produced in child art (three and four years)

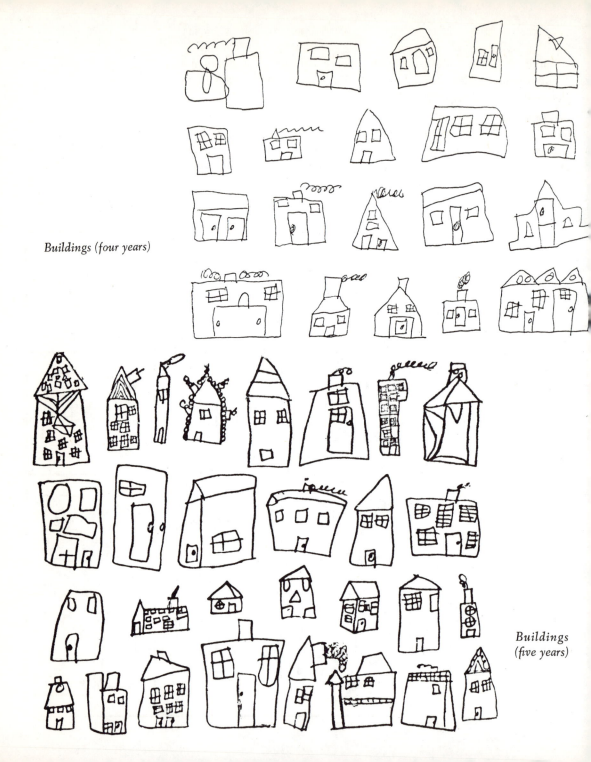

Buildings (four years)

Buildings (five years)

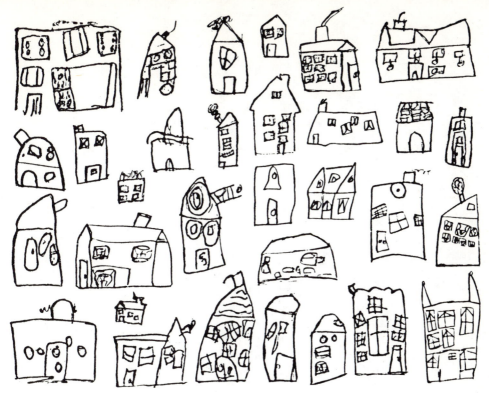

Windows of varied shapes on Houses that have equally varied outlines (five to seven years)

Houses with round roofs. The majority of the windows shown are square (five to seven years)

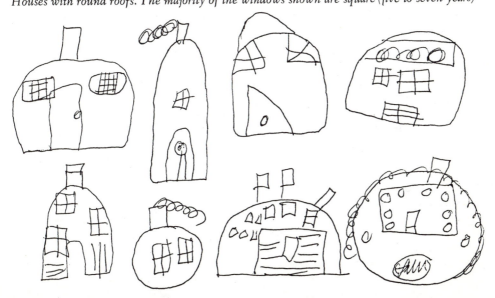

Frequency of Door and Window Designs (Five to Seven Years)

Doors as shown below	2,288	Windows as shown below	2,426
No door drawn	522	Other types, not shown	196
Total drawings	2,810	No window drawn	568
		Total drawings	3,190

Different sets of drawings of Houses were used in counting doors, windows, chimneys, and smoke. Repetitions in one drawing were not counted

Dominant door designs in 1,860 drawings

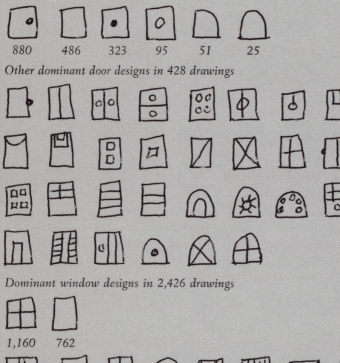

880	486	323	95	51	25

Other dominant door designs in 428 drawings

Houses constructed without any triangles (five years)

Dominant window designs in 2,426 drawings

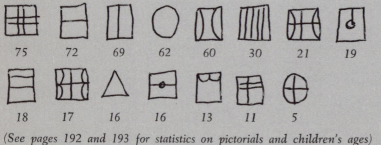

1,160	762

75	72	69	62	60	30	21	19

18	17	16	16	13	11	5

(See pages 192 and 193 for statistics on pictorials and children's ages)

Frequency of Roof, Smoke, and Chimney Designs (Five to Eight Years)

Roofs as shown below	1,745	Smoke as shown below	1,205	Chimneys as shown below	1,463
Other types, not shown	209	Other types, not shown	12	Other types, not shown	294
No roof drawn	997	No smoke drawn	1,553	No chimney drawn	1,520
Total drawings	2,951	Total drawings	2,770	Total drawings	3,277

Roof designs in 1,745 drawings

Smoke designs in 1,205 drawings

Chimney designs in 1,463 drawings

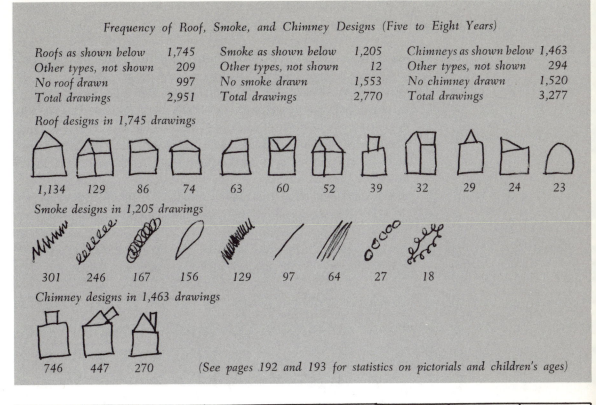

1,134 129 86 74 63 60 52 39 32 29 24 23

301 246 167 156 129 97 64 27 18

746 447 270

(See pages 192 and 193 for statistics on pictorials and children's ages)

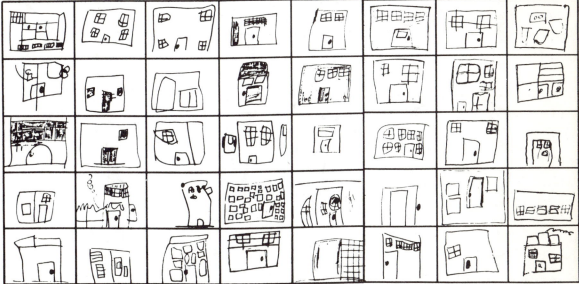

The customary Vegetation items drawn by young children are Trees and Flowers. Their prehistory is clearly visible in Scribbles, Diagrams, Combines, Aggregates, Suns, Radials, and Mandalas. The first Tree is very similar to the armless Human (H5), but with a head that contains extra markings not needed for a face. The markings make this Gestalt eligible for the label "fruit tree" or "tree with blossoms." Flowers and Trees are not drawn in sizes found in nature, but in sizes needed to complete Patterns or to achieve other esthetic goals. When children are told to imitate the relative sizes of objects in nature, such teaching destroys spontaneous child art and also insults intelligence, for every child knows the relative sizes of real trees, flowers, buildings, and human beings.

H5, armless Humans, made by children who had not yet done drawings of trees (four years)

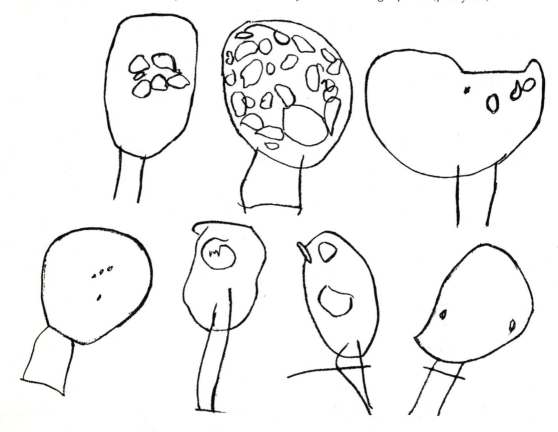

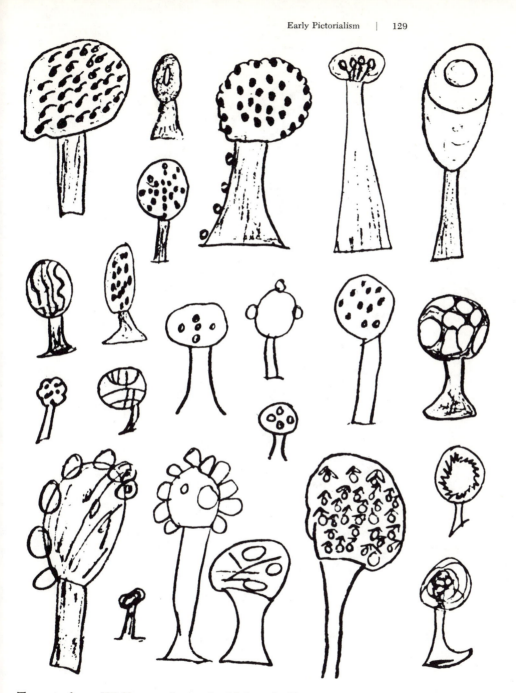

Trees similar to H5 Humans, but with added marks (five to seven years)

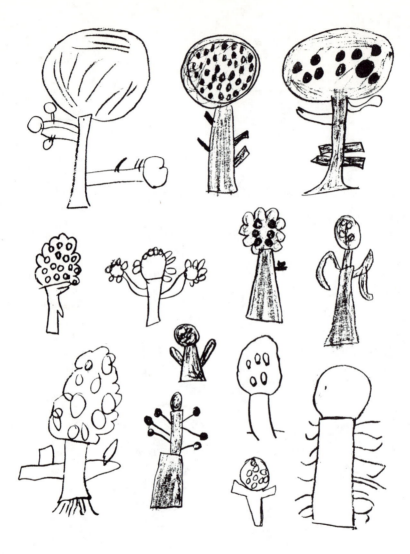

Trees similar to the Humans that are drawn with arms (five to seven years)

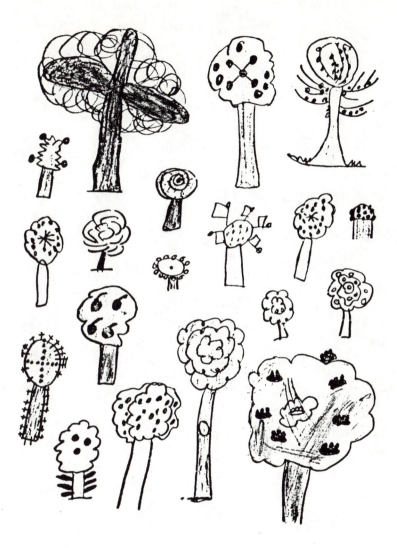

Trees that possess the balance of Mandala formations (five to seven years)

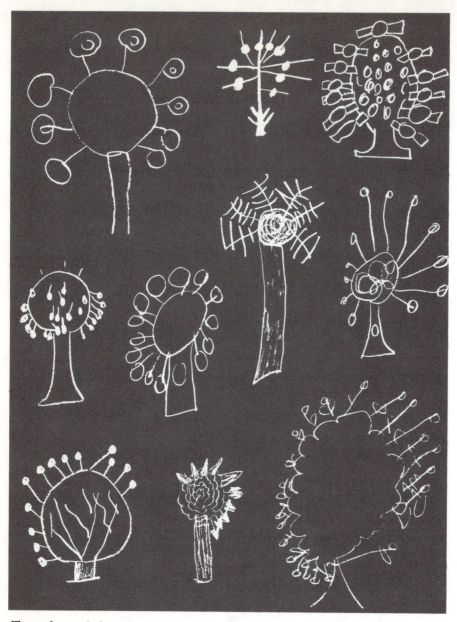

Trees that include forms related to the Sun image (five to seven years)

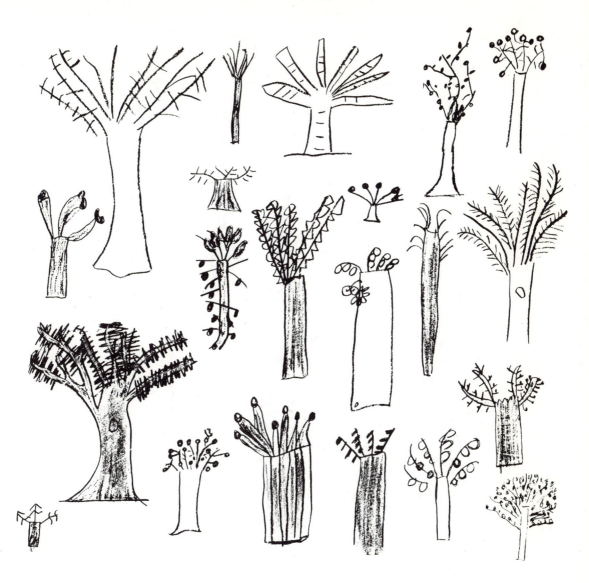

Trees that include forms similar to the Radial image (five to seven years)

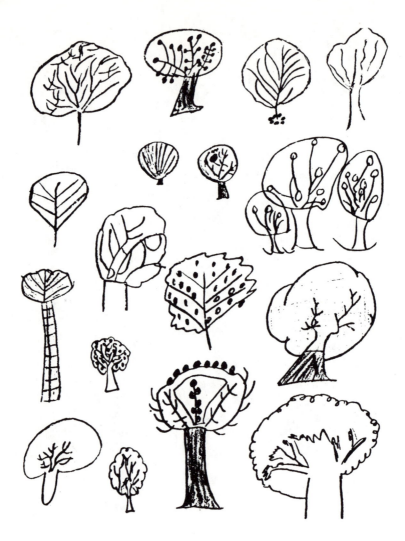

Trees that include a number of internal branches (five to seven years)

Trees with divided branches and no enclosing line (five to seven years)

Trees drawn as Christmas art. Ornaments are the single common feature (five to seven years)

Flowers. Many of them contain the images of Suns and Mandalas (five to seven years)

Transportation drawings include Boats, Automobiles, Airplanes, Rockets, and Trains, drawn singly or in combinations. Combines and Aggregates serve to represent these objects. The child, like the adult, has to rely on the basic shapes of art to pictorialize objects and scenes. It is the manner of putting the shapes together that distinguishes the spontaneous work of the child from the work of the adult, just as it is the way that basic lines are put together that distinguishes child-art Gestalts from alphabet symbols. Children draw the common formulas for boats and wheeled vehicles (the latter are listed as Automobiles in the classification of Chapter 18) whether or not they have seen boats or automobiles. The pictorial labels for these formulas may not be used by the child until an adult uses them. At this point, the child may first see some similarity between his own art, adult art, photography, and his visual experience with boats and vehicles.

Boats (four years

Cars (four years

At right and o
the following tw
pages are variou
subjects designe
for transportatio
(five to eight years

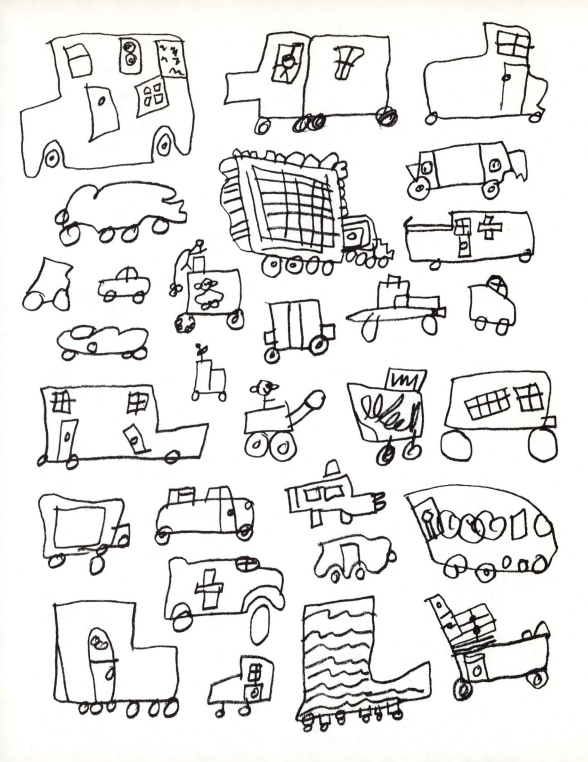

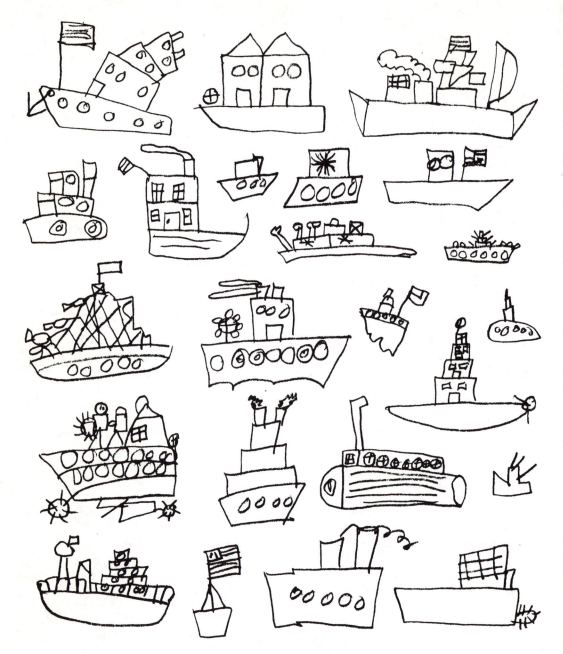

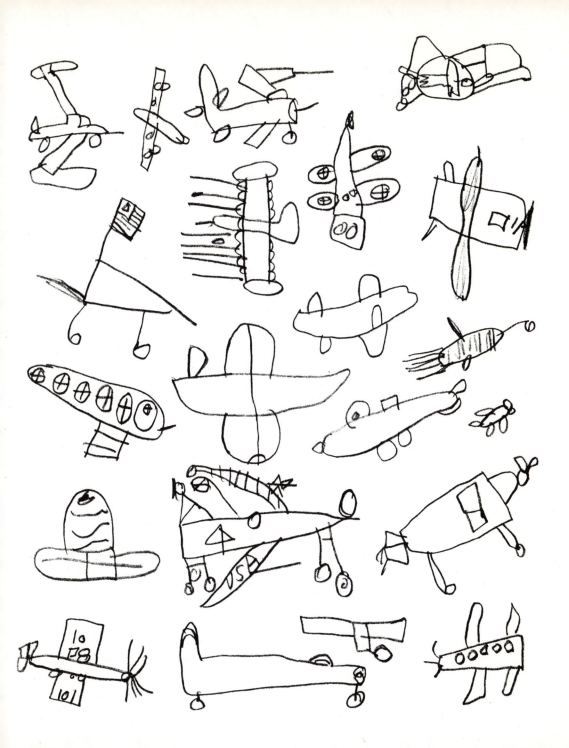

Once formulas for objects which are "acceptable" to adults are learned by the child, he will make combinations of them into scenes, and, unless his esthetic vision has been impaired by schooling, the results will have the esthetic qualities of earlier child art.

That the public school's problems with nonlearners could be greatly reduced through reforms in art education is discussed in later chapters. Here I would like to point out that assigning subject matter for art, especially subject matter associated with holidays, is not desirable, because children learn to have their work accepted by repeating some of their own immature formulas, and thus they remain arrested at a lower level of composition than they are capable of producing. A jack-o'-lantern is three-year-old art. Snowmen, Easter bunnies and valentines seldom have esthetic merit. Christmas trees are not so bad, but turkeys made by tracing around the hand are deadening. Adults do not teach the meaning or spirit of holidays through this kind of art, and it is destructive for beginners in art. The poorest art in my collection is holiday art.

Subject matter and art should not be combined except as they spontaneously arise in each individual's mind. Even then, the efforts are often a waste of time, so far as esthetic development is concerned. As for fact-learning, subject-matter art is disastrous. Neither teachers nor children are able to draw reliable portrayals of factual data in correct size relationships. Showing photographs to teach facts makes some sense, but asking the child to draw factually and then accepting his drawings out of sentimental approval for effort is destructive both to development in art and to fact-learning. The child is not fooled by teachers' responses, and he observes which drawings go into the school's or home's wastebaskets, and which are shown at public child art exhibits, where so-called factual work rates higher than esthetic composition.

A favorite subject matter for school drawing is Indians, because the child can put abstract designs on the tents and clothing of the Indians he draws. Therefore, these drawings are accepted as factual, though designs on square houses are not approved.

The percentage of children who are called "gifted" in art as a result of early self-development declines after they enter school. The percentage drops from a high in kindergarten to a low in third grade, as many par-

ents know. Allowing enough time for natural self-expression in art would not only preserve the children's abilities, but would make the children more willing to cooperate in tasks of formal learning. Art Gestalts should be visually separated from word and number Gestalts. Art is and should be the free use of lines for Gestalt-making. Combining lines for language or mathematics cannot be free, for symbols of language and mathematics are arbitrary and must be made according to whatever system the culture uses. When this distinction is pointed out to children, they are better able to see and accept the discipline of culturally determined symbols.

As the child learns to read, he is expected to comprehend various systems of Gestalt-making, each with its own order and rules: (1) the written language system of the culture, including both numbers and letters; (2) the simple art Gestalts that teachers and parents make and that the child is supposed to copy; (3) the adult art used as illustrations in books; (4) the Gestalts that appear in photographs, movies, and television; and (5) the Gestalts present in charts, graphs, diagrams, and maps.

Adults who are concerned about education must be wary of verbalizing to any child about art and, above all, must not try to coach him into the next stage toward which he is moving. The child's mind must develop through the impact of his own scribblings—not through the supervision of adults.

13. How Adults Influence Children's Art

Children feel the influence of adults in their art work first in the home and later in the school. For most children, school begins after age five, so they pass through the most important period of child art before receiving any guidance from teachers. Mothers, fathers, older children in the family, relatives, and friends are the persons whose attitudes toward scribbling can affect the child. Their attitudes are the result of their own experiences with art in early childhood both at home and in school. Thus the school's influence reaches down to the preschool child.

School and home long have been in agreement that scribblings are meaningless and that true art abilities are possessed by a few children who must study art if they are to learn to draw properly. Before the child goes to school, the influence of adults on his art work is largely indirect, though a few children are shown how to draw a "man" or a "house" by an adult. When home instruction is prematurely given at age three or four, one of two things will happen: the child makes the man or the house a few times, then forgets the learned one and goes back to his own natural system of structuring squares and circles into Humans and Houses; the other consequence of premature instruction is that the child becomes so concerned with the learned item that it dominates his

work. In every instance where I have come upon a prematurely drawn pictorial item in the work of nursery school child, I have learned that adults had coached the child. By premature I mean in terms of his particular development as seen in his previous drawings.

Parents also influence preschool children's art by providing children with good art materials, by neglecting to do so, or by prohibiting their use in the home. Few two-year-olds have access to crayons because busy mothers are not able to give the supervision needed to keep art play from being destructive to property. Coloring books, however, are popular in America and are given to young children at home. These books help to fix in the child's mind certain adult-devised formulas for representing objects. Picture books, magazine art, newspapers, comics, and television's animated creatures all have similar effect. Pictures on walls of the home, church, store, or museum, being repeatedly seen and explained to children, influence the child's visual and mental absorption of adult-made Gestalts to which special pictorial meanings are attached.

Adult response to preschool scribblings may encourage or discourage the child. The belief that scribblings have no meaning is not so destructive as might be thought. Adult ignorance may be protection for the child's going his own way and learning at his own natural rate of speed. If parents really understood scribblings, they probably would be inclined to interfere with the delicate process of self-teaching in art, even at age two or younger.

Few parents want their children to become artists, but all parents want them to succeed in school subjects, including art if the school expects success in art. Children also want to succeed in every school subject, though the desire may not always be evident. The normal child is very willing to learn the symbol systems of language and mathematics and art, if he thinks he can succeed. His difficulties in art are twofold: his mind is full of his own naturally made art symbols, which he wants to draw, but adults want him to learn new and different Gestalts. Both boys and girls are interested in "learning to draw" and are quite willing for a time to do copy work. Their difficulty is that there is no visually logical system to the copy work of adult art, and it lacks the dynamics of self-taught child art. Pupils who lose interest may abandon art since it is

A Recipe for Finger Paints

Finger paints take time to prepare and supervise, and the child's first efforts often turn bright colors into dull, brownish smears. Yet in time the child develops skill in using colors, and the following recipe helps to produce rich, glowing tones. (The recipe is much more costly than standard powdered mixes because of the dye; when possible, buy the dye at quantity rates from a bakery or a bakery supplier.)

> *2 cups flour*
>
> *2 tsps. salt*
>
> *3 cups cold water*
>
> *2 cups hot water*
>
> *1¼ cups liquid food dye*

Mix the salt and flour, pour in the cold water, and beat the mixture until it is smooth. Add the hot water and bring the mixture to a boil. Continue until it clears. Beat it again until smooth, let it cool, and then mix in the dye. For smaller amounts, be sure to use a full quarter cup of dye per cup of the basic mix to attain a rich color.

yellow

orange

blue

ed

black

A figure to fill in

This is the fireman's hat. See his hose,

"Realistic" art

not a compulsory subject. They lose interest because the methods of art instruction are frustrating to them. Some are able to use one system at home and another at school, but conflict between the two creates emotional problems.

To know how art is taught in the most up-to-date school systems, we need to know what methods are prescribed for teachers by influential art educators. How well teachers actually succeed in teaching art is a subject with too many ramifications to go into here, but we can consider the principles underlying their teaching methods.

The paramount aim of the primary school is the teaching of several symbol systems to young children. As mentioned in the previous chapter, the systems include language and mathematics as well as art. The letters of the language system have a printed form and a cursive form, and variations of upper and lower case. Only by learning these varied

sets of symbols can the individual become educated. The sets all can be learned, under suitable teaching methods, by children who are able to see the symbols and to retain them in mind in appropriate relations. Various methods of teaching the symbols of language and mathematics are successful, but those for teaching art are much less so. One reason for the lack of success of schooling in art is that the child is not required to learn art Gestalts, but he must learn those of language and mathematics. Indeed, enlightened art educators do not want children to be compelled to work in art. They want art to be the voluntary self-expression of natural creative abilities.

Five art educators who have had influence on the elementary schools in America and elsewhere deserve brief mention. One is the Austrian teacher, Franz Cizek, whose art classes for children were world famous in the early part of this century. He could be called the "discoverer" of child art because he was the first to demonstrate that basic art abilities are inherent and develop naturally in childhood. His ideas were taken up in England and America by a few pioneers, and have been recorded by Wilhelm Viola (1936). Though little is said about Cizek today, his influence has been tremendous because he so successfully demonstrated his theory. Prints of work done by his pupils were sold widely in Europe and in this country around 1930.

Herbert Read, a prolific writer on art, has greatly furthered the idea that art expression is natural and essential to all children. Read urged schools to integrate the Three R's curriculum into a broad program for schools based on art. No school, to my knowledge, has ever established such a curriculum, because it is viewed as one which would put the cart before the horse. Instead, art is largely used as a tool for promoting the learning of the Three R's in the relatively few schools in America which actually have an extensive art program for young children. However little Read's theories have been put into practice, his influence has been and is still great. My reading of his *Education Through Art* (Read, 1945) encouraged me to embark on my study of child art.

Three other art educators whose influence has been more specific in the public schools are Viktor Lowenfeld, Charles Gaitskell, and June McFee, whose books have been adopted as texts by various institutions

that give teacher training for elementary school art. It is notable that art education at the university level in America is often divided into two departments, each with a separate faculty. One enrolls students who are learning to produce and to appreciate adult art. The other prepares teachers to teach art to young children. The two art departments have little in common. The gulf between them is caused by the assumption that child art and adult art themselves have little, if anything, in common; only adult work is recognized as fine art, child art being seen as play or as promise of future art ability. In the better progressive schools of today, this gulf between child art and adult art is bridged somewhat by a more appreciative attitude toward the artistic achievements of some children. However, these achievements must be pictorial to be recognized; preschool work is not yet recognized as part of the mainstream of all art.

Among those art educators concerned with elementary school programs, the importance of pictorialism is stressed to a degree that amounts almost to a repudiation of possible esthetic values in child art. The writings of Lowenfeld, Gaitskell, and McFee can be cited to support this statement. The esthetic merit of child work is recognized by these educators only as expressed in children's designs in the crafts program. They do not consider child work to be fine art, but merely the promise of it. The child's early pictorialism is meaningful to them primarily for its "story" element or for its social or psychological significance rather than for its esthetic composition. Most educators seem to think that the child's pictorialism is an effort to draw personal experiences. Thus the child's symbol for the Human is viewed as an attempted self-portrait or as a portrait of another person. Humans are not seen as esthetic units usable as parts of drawings containing other esthetic units which tell no story whatsoever.

Lowenfeld (1954) views children's art not as lines and forms per se, but as documents that reveal child personality. He claims that child work tends to fall into one of two categories, one of which he labels "haptic," the other "visual." Haptic work is that which reflects the child's sense of touch and his muscular and kinesthetic awareness. Lowenfeld does not imply that scribblings are haptic and that structures

are visual. He uses the terms to cover characteristics that have to do more with matters of style. He admits that it is difficult, with many drawings, to place them into one or the other category. Scribblings are meaningless to Lowenfeld except as evidence of a "first stage" of art which he schedules as ending at age four. Other stages he schedules as follows: ages four to seven for preschematic work, seven to nine for schematic work, nine to eleven for realism, and eleven to thirteen for pseudorealism (Lowenfeld, 1954, p. 157). Interpretations of a psychological nature largely characterize Lowenfeld's appreciation of individual works. His popularity with college teachers may be due in part to the fact that they are generally more interested in children and in psychology than they are in art, especially child art. Lowenfeld encourages teachers to empathize with the child's effort to express personal problems through art and to search for content having personal significance.

My primary objection to Lowenfeld's categories is that I do not think the haptic and visual aspects of art can be separated meaningfully. All art is based in physical movement and visual awareness together. The haptic aspects, which Lowenfeld calls subjective, may be found universally in child art, as may the visual aspects.

Emotional aspects of art expression surely exist, but it mystifies me why adults insist that a child's work is a report on his life experiences, when even the most talented adult artists find difficulty in portraying emotional experience in art. The most extreme example of adults' projecting their own emotions and ideas on art is found in the work of Alschuler and Hattwick (1947). These authors make child art fit into Freudian theory with its oral, anal, and genital stages. It seems to me that Freud's oral, anal, and genital categories and Lowenfeld's motor and visual categories are all inseparable aspects of life, from prenatal days to death. Whatever developmental distinctions are made concerning these aspects have no bearing on the child art that I have seen.

Gaitskell's approach to teacher training in art is academic. He assumes that improving the child's capacity for pictorialism is the main goal of art education. He is more aware than are most other writers of the structural content of five-year-old work, and he does know that

schemas are self-taught, but he does not see that these self-taught Gestalts are outgrowths of earlier scribbling. Gaitskell shows too little interest in the esthetic reactions of the young child to his work. "Art appreciation, in fact, appears to be the result of prolonged education" (Gaitskell, 1958, p. 303). He thinks children should be systematically exposed to works of art done by adults in order to develop art appreciation and good taste (p. 386).

McFee's approach to art education for children stresses the sociological aspects of the subject. She thinks that teachers should "expand children's understanding of the art symbols of Western culture" (McFee, 1961, p. 89). The teacher's role is to help children "look outside themselves, as well as inside, for ideas" (p. 203). "Compare, relate, organize—in this way you can teach children to see richly and esthetically," she advises teachers. "Help them see how lines, forms and colors make objects as well as paintings beautiful" (p. 215). McFee says that many children "use shallow, sentimental symbols" (p. 198) and that the ones they know come from the popular press and are not to be found in fine art (p. 89). She encourages teachers to have children compare their own work with that of famous painters (p. 230) as seen in print reproductions brought into the classroom.

Lowenfeld, Gaitskell, McFee, and other art educators agree that children should be stimulated to pictorialize subjects suggested by the teacher. Examples of suggestions from McFee are: how one feels during a storm; how a fence looks; how light falls on a box. Help children to recall facts and features of objects, says Gaitskell. The stress which art educators place on pictorialism is evidence that they think of children's art as being most successful when the child's observations of environment are "recorded" in more or less pleasing form that adults can enjoy.

The aims of school art are presumably somewhat related to those of all art. McFee lists the "aims of art in culture" as follows: "1) to maintain the concepts of reality, 2) to maintain the culture, its organization and roles, and 3) to enhance the appearance of objects" (McFee, 1961, p. 20). This statement very well describes the aims of public school art as I have observed schools in action in various parts of the world. However, these aims are far removed from those of Herbert Read and other

art theorists discussed in Chapter 16. Public school art educators certainly do not agree with Clive Bell's statement that "the representative element in a work of art may or may not be harmful; always it is irrelevant" (Bell, 1958, p. 27). Nor do many public school art educators give thought to the fact that cultural tastes in art may be manipulated, as Robert Wraight notes (Wraight, 1966).

Most art educators believe that art is valuable primarily as a means of communicating facts or emotions, and therefore it must be pictorial. Most adults think likewise. The following item from a newspaper shows how adults stimulate children to make associations between art and facts, in this case, facts about epidemiology:

> More than 100 "germ monsters," drawn by Bay Area school children, will be on display in the Market Street [store] windows. . . . The "monsters," which are the children's impressions of germs which cause measles, smallpox, diphtheria, tetanus, whooping cough or polio, were entries in the recent drawing contest sponsored by the Stamp Out Sickness program. The purpose of the contest was to make the children and their parents more aware of the need for immunization against the six communicable diseases. [*San Francisco Progress*, February 1, 1967, p. 2.]

The methods and aims of educators have quite specific results in the classroom. After entering school, children are influenced to imitate each other in art as a result of teachers' evaluations of the work done by different students. Positive and negative remarks made by teachers about particular items in drawings also give children ideas for changing or augmenting the basic art schemas they already know. The teachers' influence need not be blatant to be effective.

Children soon learn to please teachers by using certain symbol combinations in art which promote adult concepts of realistic pictorialism. For example, a scene may show only one sun above a house. More suns might be esthetically pleasing, but would be a factual distortion. (If a drawing is not clearly pictorial, teachers prefer it to be a pure design. A mixture of the two kinds of work is confusing to adults.)· Teachers occasionally do accept the child's unrealistic schemas for objects, and even enjoy them, provided they look clean-cut. However, teachers and other

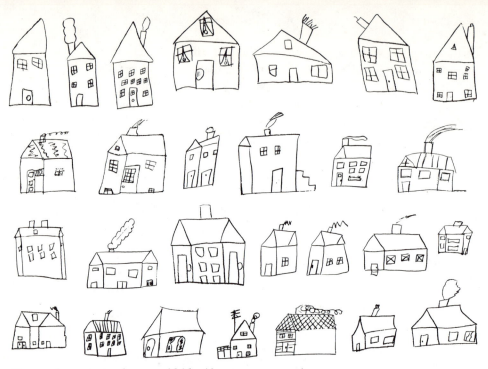

Houses that most teachers would like (five to seven years)

adults usually view these schemas as cute, childish, and something to be outgrown. Adults also can see and enjoy a kind of humor in the drawings which the child does not intend. The esthetic elements of children's schemas are largely lost on most adults, who have been processed through school art education or none. The illustrations here and following show Houses, Animals, and Humans that most teachers would like. Other illustrations show formulas that few teachers would enjoy because the formulas are drawn with too much esthetic license.

Teachers are confused by art educators who advise them to approve all child work in order to avoid discouraging further effort, but not to praise work unless it is up to the standard for the age level. Yet nowhere are age level standards defined in a way that is both objective and usable in an ordinary classroom. Thus each teacher's personal taste actually becomes the final measure of age-level achievement. The quality of art

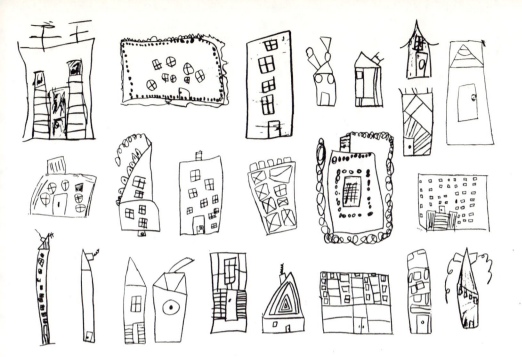

Houses that few teachers would like (five to seven years)

produced by any five different classes of first-graders can be definitely traced to the influences of their five teachers. Whatever art the teacher likes, the children somehow manage to produce, or they give up trying. It seems to me that teachers who enjoy the company of children allow considerable esthetic license, and that teachers who are especially interested in art or who themselves are expressive in art influence children more toward imitation of adult work than toward self-expression in child art. This statement at least holds true of the teachers who studied child art in classes I conducted for the University of California Extension Division.

Art supervisors often claim that complete freedom in art is the school's goal, yet the art guides which are printed for a teacher's use may state: "Do not tell the child what kind of house to draw. Tell him to draw any kind of houses he likes. Do not ask the child, 'What-is-it?'

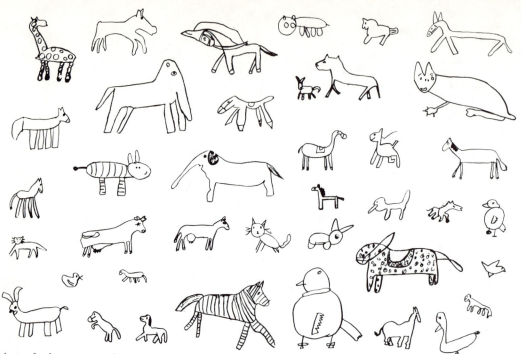

Animals that most teachers would like (five to seven years)

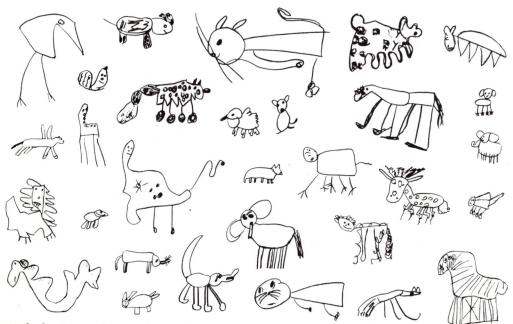

Animals that few teachers would like (five to seven years)

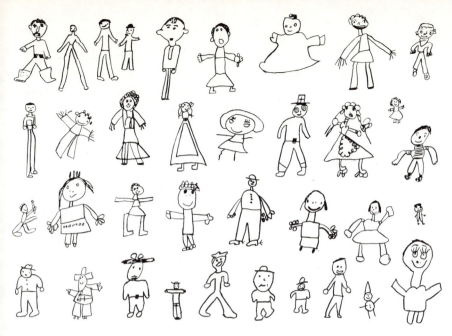

Humans that most teachers would like (five to seven years)

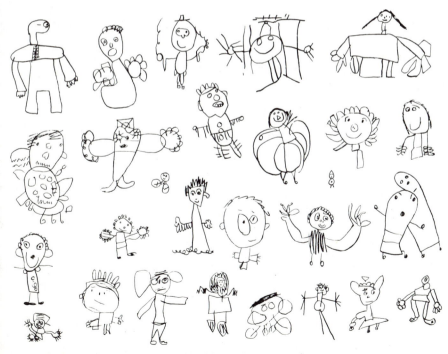

Humans that few teachers would like (five to seven years)

Instead ask, 'Would you tell me about your picture?'" Both questions, as I understand them, call for the same answer. The second question, though, does save the teacher some embarrassment when confronted with some drawings. A reply from the child to the what-is-it question forces the teacher to confirm or to doubt the child's label, and to do either can be embarrassing. She can be put into what psychologists have called a "double-bind," which means simply: wrong if you do, wrong if you don't. Teachers believe that they must not be too critical and thus destroy child spontaneity, yet they must not accept a pictorial which is absurd or below some assumed grade level. The would-you-like-to-tell approach to a drawing saves face for both the child and the adult, for the answer can be silence. One child's reply to this question seems to me the truest response: "This is not a story, it is a picture to look at."

I believe that teachers should accept everything made with good grace and should not try to evaluate its worth. No questions need ever be asked, and comments that teachers make can be restricted to such constructive ones as "very interesting," "nice colors," "I like that," "good work," "a nice scribble," "pretty," etc. (see Kellogg, 1949, p. 132). Such remarks can be made quietly and sincerely. No extended comment is usually required. A pleasant smile from the teacher is best for preventing the child from trying to draw to please the teacher rather than to continue educating himself in art.

Science drawing (seven years) *Science drawing (eight years)* *Traffic light (seven years)*

Similar constructive responses are made by primary school teachers who do not feel guilty for accepting poor pictorialism such as that seen in the illustrations below. These drawings are neither good art nor good examples of informational detail, but they may be the best the child can do under adult pressure to try to draw factually. It is unfortunate when teachers give approval to content and ignore composition entirely, because such reaction discourages development of the esthetic aspects of art, and when these are not given a place, the child is likely to quit spontaneous art entirely.

The demand for a restricted kind of pictorialism in school art is one important influence that causes children to give up art or to do poorly in art or to succeed by restricting their art formulas to those which adults appreciate. Examples of learned formulas are those for elephants, lions, and dinosaurs, all being animals which most children copy directly from adult work. Art educators have no idea how deeply embedded are the child's esthetic preferences, and how hard it is for him to change them until he literally "sees the point(s)" of the line connections that adults favor. McFee (1961, p. 38) says that the child "creates or borrows symbols" to use for representation of objects he observes, and that how he sees the objects and how he feels about them will determine the symbols he uses. Mendelowitz (1953, p. 25) writes of the "unsettled and unsystematized nature of the child's artistic expression" before age six. The

Ball park (eight years) *Post office (seven years)* *Hospital (eight years)*

true nature of the origins of child art is too little understood by authors of textbooks on art education.

It is generally assumed by educators and other adults that detail in drawing reflects increased child intelligence and ability to communicate through art. The facts about how children add details to their Human schemas are only vaguely known, however. By taking one part of a Human at a time, we can consider its development and evaluate some of the influences that affect the drawing of details. The remaining part of the chapter will perhaps convince adults that they should not judge child work except as art, free of pictorial obligations. (Unless otherwise identified, the drawings that follow are author's sketches.)

Eyebrows, eye-pupils, and eyelashes are viewed by adults as desirable added details in child art. Actually, the origin of these eye features goes back to age three or four, when the child uses the Sun image to represent eyes. As the child matures, he favors a simple circle for the eye and may draw it more carefully than the younger child. When the child is about eight years old, he again draws eye detail (along with cupid lips, breasts seen in profile, and other details copied from adults' work). In other words, the child of five or six progresses in art by using less detail for eye features than before.

The nose may be represented by a circle, a vertical line, or a mere dot. In fact, almost any marking seems to serve for a nose, and it can be reliably identified only by its placement in the face. A variety of Scribbles, Diagrams, and Combines are convincingly used for noses. A great many Humans lack noses. I have observed no change between ages five and seven in nose construction.

The mouth may be drawn in the form of any Scribble, any Diagram, or both in special combinations. An up-curving line makes a "smile," a down-curving one gives a "frown," and a straight line gives a "serious" look. Cupid lips, drawn later, are not favorites. Varieties of schemas used for eyes, nose, and mouth are shown on the opposite page.

Face markings other than ones needed for eyes, nose, and mouth are commonplace. Infrequently, face features are drawn upside down. So-called teeth are achieved even by preschool children, who use the crossed oval Diagram for this purpose. Adults may view this kind of

These and all other drawings that do not have ages designated are author's sketches

Gestalts commonly used for eyes (top), noses (middle), and mouths in spontaneous art (four to seven years)

mouth as added detail, but it occurs often on early Humans. The mouth made of the Diagram and Scribble which adults warmly endorse as a good jack-o'-lantern mouth also occurs often in the spontaneous art of preschool children.

What may be called "cheeks" are extra circles drawn in the face near the arm sites on the first Human. Careful placement determines whether these circles are arms, ears, cheeks, or mere decoration. When the cheeks are made with red color, adults sometimes call them "rouge

Arms *Ears* *Cheeks* *Decoration*

marks." Extra circles in the face are made in various colors as pure decoration. They are to be seen in the illustration of the Human who wears an unrealistic but very charming ornamental headdress.

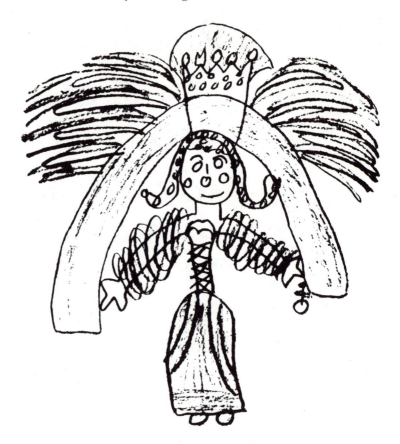

Human with cheek marks and headdress (five years)

The ears are an important bit of human head detail, but the drawing of ears presents esthetic problems. Ears can widen the figure, but not heighten it. Ears occur most often on early Humans that also have head-top markings and short legs. Having drawn ears, children often get the idea of completing the Human in the form shown here. Children seldom draw both arms and ears on a head, as illustrated. In early

Humans it is hard to determine what is an arm and what an ear. Who cares? Adults. If markings are viewed as big ears, the Humans become caricatures for adults to laugh at.

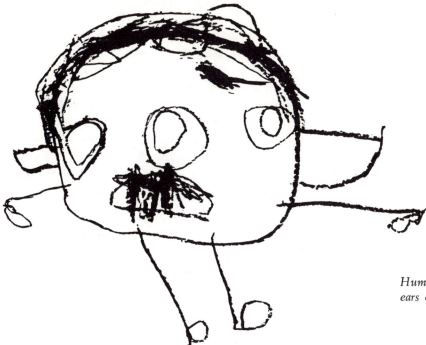

Human with both arms and ears on the head (four years)

There are problems of identification connected with drawing hats and hair so that they seem realistic. Note in the sketches here what happens when changes are made at the site where hats or hair is drawn.

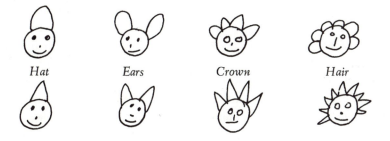

Hat *Ears* *Crown* *Hair*

Hair is discussed further at the end of this chapter. It is clear that the mere number of loops drawn upward on the head determines pictorial content. Yet there is no hard and fast rule that certain numbers of loops make a crown or hair or any pictorial object. A valid interpretation of the realism of each of the items above will depend upon other aspects of the Humans on which they appear. There is no one infallible way of showing body detail for artists of any age. There are many ways, and it is remarkable that the child is able to use a number of them.

The torso may be defined simply as the area or areas between the head and the legs. Torsos may be drawn in any shape, but the triangle, the rectangle, the circle, and the oval loop are the main ones used. Three early forms of torso are shown. All three of these torsos are found in older children's work, but would be considered regressive after age five. The ladder-cross could be interpreted as a skirt with horizontal stripes, but ladder-cross torsos are made long before the child gives other evidence of ability to draw clothing.

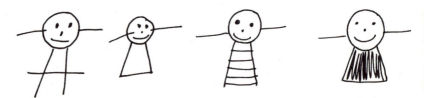

Single-line torso Ladder-cross torso Filled-in torso

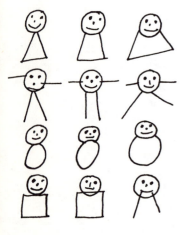

Ways in which the torso and the head are joined have pictorial implications. The triangle torso may be attached at a point, along a short arc of the head's circle, or along a wide arc. The differing head-torso attachments give different effects to an implied neck. These three kinds of attachment date back to the placement of legs on the first Humans, as shown.

With the circle (or oval) torso, contact with the head may be at a point, in an overlap, or at a wide arc. The square (or rectangular) torso may touch the head or overlap it. In early Humans the legs may touch

the mouth. Lack of muscle control may account for this effect, or perhaps a deliberate visual purpose is served. The arrangement is not a frequent one.

When the torso is made as a loop added to the head, contact will be wide or narrow. A point contact would mean, of course, that the torso was a circle, not a loop.

In my observation, torsos are usually added to the head. When the head is added to the torso, the effect is often that of an Animal rather than a Human.

A double-line Greek cross is often used for a torso, as seen in the illustrations. Note that arms and legs can be attached to this cross though they cannot be attached to a single-line cross. The Greek cross torso is impressive evidence that esthetics outweighs realism in the work of children under age seven.

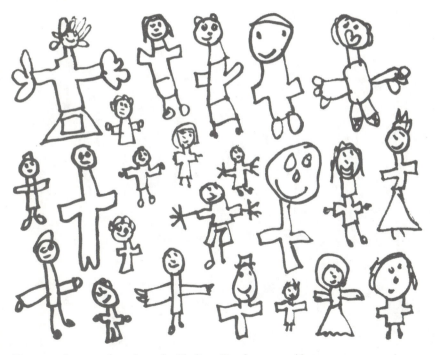

Humans that are shaped as double-line Greek crosses (five to seven years)

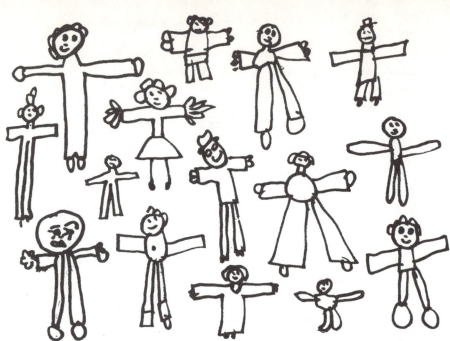

Humans made as double-line Latin crosses (five to seven years)

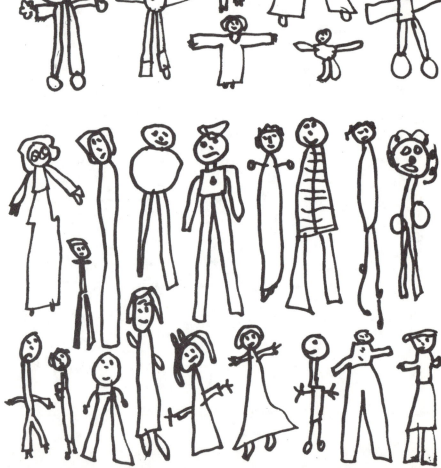

Humans elongated by narrow legs or torsos (five to eight years)

What I call the Latin cross Human is one that has the arms realistically placed high on the torso. This placement does not give an impression of height unless the arms are made short, but it does prevent the over-all balance of the Mandala.

Height for Humans is best achieved by lengthening the legs or by making an excessively long torso, whether it be an oval, rectangular, or triangular one. Tall Humans rarely look realistic because their proportions are seldom lifelike.

Torsos of unusual construction that do not at all resemble the familiar types are also made, but not so frequently as one might expect. Very unusual torso Aggregate construction may represent experimentation that leads nowhere, or it may show a deliberate refusal to draw "properly" in terms of adult expectations.

The absence of a well-defined neck is common in child art. The first Humans lack a neck, having the legs or torso attached directly to the head. (Neckless Humans are still made at age eight.) A Human with a single-section torso also has no neck. When the torso has more than one section, the upper section may be viewed as the neck. The confusion between neck and torso is one that must plague attempts to find pictorial reality in child art.

A common formula for the Human is one with a double torso, that is, with both lower and upper sections. The realism of this division results from the implied waistline. The two sections may have the same shape or different shapes. (The same waistline effect may be achieved by a straight line drawn across a single-section torso. When the line is drawn

Humans with torsos constructed of unusual Aggregates (five years)

high, however, the effect is that of a single torso and a neck.) A torso may also have triple sections. Torsos may even have more than triple sections, but these are exceptional ones and have no bearing on the problem of how to identify a neck.

Confusion concerning the neck and the torso can arise when the "neck" is made large enough to be the upper half of a double torso or the upper third of a triple torso. When the upper half or third is made small, in realistic proportion, it may be considered as the neck. Arm placement may or may not corroborate this judgment.

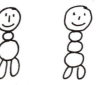

The placement of arms is *not* a sure sign of which section is the neck and which is the torso. Arms attached to the section just below the head may be considered as coming from the upper half of a double torso, when the size of this first section is torso-like. Arms from a small first section may be viewed as coming from a neck above a single torso.

Arms from the neck on a Human with a double torso would be placed as shown. Where the neck is small and the arms stem from the area below the neck, both a neck and a torso are indicated. However, the size of the neck and not the position of the arms is the clearest indication.

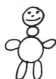

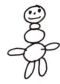

Human with a small "neck" and with arms from a single torso

Human with a "neck" and with arms at the top of a double torso

Human with a "neck" and with arms on the bottom torso section

Only when the neck is implied by having the arms placed between the head and torso is arm position definitive.

In brief, it is the relative proportions of the areas used for neck and torso, as they relate to the total image, that best indicate what is what.

Nevertheless, these proportions are often so distorted for esthetic effect that the adult becomes dismayed when he sees the relative sizes of body parts that are drawn by intelligent children. The relative sizes may be so distorted that the head will be bigger than the combined torso and legs. Component parts of Humans are often drawn in sizes needed to complete some pattern of total balance or to create some over-all esthetic effect. For example, Humans with big heads and Humans with "pinheads" are commonplace.

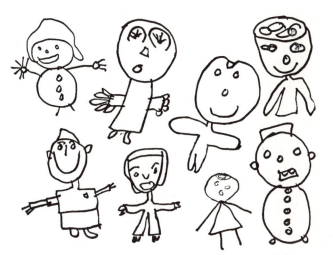

Drawings of Humans constructed with big heads (four to seven years)

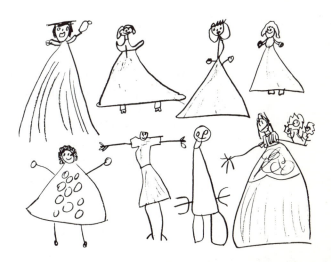

Drawings of Humans constructed with "pinheads" (five to seven years)

Sometimes the neck is so elongated that it appears to be a kind of torso, and arms are attached to it. Whether it is more properly the neck or the torso depends upon how one looks at the drawing as a whole, and even the total drawing may not yield a reliable clue as to what is what. Adults can easily disagree on the labeling of body parts.

What the child usually is trying to do is to draw a heightened Human which also has Mandaloid balance. Omission of the arms may solve the esthetic problem, but not the problem, imposed by adults, of pictorial realism. Unless the arms are drawn to hang down alongside the torso, they inevitably suggest a round instead of a vertical Human. Arms that slope down look "droopy" and unesthetic, unless they are placed so low as to result in the rounded Radial Humans shown on page 106, and such Humans are not realistic. An elongated neck or torso is a solution to the esthetic problem that is not too far from adult wishes for realism.

Arm and leg placement that produces a Mandala effect persists at least through age eight. The effect is variously achieved. Humans may be drawn in proportions that fit nicely into an implied Diagram, one that would go around the figure. To look at these drawings realistically is to miss their point. They are Humans, drawn under the esthetic wish to make them look Mandaloid.

Realistic placement of arms and legs is not a simple matter to define. When the torso is first made by a line crossing the legs, as illustrated, the legs are not eliminated. If the crossing line is neatly made at the ends of the legs, however, they are destroyed and new ones must be added.

Arms on early Humans are attached to the head or to the legs. Later they are positioned on the torso.

Arms which come from the legs often fit an implied circle. Arms which come from the torso are commonly placed so that they give the figure the over-all balance of the Mandala.

Arms may be drawn high on the torso at a shoulder point. (Such placement on a Human having a neck probably constitutes as much pic-

torial accuracy regarding the arms as can be expected of the young child, though adults often expect far more.)

Human with arms that are placed high on a torso of one section

Human with arms that are high on a torso made of two sections

Human with arms that are positioned high on a three-section torso

Legless Humans with arms are rarely made. Such drawings may be uncompleted ones. Humans that are both armless and legless also are uncommon. When they are made with head-top markings, it is difficult to discern which area is the torso and which is the head. Face features are perhaps the best indications, for the torsos and the head-top markings are interchangeable. There are, of course, no rules for the size of either.

Armless and legless Humans are like the three-year-old's abstractions illustrated here, which are derived from the sequence of Mandala formations shown.

An arm may be defined as a line or an elongated area that is attached more or less horizontally to a head or torso. Certain "arms" are more wing-like than arm-like, and they are commonplace. I think that they are a variation of the persisting Mandala theme, but they also may be an experimental effort to make the figure fit an implied oval that is wider than high. Vertically oval Humans, in contrast, are made by leaving off

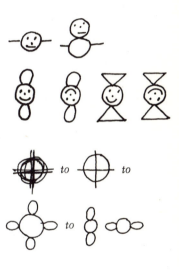

Humans made with wing-like arms (four years)

the arms or by making the arms very short or by using a hat or hair to extend the height of the Human. Wing-like appendages also may be used to make the figure fit an implied rectangle rather than an implied oval shape.

As the images of shapes clarify themselves in child art, children sometimes draw outlines of them, as illustrated. The outlined Human is uncommon in child art, however. The Human customarily drawn is built up by adding area to area, and the process provides esthetic flexibility, for as each part is added its size and shape can be accommodated to those already made in proportions that will achieve esthetic effect.

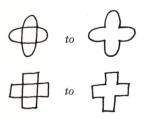

Humans with bodies drawn as clearly outlined units (five to seven years)

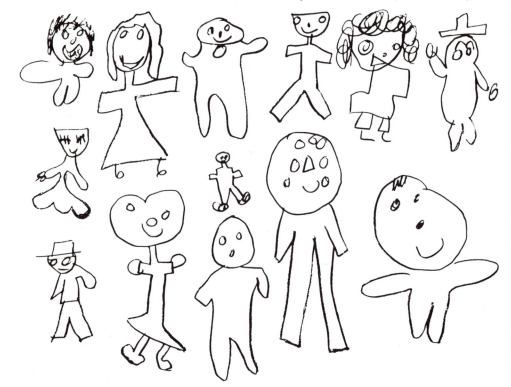

Showing sex differentiations in Humans is neither easy for children to do nor for adults to evaluate. Sex can be shown either by anatomy or by clothing. Anatomy, so far as it appears in children's work, involves the drawing of breasts, phallus, hair, and pregnancy. Though children may see and know about male and female anatomy, they are certainly not encouraged, if permitted, to portray the bodily signs of sex, except for hair length. Drawing of a phallus is rare, partly because of adult taboo, no doubt, but primarily, in my opinion, because it is not needed for balance in the child's esthetic schemas. A loop on the torso placed between the legs could be called a phallus. Such an isolated loop is rare, but the same loop with others so that it does not suggest a pictorial phallus is common. Children do not often draw breasts until about age eight, and then they learn the schema from others.

Because women in many parts of the world wear trousers and men wear skirts, the clothing on Humans made by some of the world's children can confuse adults as to which Humans are males and which are female. In general, a triangular torso is labeled a female's skirt and a double rectangle torso is viewed as the trousers worn by a male. When loops, single rectangles, and circles are used for the torso, the Human may be considered sexless.

A female Human may be identified by the amount of hair shown. Hair is usually made by Basic Scribbles, either loops or multiple line Scribbles. The Sun's rays make hair and so do lines outlining most of the head. The following sketches show lines used for hair.

Three-year-olds draw loops for hair, and for many years loops remain a favorite way of showing hair. The hair is often drawn so that it sets the line for an implied circle that would enclose the whole figure. The complete loop often circles the head, showing that the artist is at work, not the accurate pictorialist. Until the hippy movement, only females could be represented with esthetically flowing hair, which has various

basic styles. Hair to the shoulders, to the hands, to the ground, or in an enclosing circle are favorites.

The hair often hugs the top of the head's curve, or it may form a triangular peak above the head or a three-quarter square around it. Head-hugging hair drawn only on the top of the head is usually interpreted by adults as male hair, but when such hair comes far down on the head it is considered to be female hair.

Peaked hair

Squared hair

Head-hugging male hair

Head-hugging female hair

A formula for hair, one which may be copied from adults, is to form four areas inside the head's circle, as shown. This image is, however, reminiscent of the design beside it. The formula eliminates a round face, but it leaves a round head.

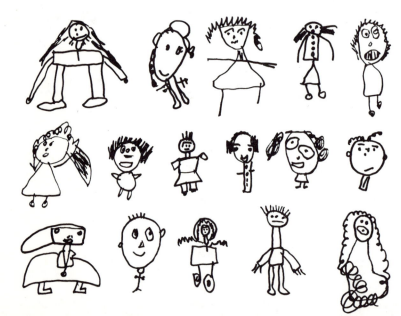

Various uses of lines for hair (five to seven years)

It is particularly hard to differentiate between male and female when hair suggests one sex and clothing suggests the other. Trousers are basic to the male's costume in Europe and America, but they indicate a male Human only if reinforced by male hair, no hair, or a masculine hat. If feminine hair is used with trousers, the result can be a sexless figure. Note in the following sketches that the hair and hat are the significant sex determinants.

 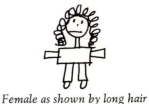

Male with no hair *Male with short hair* *Male with man's hat* *Female as shown by long hair*

It may be difficult to tell whether a Human has the thick legs of a sexless figure or the trousered legs of a male figure. A slightly flaring line on the legs suggests trousers, but this flare easily can be more accidental than purposeful. To increase the problem of pictorial identification, one leg may flare and not the other.

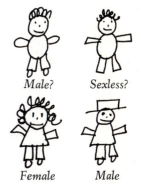

Male? *Sexless?*

Female *Male*

Since the female is often identified by a triangular skirt, two rectangles below a triangular torso can be interpreted as female legs in pants. However, a male Human—"male" as shown by the hair or hat—can have a triangular torso, for then the "man" has on a "long coat." The width of the triangles may be helpful in making a decision.

Humans made with triangles (five to seven years)

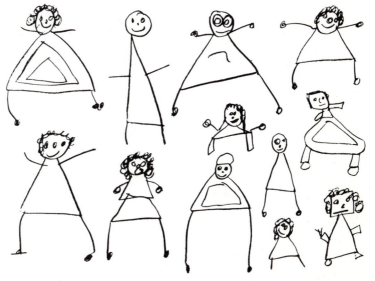

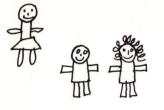

It can be argued that a square torso looks more masculine than feminine. However, when a double torso consists of a square above and a triangle below, a female is indicated. When the trouser rectangles fall below a square torso and there is no hat or hair, the figure is male, but if feminine hair is added, the figure becomes a female wearing slacks.

If *both* the lower and upper sections of the torso flare a bit, only the hair or hat will indicate the figure's sex. If there is no hair, the Human presumably is sexless.

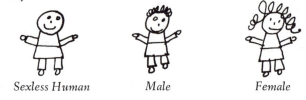

Sexless Human Male Female

All of the identifications mentioned demonstrate the difficulty in asking for "reality" in art. Adults seldom realize how arbitrary and artificial their judgments of pictorialism are. The source of the difficulty is not simply the child's inexperience in making the culture's conventional schemas for reality. The difficulty also stems from the child's concern for

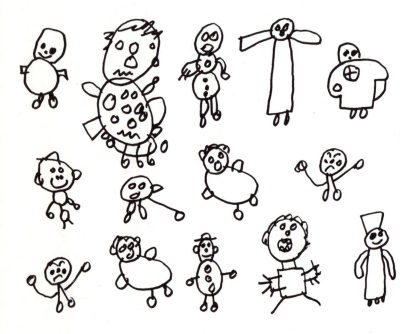

Varied formations of sexless Humans (five to seven years)

values other than pictorialism. The presence of a hat or hair in a draw-
ing is not a reliable sign of the child's capacity to represent sex
differentiation. Many early Humans are drawn with line formations that
may be identified as hats or hair, but these formations, like hands and
feet, tend to be more decorative than realistic.

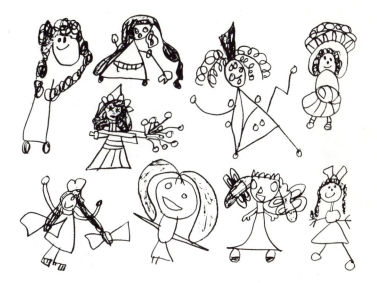

*Humans with decorative head
markings (five to seven years)*

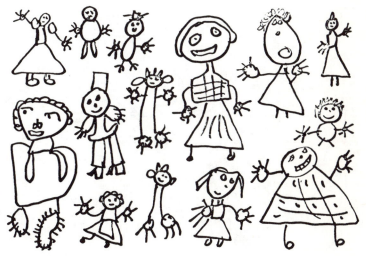

*Humans with Suns for hands
and feet (five to seven years)*

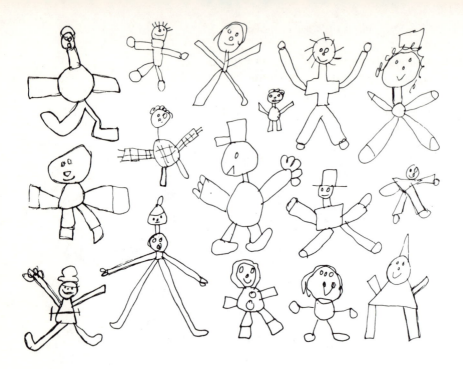

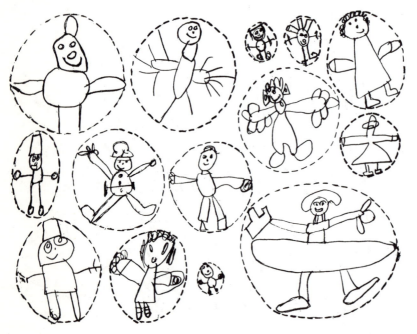

Humans in poses that are not realistic, but that fit implied ovals (five to seven years)

To judge children's knowledge of the appearance of the human figure by the Humans drawn is erroneous, and, as explained in the next chapter, to deduce conclusions about child intelligence from the Humans would be valid only if a "drawing test" takes into consideration the complexities of the esthetic preferences of the child.

As a further example of the difficulty in making pictorial judgments about children's art, various Humans are shown here. To most adults, they look distorted. The implied circle outline explains the "distortions." When similar distortion is made in Humans that can be called "dancers," adults accept the drawings as realistic. The art of dance becomes an explanation for the seeming lack of realism in drawing. As Edwin Denby (in Isaacs, 1961, p. 507) states: "A dancer can emphasize a passage in the dance by emphasizing the shape her body takes in the air. When she does this she does not call attention merely to the limb that moves, she defines her presence all around in every direction." Adults accept in dance the total arrangement of line that they ignore or reject in child art.

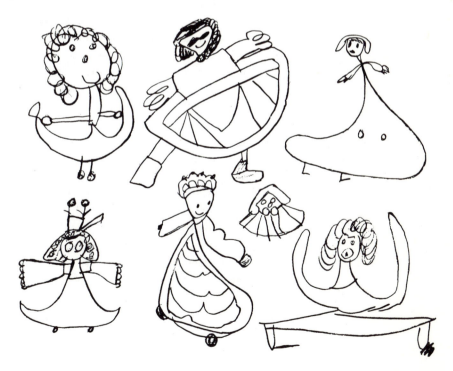

Humans that appear realistic when they are called "dancers" (five to seven years)

14. Children's Art as a Mental Test

As the foregoing chapters make clear, the "mind-gap" between adults and preschool children is indeed a wide one so far as art is concerned. The gap exists in other areas, as well. In 1948 Arnold Gesell wrote, "Our present day knowledge of the child's mind is comparable to a 15th century map of the world. Vast areas remain to be explored. Much of our knowledge is disjointed and topical; many current ideas are sheer speculative derivations rather than fruits of observation. There are scattered islands of solid dependable fact, uncoordinated with unknown continents. Under mounting influence of biologic rationalism, however, the unfinished map of the child's world is taking on more accuracy and design" (Gesell, 1949, p. 310). Gesell pioneered in systematic observation of young children's behavior, and said, "Every child organizes his space-world in obedience to laws of development general for the species and unique for himself" (p. 311). His organization has skeletal, visceral, and retino-cortical aspects working "concurrently but unevenly" (p. 310).

Gesell used drawing to investigate the child mind. When he asked three-year-olds to copy geometric shapes—squares, circles, triangles, crosses, diamonds—they did rather poorly. Yet the normal child of this age spontaneously draws esthetic versions of these geometric forms except for the diamond. Apparently, the mental activity involved in copy work differs from that needed for spontaneous art.

That a child's drawings somehow reflect his precise mental capacity

has been an idea in good repute among educators and psychologists for many years. The Goodenough Draw-a-Man Test (devised in 1926 and recently revised by Dale B. Harris), the Bender Visual Motor Gestalt Test, and the Lantz Easel Age Scale are three well-known tests currently used by clinical psychologists and educators. The tests are said to measure some aspect of "general intelligence" which develops with age-level growth. Today psychologists think that different kinds of mental abilities, rather than unitary intelligence, can be measured directly by tests.

A useful definition of intelligence is given by D. O. Hebb, who says that the word has two meanings: (1) the possession of a good brain and good neural metabolism; and (2) the average level of performing or comprehension by that brain (Hebb, 1961, p. 294). He claims that existing intelligence tests measure mainly the second sort of intelligence, and that full use of the first sort may or may not take place when tests are given. Harris says it is desirable to "replace the notion of intelligence with the idea of *intellectual maturity,* and perhaps more specifically *conceptual maturity.* This change gets away from the notion of unitary intelligence, and permits consideration of children's concepts of the human figure as an index or sample of their concepts generally" (Harris, 1963, p. 5). Mental capacity is indeed hard to measure specifically, and so is intellectual or conceptual maturity.

Harris says that intellectual maturity means ability (1) to *perceive* likenesses and differences; (2) to *abstract* or classify these likenesses and differences; and (3) to *generalize,* or assign an object to a correct class, according to its properties. These three functions are involved in *concept formation* (Harris, 1963, p. 5), and a child's drawing of "a man," "a woman," or "the self" will reveal the nature of his concepts about the human male, female, and self. What Harris is then saying, in agreement with Goodenough, is that the way a child makes a drawing of "a man" reveals what his mind has perceived and conceived about human males and therefore reveals his "intellectual" or "conceptual maturity." However, from the presentation in the foregoing chapters of the evolution of children's drawings, it should be evident that the drawings do not accurately reflect children's conceptions or perceptions of objects, including human bodies.

The difference between perceptions and conceptions is important. According to Sir Russell Brain (1960, p. 444), perceptions are "the receipt of information about the external world" which is handled by the nervous system as coded electrical impulses. Conceptions are thoughts, ideas, or opinions, that is, are mental patterns based mainly on perceptions. Conceptions also can be based on previously held conceptions. Goodenough's idea that a Draw-a-Man Test can measure child mental capacity was based on her own perceptions that children's drawings of the human figure do "improve" with age, and her conception that such improvement was due to a basic increase of intelligence resulting from increased age and experience.

Objections to the tests which she and Harris have devised are numerous and have frequently been stated, but these tests are still being used, with the Harris revision as justification for continuing use despite the criticism. Goodenough employed fifty specific details of a drawing for scoring purposes. Harris added twenty-one more to include every item of the body or the clothing. These items must be drawn to standards devised by Goodenough and Harris in order to get "credit." "No credit" means the items are not properly drawn by test standards.

Goodenough standardized her test on 3,593 request drawings, mainly from children of ages four through eight of low economic status living in Perth Amboy, New Jersey, about 45 years ago. Only 119 drawings were used to "standardize" work at age four. Harris used 3,000 more drawings done by children living in Minnesota and Wisconsin of kindergarten through ninth-grade ages. He also added a Draw-a-Woman Test and a Draw-Yourself Test. Formerly, if a child drew "a woman," the drawing was accepted as "a man."

Both the original and the revised tests have had the ordinary statistical analysis. Pages of charts and statistics about the new test "prove its reliability." These statistics are, in fact, the most scientific thing about the test. Such small amounts of art material cannot possibly give precise and valid information either about what the child knows about human beings, or why he draws his Humans as he does. The concept of the test is faulty. The authors of the test were unaware that the mental images which children use in art differ from those which are stored in the mind

as a consequence of observing live human beings. Children's drawings may or may not reflect either their percepts or concepts of living persons. Children do not draw from "life"; they first learn to draw by observing their own drawings and those of their peers. Being unaware of the whole natural system by which children teach themselves to draw in childhood, Harris makes no allowances in the test for the Gestalts of this natural system, either as assets or liabilities in the scoring process.

The child's natural system of drawing undoubtedly does reveal both perceptual and conceptual abilities, but the three Harris art tests do not measure them in relation to art or to knowledge of the Gestalts of live human beings. They do not even measure capacity for drawing what the adult thinks is a "good" likeness of a man or an object. The adult's ideas about how "a man" should be drawn are a hodgepodge of general conceptions and misconceptions. Many intelligent adults could not draw a man that would rate very high on the test, and only one request drawing can be used. No second or third efforts are allowed. The drawings used for standardizing were mainly done by children who probably had little prior opportunity to draw at all. Their work therefore no more measures their intelligence than an average adult's drawing of a man would. Nevertheless, Harris remains committed to the validity of Goodenough's interpretations of a "credit" chin, a "credit" nose, a "credit" mouth, etc. Griffiths has found that the mental-age scores of one girl aged 3.10 varied on the Goodenough scale from 3.9 to 4.6 during a twenty-day period (Griffiths, 1945, p. 218).

After reviewing the literature on child art, including *What Children Scribble and Why*, the precursor of this book, Harris still thinks that young children's enjoyment of scribbling is largely motoric (Harris, 1963, p. 228), and that interest in shape and design first appears at age six or seven when children are "discovering the techniques of graphic art" (p. 228). Read's (1945, p. 189) explanation of children's circles, whorls, and radiating lines as "electrostatic patterns produced in the cortex by normal phenomenal experience" is dismissed by Harris (1963, p. 156) as a "rather curious theory" derived from Jung and a "concept apparently borrowed from Gestalt psychology." Harris instead agrees with Goodenough that children's drawings cannot have an esthetic or

artistic merit until children have been taught to master techniques of various media (p. 235).

It is interesting to note that few of the children's drawings of "a man" shown by Goodenough or Harris have the esthetic characteristics typical of child art development. There must have been some in the few thousand works they collected, but the ones they reproduce reflect little of the child's natural capacity in art, and that little receives low scores.

Harris does not accept the ideas that Francis Galton first expressed in 1885 about children's eidetic images (optical perceptions), nor those of E. R. Jaensch, who in 1930 reported that children's perceptions pass through a building-up process of several phases and that elements of their eidetic image are easily fitted into the external world. Both views are summarized by Read (1945, p. 48). Jaensch also reported that elements of the eidetic image "enhance the meaning of stimulus situation for the child and enable him to perfect his adaptive responses" (p. 49) and to develop powers of logical thinking (p. 60). Read said in 1945 that it is difficult to prove the existence of eidetic images, but he later commented (Read, 1966, p. 241) that material in my collection is valuable evidence. Surely the implied shapes are especially significant.

A number of mental tests have been devised mainly to enable adults to assess behavior of children in trouble. These tests are utilized largely with children who are failing in formal learning or in social adaptation, but the Goodenough test is widely used as a tool for assessing progression of every child in the classroom. Mental testing is now a big business for schools and for practicing psychologists.

The Bender Motor Gestalt Test is based on Gestalt psychology, which points out that when one sees an object one sees only many whirling spots of light reflected from that object onto the retina of the eye. It is the brain which organizes the spots into closed circles or segments of circles that become the image "seen." The maturity, experience, and interest of a person all affect the way his brain organizes multiple spots into meaningful images. This organization is something that originates as a physiologic characteristic of the nervous system, and attitude, selection and suppression in some way influence the organization in the sensory field.

The Bender test presents the child with eight adult-drawn, unesthetic Gestalts, which he is asked to copy. None of these Gestalts is a structure that children spontaneously make, but two of them do look *very similar* to such a structure. No doubt these two Gestalts look "wrong" to the child. The Gestalt illustrated, for example, would look wrong because, to the child mind, a circle and a square should be drawn so that the circle rests on the square. Further, two touching lines that look like a poorly drawn diagonal cross would naturally be made as a clarified cross. If the child being tested draws these natural, "corrected" versions, he fails in the test. The results of this test show that as children mature from age five to age eleven, they can do better copy work of the test Gestalts, though few can complete the test perfectly.

Author's sketch

Two implications of this test are that basic intelligence increases with age and that this intelligence can be measured by ability to copy certain Gestalts. There is no evidence, though, that the particular Gestalts of this test are better than others which could be devised for measuring mental capacity to do copy work. The Bender test was standardized on 1,104 children, and, having been so processed and correlated with the Goodenough test, it became a scientifically approved tool for clinical psychologists.

Clinical psychologists admit that the test situation itself may not be favorable to the child and can affect outcome. This objection is minor compared to those which can be leveled against the test itself, but the test situation nonetheless is significant. All request drawings depend upon the child's willingness and ability to do his best at the moment, and teachers and parents know that children are very unpredictable in this respect. Neither the Harris nor Bender test can be repeated the next day because that would throw out standardization and ruin the test. Thus intelligence is measured by ability to draw something at one given moment in life—not two hours or two days later. A single test situation can never be as reliable an indication of cortical capacity for drawing as can a group of spontaneously made drawings. In the request situation there is too much chance of inhibition owing to a new or possibly threatening set of circumstances.

Bender says children like "to draw what is seen and to draw what is

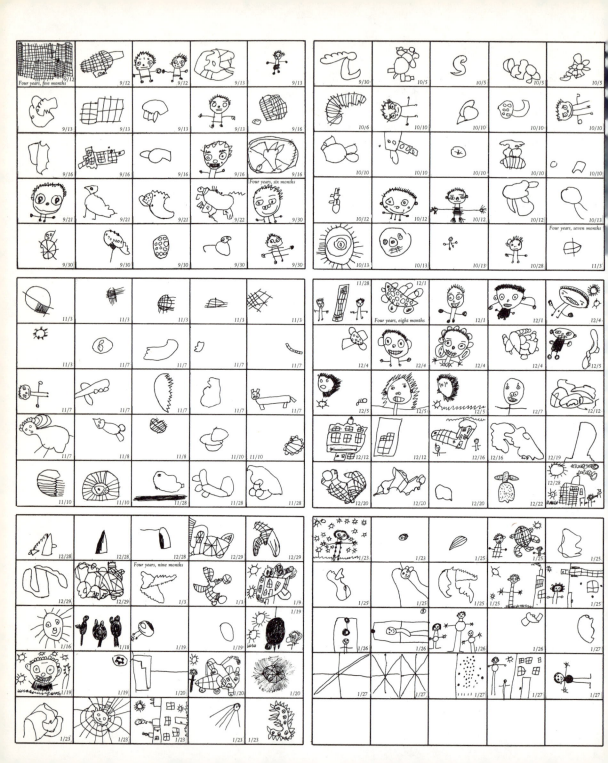

Gestalts made during four and a half months (note the dates) by a girl of apparently normal intelligence. There is much variety and very little "reality"

known," and that their "chief desire is to draw reality as it is" (Bender, 1952, p. 108). How does anyone draw "reality" except by constructing Gestalts that certain minds have learned to accept as descriptive of places, objects, and events? An objective study of the Gestalts of child art gives little information about what children see in life, or what they "know," except about the Gestalts themselves.

Still another art intelligence test used today is the Easel Age Scale devised by Beatrice Lantz, based on a study of 3,000 easel paintings of children aged four to nine years. The test is valid only for paintings, not for drawings. The majority of the paintings studied were of houses and boats; painted human figures proved too complex to be reliably categorized. The assumption of this test is that a child's drawing of a house or a boat records what he has observed about these subjects. Since children's drawings of persons admittedly do not look like human beings, they are eliminated from this test. Yet Humans are by far the favorite subject matter of child art.

Abstract paintings are not only thrown out of the Easel Age Scale, but are held suspect and are described as "primarily an expression of emotions rather than ideas" (Lantz, 1955, p. 14). They are called "Q" paintings in this test. Judging by the examples reproduced in the test manual, all nonpictorials and abstract designs are "Q" paintings. "Persistence in painting 'Q' pictures may be the child's unintentional way of revealing his need for understanding help of a special psychological and/or medical nature," says the text (p. 14).

The test consists of rating only one painting made by a child for the following: form, detail, meaning, and relatedness. A seven-point scale is used for form and for detail, an eight-point scale for meaning and for relatedness. The highest score for meaning is given when "recognizable object or objects are portrayed in clearly discernible action. The meaning of the picture is clear" (Lantz, 1955, p. 16). For relatedness the highest score comes when "recognizable object or objects are portrayed

in seeming action. The details of the picture are clear. The meaning may or may not be clear" (p. 17).

The test sets up certain scores as representing the "Easel Age" of a child. A score of three gives an Easel Age of 48 months, a score of four an Easel Age of 51 months, and so on up the ladder to a score of thirty for an Easel Age of 102 months. The reliability and validity of this test have been "satisfactorily correlated" with the Goodenough test and other tests. The statement that "special effort has been made to avoid turning the Easel Age Scale into a measure of artistic ability" is indeed significant (Lantz, 1955, p. 10). Children as artists have no honor in the art mental test situation.

Another use of children's art as a mental test has been devised by E. M. Koppitz. Like Goodenough, Koppitz has based her test on a single requested drawing from each child tested. She developed the test by examining 1,856 human figure drawings, or HFD's, produced by 1,856 children of ages five through twelve. For her test she selected thirty Developmental Items, "derived from the Goodenough-Harris scoring system and from the writer's own experience" (Koppitz, 1968, p. 9).

In the test situation, each child is requested to "draw a whole person" (Koppitz, 1968, p. 6). Only one drawing can be used for the test, which may be given individually or to a group. Spontaneous drawings of the human figure "cannot qualify as HFD's" (p. 85). The thirty Developmental Items are grouped in four categories at each age level: "Expected," "Common," "Not Unusual," and "Exceptional" (p. 9). Koppitz "hypothesized that Exceptional Developmental Items are found only on HFD's of children with above average mental maturity" (p. 13), and in her scoring she gives a value of one to each Exceptional Item. Each Expected Item also gains a one, and the absence of an Expected Item receives a negative one. To prevent total scores from being negative, Koppitz adds five to the sum of each child's actual points. A score of seven or eight is high, representing an I.Q. of at least 110, and a score of two implies an I.Q. of from 60 to 80 (p. 331). A score of less than two indicates mental retardation or a serious emotional problem.

In addition to the thirty Developmental Items, Koppitz lists various Emotional Indicators that she has found in HFD's. These Indicators

include: the absence of eyes, mouth, arms, legs, hands, feet, or neck; a figure height of nine inches or more; a height of less than two inches; a slant of more than fifteen degrees from the perpendicular; very long arms; very short arms; and added clouds, rain, snow, or flying birds.

The Emotional Indicators were validated with seventy-six pairs of children. Half were selected by their teachers as being "students with good social, emotional and academic adjustment," although their "intelligence test score were not available" (Koppitz, 1968, p. 40). The other half were patients in a child guidance clinic. The clinic children produced 166 Emotional Indicators, whereas the seventy-six adjusted children produced only 22 (p. 42). The degree of each child's emotional adjustment or disturbance must be gauged by the total number of Emotional Indicators in his request drawing.

The tabulation to the right presents the number of Emotional Indicators in eight of the categories described by Koppitz as these Indicators were counted in 2,683 drawings of Humans made by five-year-olds who attended public schools in the Bay Area of California. Although the children were not asked to "draw a whole person," it is notable that more than a quarter of the drawings lack a body. The other listed Indicators show a range of frequency down to fewer than one in twenty for tiny figures. This variation suggests that the Indicators are far from equal in significance.

Koppitz is quite explicit in cautioning against simple interpretations:

Emotional Indicators Counted in 2,683 Drawings of Humans from the Rhoda Kellogg Child Art Collection (Five Years)

No body	*741*
No nose	*692*
No hands	*644*
Shading of face	*499*
No mouth	*253*
Slanting figure	*216*
Asymmetry of limbs	*164*
Tiny figure	*125*

There appears to be a consensus among the experts on HFD's that no one-to-one relationship exists between any single sign on a HFD and a definite personality trait or behavior on the part of the boy or girl making the drawing. Anxieties, conflicts, or attitudes can be expressed on HFD's in different ways by different children or by one child at different times. This writer can only underscore what others have emphasized again and again: It is not possible to make a meaningful diagnosis or evaluation of a child's behavior or difficulties on the basis of any single sign on a HFD. The total drawing and the combination of various signs and Indicators should always be considered and should then be analyzed on the basis of the child's age, maturation, emotional status, social and cultural background and should then be evaluated together with other available data. [Koppitz, 1968, p. 55.]

These cautions are wise, though they do not acknowledge the influence of the child's spontaneous art nor the difficulty, stated in the previous chapter, of identifying and naming the parts of Humans. Yet when Koppitz comes to particular characteristics of HFD's, she is not reluctant to assign definite meanings to the presence or absence of certain line formations. Omission of the mouth indicates feelings of "intense inadequacy, resentment and withdrawal" (Koppitz, 1968, p. 52). "Shading of the face on HFD's is quite unusual at any age level . . . and indicates discontent with oneself. . . . Shading of the body on a HFD reveals body anxiety" (p. 57). Shading of the arms means that the child "suffers from anxiety because of some actual or fancied activity he engaged in with his arms" (p. 58). A slanting figure "seems to be a sign of instability and imbalance which interferes with academic achievement" (p. 52), and slanting figures also "suggest that the child lacks secure footing" (p. 59). Tiny figures mean timidity, big figures mean aggressiveness and immaturity, and tiny heads "indicate intense feelings of intellectual inadequacy" (p. 61). Children who draw short arms are well behaved, "too well behaved for their own good," and long arms indicate aggressiveness (p. 62).

The drawing of a cloud on a HFD means that "the child is in effect standing under a cloud, under pressure from above" (p. 66). Referring to Plate 19, Koppitz calls a Sun Gestalt a cloud. She says of the clouds (ovals) in Plate 23 that "they are welcome signs of more snow to come and more fun to be had" (p. 86). Other, similar interpretations of HFD's may be found in the book.

Koppitz, Goodenough, Harris, Bender, Lantz, and others ignore the fact that art, especially child art, has its own basic characteristics. The evaluations erroneously assume that the child's art work gives reliable evidence of what the child has observed in the world about him, and that his drawings record his observations adequately and thus indicate degrees of intelligence. In fact the study of preschool art shows that all children work primarily in esthetic fashion and that the "Q" frame of reference is not only a healthy one, but it seems to reflect cerebral capacity as well as does pictorial work. If art is to be used as a test, the artistic aspects of child work cannot be disregarded; instead they must

be part of the basis of test construction. Every child can identify a house or dog long before he can draw one. The child's esthetic capacity as reflected in his spontaneous Gestalts is, in turn, a reflection of a good brain and good neural metabolism, to use the first part of Hebb's definition of intelligence (Hebb, 1961, p. 294). Pictorial capacity, other than in childlike esthetic form, does not exist until the child is trained to substitute an adult's idea of how lines "should be drawn" for his own highly developed and natural ideas about drawing. If the capacity for such training measures intelligence, most adults lack it, for few can draw according to the standards in the minds of those who have devised the art mental tests.

By the time the child is old enough to be trained in drawing, a drawing test has lost its usefulness. Other tests of mentality are better and more reliable, such as a test of ability to read with comprehension or to do simple mathematics. Art tests exist because there is a need to assess mental ability "objectively" before the child is old enough to read. However, the tests here described are far from objective in their assumptions about child art.

Psychiatrists and psychoanalysists also interpret the art of children. They use a qualitative, rather than a quantitative, or statistical, approach, and they are interested in the individual's emotional condition rather than in numerical scores of mental development. Freud, Jung, Rank, and others have written about art in relation to their psychoanalytic theories. These theories are discussed in Chapter 16.

Why should not a drawing test be based on the Gestalts that children normally draw? Once statisticians ascertain the presence or absence of definite Gestalts in the developmental sequence, testers could estimate a child's progress by observing all the drawings he has spontaneously made, rather than just one or two made in a request situation.

It is my judgment that the esthetic mental images that produce child art would be found to reflect an intelligence *similar* to that needed for learning to read. If the child can learn to see certain Gestalts in art, he is capable of learning language Gestalts. Children naturally want to learn those of their art, but they must be properly motivated to want to learn those of language, and then they must be helped to do so. Learn-

ing the meanings of art Gestalts and of word Gestalts involves kinds of mental activities which are both similar and different, and both are inseparable aspects of a developing intelligence in childhood. Art begins first, so it cannot be ignored without taking the risk of making serious errors in education.

The intelligence shown by children's art also appears to be related to mathematical learning. Jules Poincaré says that "without a rather high degree of . . . aesthetic instinct, no man will ever be a great mathematical discoverer" (in Hadamard, 1945, p. 38). A much more general statement comes from Matila Ghyka: "There is a geometry of Art as there is a geometry of Life, and, as the Greeks had guessed, they happen to be the same" (Ghyka, 1946, p. 154).

Child art could be used as a mental test in the sense that a group of drawings done by a child could be evaluated as "standard," "below," or "above" what is commonplace or normal at certain age levels, once such norms were set. To make such a test it would be necessary to take large quantities of drawings by many children and to document the age at which certain Gestalts first appear and perhaps how frequently they recur thereafter. If, for example, the Sun Gestalt is rarely made before thirty-six months of age and commonly thereafter, as is now my

Pairs of Humans, each pair drawn by one child in one week (five to seven years)

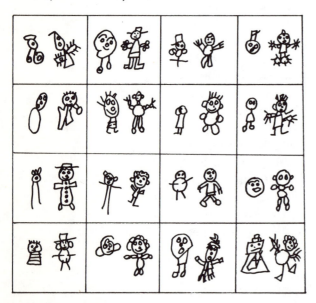

impression, then the presence of the Sun before age three would be "above," after age three would be "standard," and absence at age four would be "below." The frequency of occurrence of any one Gestalt would not be too significant for measuring basic mental capacity, but the frequency of a variety of Gestalts would be.

As for the Draw-a-Man Test, I have collected and studied sets of drawings of some 2,500 public school children who were asked to "draw a man" each day for five days in one week. About one-third of the children drew such different Humans in one week that ratings done by an expert, according to the Goodenough scale, resulted in scores that varied as much as fifty per cent. Pairs of drawings, each pair done by one child within one week, are illustrated. Yet Harris will not let a score be compiled from two drawings from one child.

Children draw both "mature" and "immature" Humans, though for a time they may repeat a single version which engages their interest. Only a series of Humans can be used as a basis for a reliable test. Even then the child may not do his "best" in any given short period of time. All that can be ascertained is that the child's ability is no less than that to be found in the "best" drawing he makes. This no-less-than rating can be very useful for estimating intelligence of a kind needed for learning the

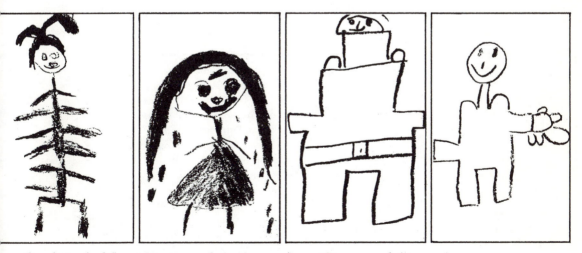

Five distinctly different Humans made by the same boy within one week (six years)

SPONTANEOUS ART AS A MENTAL TEST

To gauge the possibilities of a mental test based on spontaneous child art, several colleagues and I examined 99,964 drawings made by 250 children. We made two kinds of measurements: the number of drawings that contained each of six pictorial items and the mean age in months at which each item was first made.

The children were selected because their drawings were available, filed by individual, and because they all had attended one of the several nursery schools once operated by the Golden Gate Kindergarten Association from at least 38 through 44 months of age. (This span of months corresponded with the early pictorial work that I had observed.) Many of the children attended the school for longer periods, from as early as 24 months to as late as 60 months or more.

The numbers on the opposite page and the mean ages reported below support the possibility of a test based on spontaneous art.

Pictorial items	Number of drawings	Per cent of total	Number of children drawing item	Mean age in months for first item		
				Study 1*	Study 2*	Study 3*
Sun	1,841	1.84%	193	43	42	41
Humans	5,293	5.29	195	43	44	42
Animals	342	.34	82	48	51	50
Vegetation	362	.36	74	49	51	47
Buildings	402	.40	68	51	51	51
Transportation items	247	.25	46	53	53	51

Average number of drawings per child: 400
Number of children drawing letters: 134
Fewest drawings by one child: 36
Most drawings by one child: 2,863

*Study 1 is of the 99,964 drawings done by 250 children. Study 2 is of an additional 644 children who were enrolled for at least two months but not for the full period from 38 through 44 months. Study 3 is of 33,742 drawings by 150 children, tabulated on the opposite page.

A number of people assisted me in counting the Placement Patterns in 104,000 drawings:

P3	20,000	P5	3,300
P16	19,500	P7	3,300
P10	18,000	P13	2,800
P9	14,500	P14	2,800
P2	13,000	P6	2,000
P1	7,000	P11	2,000
P4	7,000	P17	2,000
P8	4,500	P15	1,300
P12	4,500	Total	123,000

The total number of Patterns exceeds the number of drawings because one drawing may include two or more Patterns, such as P1 and P16. The counts given are approximations. The fact that Patterns 1, 2, and 3 ranked high may be traced to the child's awareness of the perimeter of the paper. Similarly, the frequency of Patterns 7, 8, 9, and 12 argues for awareness of diagonals.

The 267 children who produced the drawings include the 250 children described above. See pages 24 and 25 for illustrated definitions of the Placement Patterns.

Number and percentage of drawings
made in categories of the classification system
150 Children 33,742 Drawings

Classification		24-30 Months	31-36 Months	37-42 Months	43-48 Months	49-54 Months	55-60 Months	Total	Number of children drawing item
	no.	3,742	5,437	8,334	7,035	6,122	3,072	33,742	
Scribblings only	no.	3,400	4,769	6,600	4,664	3,189	1,376	23,998	150
	%	90.86	87.71	79.19	66.30	52.09	44.79	71.12	
Placement Patterns	no.	3,724	5,430	8,289	6,753	6,012	3,014	33,222	150
	%	99.52	99.87	99.46	95.99	98.20	98.11	98.46	
Emergent Diagrams	no.	3,061	4,073	3,966	2,528	1,755	780	16,163	150
	%	81.80	74.91	47.59	35.93	28.67	25.39	47.90	
Diagrams	no.	45	413	985	830	696	350	3,319	139
	%	1.20	7.60	11.82	11.80	11.37	11.39	9.84	
Combines	no.	14	136	288	319	364	182	1,303	121
	%	.37	2.50	3.46	4.53	5.95	5.92	3.86	
Aggregates	no.	10	251	828	1,151	1,345	753	4,338	127
	%	.27	4.62	9.93	16.36	21.79	24.51	12.86	
Mandalas (1-4)	no.	360	522	616	317	102	85	2,002	140
	%	9.62	9.60	7.39	4.51	1.67	2.77	5.93	
Mandalas (5-13)	no.	3	4	44	165	242	156	614	58
	%	.08	.07	.53	2.34	3.95	5.08	1.82	
Suns (1-2)	no.	5	75	114	74	35	8	311	88
	%	.13	1.38	1.37	1.05	.57	.26	.92	
Suns (3-13)	no.		24	148	201	251	100	724	78
	%		.44	1.78	2.86	4.10	3.25	2.15	
Radials (1-3)	no.	818	977	1,152	715	240	165	4,067	143
	%	21.86	17.97	13.82	10.16	3.92	5.37	12.05	
Radials (4-7)	no.	7	8	30	40	39	24	148	51
	%	.19	.15	.36	.57	.64	.78	.44	
Humans	no.		97	445	687	743	413	2,385	85
	%		1.78	5.34	9.76	12.14	13.44	7.07	
Animals	no.			5	29	59	66	159	28
	%			.06	.41	.96	2.15	.47	
Buildings	no.		1	5	50	76	98	230	37
	%		.02	.06	.71	1.24	3.19	.68	
Vegetation	no.		5	35	33	50	45	168	31
	%		.09	.42	.47	.82	1.46	.50	
Transporta-tion items	no.			18	23	40	112	193	25
	%			.22	.33	.65	3.65	.57	
Joined pictorials	no.				9	58	56	123	24
	%				.13	.95	1.82	.36	
Learned from others	no.		56	116	158	416	441	1,187	65
	%		1.03	1.39	2.25	6.79	14.35	3.52	
Formal design	no.			5	5	21	72	103	15
	%			.06	.07	.34	2.34	.30	
Advanced scribbling	no.		51	115	426	790	520	1,902	71
	%		.94	1.38	6.05	12.90	16.93	5.64	

Note: Because several categories are usually found in one drawing, the columns do not total 100%.

abstract Gestalts of letters and numbers. For this reason an evaluation of the child's capacity in art can be useful in diagnosing the problems of children who do not learn to read.

A "mental test" based on a group of drawings can be devised for detecting the "pseudoretarded" child. Differentiating the children who do not have the mental ability needed for learning to read from those who do, but lack other abilities for this learning, is an important task of the school. It has long been known that some retarded children do very well in art. Goodenough and Bender say that there is no explanation for this fact. There is one hypothesis that occurs to me, however: retarded children who are good child artists do not lack normal mental capacity, but they fail to use it properly outside art. I think these children are pseudoretarded and afraid to be self-assertive, except in art. Art is a "safe" outlet for such children because neither they nor adults know that their scribblings reveal a kind of intelligence which is comparable to that needed for learning the many things adults want them to learn, but on the adults' terms. The genuinely mentally deficient child does not do well in art, so far as I have been able to observe. Certain mentally deficient adults are capable of doing well in child art, but their deficiency may have an environmental origin.

The pseudoretarded child might be detected as early as age three by a study of the structured work in his drawings. The absence of structures never proves retardation in a child unless many drawings, made over a long period, are available. In a number of instances I have been able to change parents' estimate of a child's intelligence by assuring them that their child's drawings could not have been made by a person of low mental capacity, and that therefore another explanation for their child's slow behavior must be found. No one wants to expect too much of a child whose mentality may be subnormal; but acceptance of pseudoretarded behavior as mental incapacity is just as unfortunate and highly prevalent today. Unfavorable emotional environment or environment lacking in proper mental stimulation is often the cause of pseudoretarded behavior. Some parents are able to alter their estimate of their child and to begin altering the environment when this is pointed out to them. Although age three is late for correcting pseudoretarded behavior, it is

probably the earliest age at which a drawing test based on structures could be used. Perhaps presence of clear Placement Patterns at age two could be admitted as evidence of good mental functioning. Certainly evidence of structuring before age three should be convincing evidence of good mental ability. The illustrations here show the work of two children with very advanced capacity for doing structured drawing between thirty-one and thirty-six months of age. Note the difference in the "styles" of these two children, who otherwise seem similar in ability.

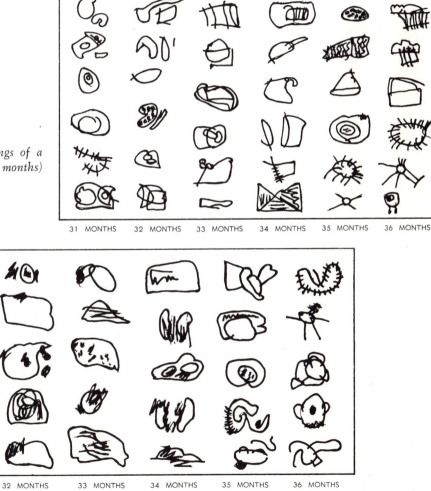

Structures in the drawings of a young child (31 to 36 months)

31 MONTHS 32 MONTHS 33 MONTHS 34 MONTHS 35 MONTHS 36 MONTHS

Structures made by another child (32 to 36 months)

32 MONTHS 33 MONTHS 34 MONTHS 35 MONTHS 36 MONTHS

A test of intelligence using spontaneous art would be based not only on the assumption that ability to draw Gestalts involves cortical capacity *similar* to that needed for learning to read, but also on the assumption that a child who can learn to read with comprehension has an I.Q. adequate for receiving the school training customarily called "education," whether or not he is given it or accepts it. Art ability would then be used as an indication of the first part of Hebb's definition of intelligence, which is similar to if not identical with the "fluid intelligence" described by Cattell (1968, p. 58).

Because good brains probably are distributed in the population about as equitably as good hands, hearts, or livers, we should expect few children to have insufficient cortical potential for learning to read and for meeting the usual demands of schooling under suitable conditions.

The difficulty with a child art test of intelligence is that no numerical scores could be given, and all that such a test could record is that the child is either slow, average, or advanced in art. This would not satisfy schoolteachers, psychologists, or most parents. They want quantitative or numerical "grades," despite the fact that no one is justified in giving such grades to art products, as do professionals who use art tests.

There is a further difficulty in the use of a mental test based on child art in the way I have described: The test probably would point to adequate cortical capacity in all but a few children, and so the blame for poor performance in school would rest primarily on teachers and parents. Adults who have assumed that poor performance stems chiefly from low potential would have to change their views.

One other major difficulty remains. Even if a basic test of mental capacity through child art were accepted, the evaluations needed would not be as simple as they might seem. For example, structured scribblings, which would be significant for the test, often are covered by unstructured ones. In the illustration shown, there are structured images, including a Sun, which are not easy to detect. In the original drawing, the Sun can be seen because it was made in a color different from the scribbling over it, but many drawings have layers of work that are all in the same color. (The structures in the original are indicated here by separate tracings of them.)

Drawing that includes structures covered by scribbling (40 months)

Five separate structures traced from the complete drawing above

The following illustrations suggest other problems in the evaluation of child art. Some of the problems derive from the condition of the child. For instance, the structured work shown was drawn by a five-year-old girl afflicted with cerebral palsy, which accounts for the unsure quality of the lines. The structures in this work seem to me to reflect adequate art intelligence for age five. An armless Human is at the left, a wheeled vehicle at the right, and an outline of a house in the upper left.

The next illustration has a house with a door and some windows, two hatless Humans, flowers, and a fine over-all organization—all of which reflect cognitive ability that is normal for age six, and indicative of mental capacity which should be adequate for learning the Gestalts of letters and numbers. More than mental capacity is needed for learning to read, of course. The desire to learn must also be there, as well as adequate teaching techniques.

The accompanying illustrations show the best structural content found in some 600 drawings which were made by a child in nursery

Drawing by a girl with cerebral palsy (five years) *Drawing that indicates basic intelligence (six years)*

Structures from the drawings of a malnourished child (36 to 54 months)

school between the ages of thirty-six and fifty-four months. Her twin sister made 250 scribblings, but no structures, during that period. Both girls were malnourished refugees from the Nazi invasion of Holland. Both proved to be mentally deficient. The one who made 250 scribblings died at age six; the other was enrolled in a special school for the mentally retarded. The drawings here confirm a diagnosis of mental incapacity for doing regular school work. Note that there is no Mandala, no Sun and no Human, and that even the Diagrams and the Aggregates are poorly assembled.

The drawings of horses, knights, and birds were made by an eight-year-old boy whose I.Q. score of 80 placed him in a class for the mentally retarded. The message of this illustration is: something is wrong with the accepted concepts and measurements of child intelligence.

Evaluating run-of-the-mill drawings made in school is difficult. How can a teacher judge the two boats shown for their realism? What can a teacher say about the realism of any of the group of six drawings shown? All of these drawings have the merit of revealing the ability to construct Gestalts, and the drawings probably were a pleasure for the artists to make and to look at, but would they ever be hung on the walls of a classroom? I am sure that they would have been discarded in wastebaskets had I not requested teachers to save all drawings made in their classrooms. These works are disturbing to adults. If drawings of this type are made too frequently by a child, his teacher may refer him to the child guidance department, unless he is otherwise well-behaved. A psychiatrist might make a diagnosis of a neurosis from one of these drawings. Yet I know that all of them represent work of normal children working as freely as Klee or Chagall, and I find them delightful to look at and not symptomatic of personal problems.

Drawings by a boy whose intelligence quotient as measured by accepted tests was 80, and who was placed in a class for the mentally retarded (eight years)

Boat (five years)

Boat (six years)

ive years)

(Five years)

(Four years)

ur years)

(Six years)

(Four years)

Duplicates (seven years)

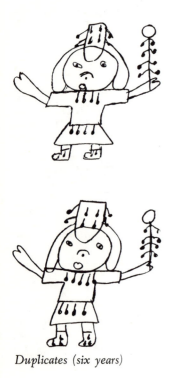

Duplicates (six years)

The two pairs of drawings are examples of children's work in duplicate. My collection has many hundreds of such sets, as well as some triplicates. Should such works be viewed as "compulsive"? Duplications made by adult artists are called "studies"; when made by children, however, they may be considered unusual and not quite wholesome.

The hidden meanings which some therapists find in children's art are based on symbolic interpretations which a particular psychiatric or religious theory attaches to structures. These meanings, which are learned as part of training in psychiatry, are often frightening to laymen—and rightly so. Karen Machover, for example, says that bilateral symmetry in drawing denotes compulsiveness; that profile drawing is a male characteristic and front-view drawing is a female characteristic; that the "right side of the page is considered environment oriented, while the left side is self-oriented" (Machover, 1949, p. 360). In fact, bilateral art is a dominant category of all human art, of all kinds and of all eras. If it is normal for all human beings, then the individual's expression of it should be considered normal also.

W. Grozinger's study of children's art led him to say, "Children do not draw what they see but what they know about form, i.e., what has accumulated in their form-memory as a store house of inner images" (Grozinger, 1955, p. 61). The "whole body feeling participates in the process of vision" (p. 65), and the "symrhythmical" (not symmetrical) bilateral drawings that children make "symbolize the motor and haptic aspect of our being, and thus stimulate our primal sense of space and body" (p. 113). Whatever their possible symbolic meanings, bilateral drawings occur too often to be considered abnormal.

The evaluation of child art may require interpretation of basic line formations. For example, in the drawing here I see evidence of effort to scribble the images of a square, possibly a circle, and some crosses, all of which I find good work for a child aged thirty-two months. This is not random scribbling, but is a mentally controlled effort of the hand attempting to make certain Gestalts.

Controlled scribbling (32 months)

The accompanying odd-shaped Diagram contains two little marks that could be interpreted as representing an "eye and a mouth on an elephant in a zoo cage." I suggest this because the little marks would not be present on a simple Diagram. Also, I know that in school, children learn to draw vertical lines over animals to represent the zoo cage. Knowing the age of the child helps in interpretation, as does seeing a drawing in a sequence done by the same child. Unfortunately, I lack these helps in this instance.

Animal? (age unknown)

The illustration of a Human here includes a mark which adults might label a "belly-button." However, I see a Human with a Mandaloid torso, consisting of a large and a small circle. Shading lines drawn in the four directions make the torso Mandaloid. The intent of this circle is to mark the Mandala's center, not to show the navel of a person.

In another drawing I see scribbles and four structured items: an armless Human; an armless and faceless Human; an Animal; and an area with a few rays. All of these structures indicate to me that a child with a four-to-five-year-old level of intelligence made the drawing. I also note a confused style, which suggests insecurity, either in relation to the Gestalts or to some other aspect of self-expression in drawing.

Human (four years)

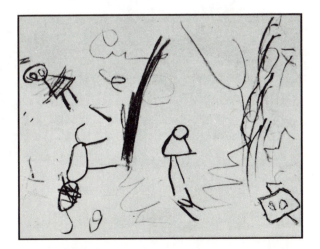

Four structures (age unknown)

The remarkably detailed drawing is a work done by an eight-year-old boy in a class of retarded children. My impression is that it is the work of a schizophrenic mind, but I do not know the child. The schemas of child art are often prominent in the work of adult schizophrenics, who combine them with formulas learned later in life. Schizophrenics may draw combinations that cannot be justified either on a pictorial or esthetic basis. The drawing here is an example, though the technical skill it reflects is great. Schizophrenic art is known for having child-art motif content, which doctors may consider peculiar because they do not know how the motifs originate in child art. The motifs need not be throwbacks to prehistory except in the sense that child art motifs are archetypal. The little Mandalas are illustrative of archetypal material from child art.

Unusual drawing with many details (eight years)

The views of A. Bader on the art of certain schizophrenics are pertinent. He says (Bader, 1961, p. 43) that from the purely formal aspects, their work "contains little that is specifically morbid. More often than not, we find in them the same elements as are contained in the drawings of children in the art of all epochs, [certain decorative motifs] in the work of prehistoric man or of uncivilized peoples, as well as in modern paintings. In the work of adults who are incurably insane is to be found a dividing of surfaces into geometrical figures, skillful compositions giving proof of unquestionable artistic taste, and the intuitive compositional skill of the true artist, though they have never had any lessons in art. These patients work from the unconscious, being free from conventional inhibitions." Bader says that artists like Klee and Picasso and other moderns have such access to the unconscious.

Drawing by a boy with a serious heart condition (12 years)

The drawing with the dagger so puzzled me that I sought out information about the child who made it. Its skull and dagger was neither child art nor the conventional learned formula. The drawing is one of two that are similar and was made by a twelve-year-old boy not long before he died of a congenital heart condition.

Mental tests are mainly used today, in my judgment, to reduce adult guilts over children's failure to behave and to learn. Society is controlled by adults who, having had their childhood's deprivations, must try as

(Five years)

adults to improve their own lot in life. There just does not seem to be enough time, attention, love, money, or success to go around for everyone to be able to lead the good life. Though more effort is being expended today than ever before on behalf of children, we still have far to go. Some of our efforts are superb, others are ludicrous or destructive. Mental tests via art are the latter, because they are established under adult misconceptions about what art is and how young humans function in art. They measure nothing about a child's potential brain capacity. Even if a test that did this could be devised, of what use is it unless an education system can be developed which protects most children from arbitrary standards of failure? Such standards currently are applied not only to unusual drawings like the ones on these pages, but to every area of formal schooling.

We do not have such education today nor much likelihood of starting it. As more and more we move away from a holistic concept of the child, we try to stuff his mind with what deserves to be called the accumulated "garbage of the adult mind," including traditional lore, such as

Drawings that fail to satisfy the conventional expectations of adults

(Six years)

(Six years)

Mother Goose, which was written for children of a different era. Today the adult generation has lost control over the behavior of many children who roam the streets and are a nuisance or a menace to property.

School failures and the destructive behavior caused by them probably could be reduced through organized, art-centered education for children from two to ten years of age. Such education is now underway in the Preschool Learning Center which I direct in San Francisco. The "culturally deprived" children living near the Center now have art classes open to them. The children come and go as they like. They are not destructive in the classroom, but are creative, cooperative, and happy to be allowed to use art materials freely during hours when they are not required to be in school or at home (Kellogg, 1967b).

In this atmosphere, any mental test via art that pretended to yield precise, quantified gradations of intelligence would be an insult to the children. By developing new habits of thought about child art, we may avoid some of the mistakes we often make while acting as guardians of the young.

(Six years)

(Four years)

(Seven years)

(Eight years)

15. Universal Aspects of Children's Art

Modern man is interested in understanding the origins of human history and culture as reflected in the art and artifacts of earlier times and remote places. Designs and other line formations on exposed rocks and in caves date to paleolithic times; that is, to a period from about 30,000 to 10,000 B. C. Indigenous art appears in cultures throughout the world. Scholars, including archaeologists, anthropologists, and art historians, study ancient and remote articles in an attempt to understand mankind's social and cultural development.

Prominent in the art of prehistoric man are the abstract and early pictorial motifs commonly found in child art today. Indigenous art also contains these motifs. Yet most scholars have ignored this fact and have sought explanations for ancient and native art without regard to the work of children. There are two reasons for this neglect: scholars have insufficient familiarity with child-art motifs, and they have their own familiar ideas regarding prehistory, art, and children.

Achievements in art by archaic adults often cause scholars to express awe or wonderment as to the ideas and feelings that filled the minds of the artists. I have seen too much child art to adopt that attitude. Examples of child art illustrate other chapters in this book. The illustrations for this chapter are primarily author's sketches of the basic designs and line formations of archaic and indigenous art that I have seen in museums, on structures, and in reproductions. The first set of illustrations presents groups of motifs. At least one source for each set is noted. My

aim in showing the similarity of child art and the art of ancient or re-
mote adults is not merely to illuminate the sources of mankind's artistic
development, but also to raise the reader's estimation of children's art.
The illustrations in this chapter represent art that commands the respect
of scholars, and child art should be accorded the same respect.

The ideas that scholars bring to their examination of archaic art come
mainly from subjects such as economics, social relations, and mythology,
which are outside the realm of art. An exception consists of ideas about
perspective. Art historians and other scholars tend to gauge develop-
ment in art in terms of perspective, even though the systematic study
of perspective in art first occurred in the Renaissance. The term *perspec-
tive tordue* (warped or twisted perspective) is used by Giedion (1962, p.
19) to describe prehistoric paintings of animals in which the horns are
seen in front view and the body in side view. The term is not applied
to child art, even though similar drawings are made by children, because
young children lack the ability to draw in true perspective. Prehistoric
man presumably had this capacity, and so his childlike work puzzles
scholars. (Certain prehistoric art clearly was not done by children be-
cause child musculature could not have made rock carvings or paintings
on the ceilings of caves.)

American Indian motifs. Steward (1929) and Lowie (1954) provide examples of such art

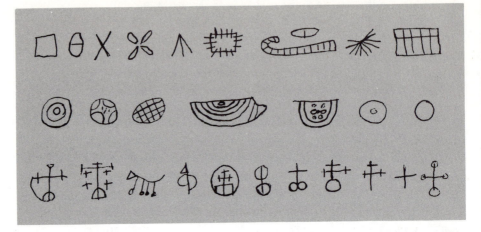

Spanish motifs. The designs at top are prehistoric ones from Altamira Cave. Kühn (1956) and Abbé Breuil (1952) present Spanish motifs, as does the manuscript, "Engraved Bone Flakes," by Charles Groves. The manuscript is kept at the Royal Irish Academy, Dublin

Perspective is a major concern in understanding artistic development only if art is valued for its pictorialism. However, perspective and pictorialism are not universal characteristics of art, and they have been judged important only in certain periods. Scholars who rate archaic art in terms of perspective rely too much on relatively recent developments in art and too little on the Gestalt constructions of spontaneous work. They prefer to look for pictorial or symbolic meaning in art, rather than for structures which are appealing in themselves.

Archaeologists often call the female figure in archaic art a Venus or goddess. Since the customary female figures of child art are rare in archaic art so far as I can learn, I think that the archaic figures were done by adults from live models. However, it is evident that archaic artists felt free to distort the figures, to fit them into abstract patterns. Perhaps the appeal of primitive carvings to modern art lovers is that such figures are distorted to fit the balanced shape of a piece of wood.

Sigfried Giedion says of archaic female figurines that for the overwhelming majority, "meaning revolves around an ardent desire for fertility and procreation" (Giedion, 1962, p. 4), adding that "these figurines

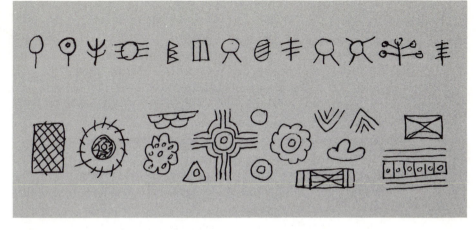

Indian motifs. Examples of art indigenous to India are shown by Wolff (1948), and are on display, as artifacts, in the National Museum of Art, New Delhi, and in similar collections. Many of the motifs pictured above are from the Indus Valley of northern India

were in no way prehistoric pin-up girls" (p. 5). Giedion's attempt to explain art pictorially causes him to label bilateral nonpictorial figures (p.451) as Mother Goddesses and to call familiar Diagrams and Combines "vulva symbols." The "double figure" from Laussel (p. 238) is a most interesting example of how adults read their own ideas into a work of art. The photograph of the figure shows an abstract Gestalt of a restful, nonpictorial, oval design, and this could be what the artist intended, but Giedion views the work as a bisexual fertility figure. Giedion's shaded sketch of the carving, as photographed, produces a "female" with a head, arms extending to the feet, huge hanging breasts, a small belly, legs, and feet, all inside the enclosing oval. If the oval is inverted, he claims to see both male and female figures in a combined position, which makes the work a symbolic, androgynous, fertility figure. Giedion admits that Freud and Jung have influenced the thinking of archaeologists, and he gives two pages to the explanations of others who see more than design, and who are intrigued by this stone carving.

Erich Neumann in *The Great Mother* (Neumann, 1955) has written extensively about archaic Venus and goddess art, which he explains in

terms of Jung's archetypes of the female. The illustrations of the goddesses, created presumably by male artists, are frightening as psychology. Seen as basic art or as child art, they are delightful. The distortions of the female figures could easily be expressions of esthetic license, rather than abnormal glandular development or male fear of "the great mother." The Venus of Laussel (Neumann, 1955, Plate 1), seen as a great circle Aggregate suggested by the female body, is a timeless work of art. As a record of the artist's unconscious attitudes to females or the natural obesity of women of the era, the Venus is a mere curiosity.

Aggregates as art are not Neumann's concern. Neither are child-art Suns the concern of Emmanuel Anati (1961), who says that the prehistoric inhabitants of Camonica Valley were sun worshipers because they painted so many suns on rocks.

Another example of modern reaction to basic art comes from James Mellaart, who says, ". . . one has the rare opportunity of exploring the Neolithic woman's mind by studying the symbolism she used in her effort to comprehend and influence the mysteries of life and death" (Mellaart, 1964, p. 101). He goes on to describe her art as "net patterns," "crosses," "children's hands," and "rosettes," all of which are child-art motifs that could have been made by either males or females. Even children could have marked soft clay, one of the materials Mellaart investigated in this fashion. Mellaart also asserts, "Most of these paintings had a religious purpose." A simple cross he labels a "flower" (p. 104).

The Abbé Breuil writes of the "White Lady of the Brandenberg," a mesolithic rock painting of South Africa: "eternally she walks there, young, beautiful and supple, almost aerion in poise . . . may she teach her visitors the cult of things of the Spirit, and of Beauty; may they learn from her, as did our ancient animal artists, to soar upwards above common utilitarianism to those realms where blossom the visions of the soul" (in Read, 1960b, p. 263). Herbert Kühn did not consider the figure of which the Abbé wrote to be a female figure, according to Read.

Both Kühn and Giedion are art historians who are able to find the origin of mankind's religion, mythology, culture, and customs in archaic man's art. Strangely enough, the dominant motifs they offer in evidence consist of Gestalts commonly produced by children today. Because no

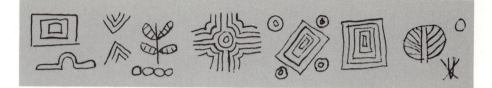

Baluchistan and Pakistani motifs. Artifacts in the British Museum display such designs

Egyptian motifs. Wilkinson (1841) is one source for ancient art that is native to Egypt

Coptic motifs. The Coptic Museum in Cairo displays such designs as part of wood carvings

Art by Chinese children living in an orphanage on Taiwan shows that universal motifs persist in child art when adults do not interfere (10 years)

Chinese motifs. Such designs were once in the de Young Memorial Museum, San Francisco

adult can escape childhood, we cannot say that all ancient art reflects adult religious or cultural development. Nor can we assume that each generation's art Gestalts are learned only from adults, for certain art Gestalts are produced anew by each generation of children. I agree with Read that art-making is as natural as movement for human beings and hence that art has its archetypal or universal aspects. The Twenty Basic Scribbles and the Diagrams are archetypal. The potential combinations of them are endless, but certain favorites of children also are archetypal. Jacobi (1953) views the child mind as being mainly archetypal.

Another idea of historians and prehistorians is that the art forms to which mankind has attached symbolic meaning are transmitted from adult to adult and from society to society along trade routes. The "migration of symbols" via the "gold route" or the "tin route," or some other route is asserted by Kühn (1956, pp. 167, 169, 180, and 182) and other writers even when symbols are those basic Gestalts which are reborn in the minds of each generation in childhood. Pertinently, Jorge Encisco says that the ancient designs on clay stamps found in the New World were *not* imported from Mediterranean cultures (Encisco, 1963, p. 7).

The archaic work in which one can see the carry-over of the child mind in art often seems to disturb the art historians. The lovely scribblings called "macaroni" are an example, and so are certain Combines and Aggregates which Giedion calls "abstract vulvas" (Giedion, 1962, pp.

Mayan and Peruvian motifs. The Mayan designs are at top. The writings of William R. Coe concerning the glyphs at Tikal in Guatemala and artifacts once displayed at the California Palace of The Legion of Honor in San Francisco are two sources for this art

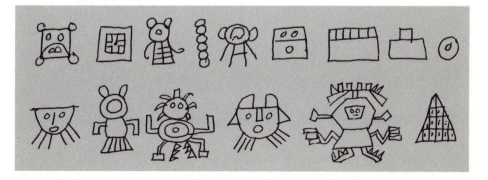

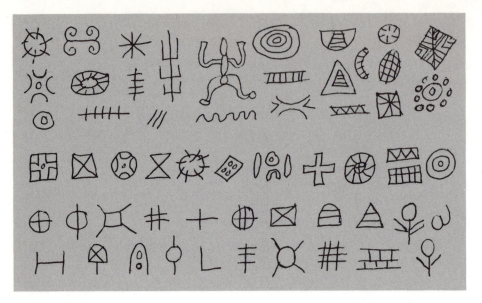

Oceanic motifs. Designs from the islands of the central and southern Pacific Ocean may be seen in Wolff (1948), in writing by M. D. C. Crawford in One World of Fashion *(New York, Fairchild, 1967), and in* Oceanic Art, *by Tibar Bodrogi (Budapest, Corvina, 1959)*

183-191). Aggregates at Altamira, which are "inexplicable" (p. 10) to him, look familiar to me. The "unrealistic" horns on the stags at Lascaux Cave (p. 299) cause an implied circle to fit nicely over the whole animal. The famous impressive "red symbols [at Lascaux] which defy understanding," according to the Abbé Breuil (1952, p. 267), constitute quite a good diagonal cross plus an implied triangle design which goes well with the large hind close by, making a combination of abstract and pic-

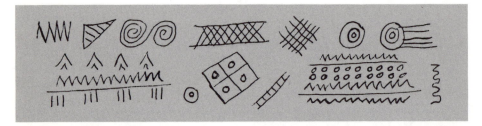

Japanese motifs. Ancient funerary urns in the British Museum include these designs

torial work which has visual unity. A childlike mandala design in the Tassili Frescoes is called by Lajoux (1962, p. 124), "a most enigmatic painting . . . any meaning would be arbitrary."

Scholars' interpretations of archaic art extend to general development as well as specific meaning. Kühn insists that the pictorial work of prehistory preceded the nonpictorial or symbolic stage of art (Kühn, 1956, p. 99). However, Giedion says, "Art, indeed, began with abstractions" (Giedion, 1962, p. 17). Nonpictorial child-art motifs are present in cave art, and I cannot see how they can be considered a post-pictorial development of the adult mind.

Giedion also says, "Abstraction is closely tied up with the creation of symbols" (Giedion, 1962, p. 10). (Kühn thinks that nonpictorial work evolved out of man's religious feelings and his need to get above reality in its awesome nature, a thought similar to Read's idea that art comes

Australian motifs. Aboriginal art of Australia is displayed in the Australian Museum in Sydney, in Die Kunst des fünften Erdteils Australien, *by Andreas and Katharina Lommel (Munich, Staatliche Museum für Volkeskunde, 1959), and in other exhibits and publications*

from "cosmic anxiety.") Giedion believes that art symbols were "invented" by prehistoric man and that they deal largely with his fertility concerns. He and other scholars do not realize that making "symbolic" Gestalts is a capacity of young children, whose minds are not concerned with religion or fecundity. That these Gestalts were used by adults for purposes other than esthetic enjoyment is conjecture.

I do not wish to be disrespectful of scholarship or of anyone's interpretation of art, but I do wish to state that an interpretation based on the child-art motifs found in adults' work is not beyond question. Thorough examination of child art is needed in order to appreciate its significance and the carryover it has in the adult mind. A comprehensive documentation of the Gestalts found in child work and a consideration of the possible bearing they have on the adult art of all times and places would enhance human self-understanding.

Two investigators have raised such a consideration in their intensive study of petroglyphs in the Transvaal. The petroglyphs studied appear

European motifs. The folk art of Europe would yield identical designs, but these line formations represent prehistoric art from the region. Anati (1961) and Kühn (1956) are among the sources that offer reproductions of art work that has lasted for many centuries

Irish motifs. The Royal Irish Academy in Dublin contains examples of such native art

Swedish motifs. Rock carvings exhibited at the Smithsonian Institution showed these forms

Greek motifs. These designs are shown by ancient figurines in the Delphi Museum, Athens

to have been made from 100 to 500 years ago. Of the 244 petroglyphs discovered and copied, 233 are geometrical, and 172 (73.8 per cent) of these include circles (Willcox and Pager, 1967, p. 493). "Many are fairly elaborate compositions of concentric circles with or without 'rays' " (p. 493). Although the investigators noted general similarities, the petroglyphs did not show repetition of specific designs. "This lack of repetition . . . argues strongly against the theory held by some that the non-representational petroglyphs are a form of pictographic or alphabetic writing for, if this were so, more repetition must occur among so

many examples. Moreover, any kind of writing requires orderly arrangement, e.g., in horizontal or vertical lines, and none is to be found at any of the sites" (p. 496).

The presentation by Willcox and Pager is unusually well illustrated. My search for child art motifs in archaic, primitive, traditional, and modern art indicates that they do abound in all places and periods, though they are not well documented in books on art and archaeology. Mention of them is frequent, but illustrations are not often given. Giedion describes the numerous seeming radials in the Altamira caves as "lines radiating from one point" (Giedion, 1962, p. 247), but he shows no illustrations. Ladder crosses and square aggregates (techtiforms) are shown, as is one double mandala (p. 252). Child-art trees are called penniforms and "male symbols." Archaeologists' habits of thought cause them to look for pictorial or symbolic meaning rather than for structures

viewed as esthetic formations. In the light of what is now known about children's art Gestalts, a new look at the evidence is needed.

As for the art of living primitives, Gajdusek, who has long worked in New Guinea, recognizes the universal aspects of art motifs. He says that among primitive peoples there is a "complete group uniformity of symbolic expression in drawing" (Gajdusek, 1964, p. 91). I was able to see

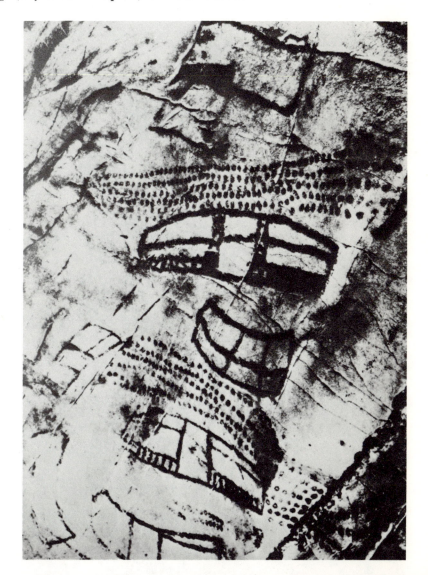

Paleolithic rock paintings from Spain. The shapes are familiar ones in child art: a diagonal cross, at left, and Aggregates of squares, at right (photographs from Musée de l'Homme, Paris)

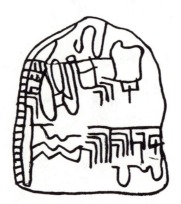

Archaic designs, at left, and similar structures produced by preschool children. Pequart et al. (1927) present such designs by archaic adults

many drawings, done by South Sea children, which Margaret Mead brought to the Museum of Natural History in New York. They had the familiar look of universal child art. In a documentary film of the Congo jungle, there is a scene in which the medicine man invokes rain by drawing a crossed circle on a large rock (Anonymous, 1963). Art and religion can be combined for double satisfactions ... the esthetic one being the primary determinant of the religious symbol.

The artist Miguel Covarrubias has observed that the "motivating force behind all art expression seems to be primarily esthetic and not religious" (Covarrubias, 1954, p. 94), a statement with which I agree. The "new esthetic look" that vitalizes the contemporary art of Klee and others he claims comes from a rediscovery of primitive art. This source is, I believe, a secondary one, the primary one being child art.

A few adults have noted some of the similarities to be seen in child art, primitive art, and archaic art, but no satisfactory explanation has been offered for these coincidences. Authorities in archaeology and an-thropology have shown little interest in comparing child art with adult art. Margaret Mead says that "art comes from art," meaning that each generation learns art from its elders. It is assumed that study of the art and artifacts of our ancestors can give us insight into the minds of our ancestors as adults, not as children. There is little awareness of the effect that archaic man's child art could have had on his adult art, yet it is doubtful that any adult could eliminate child-art images entirely from his mind. Possibly in some areas these images were held in higher es-teem by adults than they have been by modern man, although some modern artists have revived definite child-art motifs for use in serious adult work. Though Read says that these modern artists are getting back to the eternal source material of all art, he may not realize how much the contemporary painters draw upon motifs known to them through their own art activities in childhood.

Despite recent use of child-art motifs, modern art historians, like other scholars, are far from recognizing the possible significance of child art as a guide to human self-understanding. To interpret archaic or primi-tive man's mind through his art in terms of modern man's attitudes to-ward art is to make a serious error. Certain connections between adult

art and child art should be studied systematically. Child art has never been and can never be completely absent from a culture because it is "biological art," or art natural to the species. It is not wise to assume that archaic man could not enjoy both child art and adult art, as certain modern artists do. If archaic man held child-art motifs in high esteem, then art works in the caves which are pure child-art Gestalts need not be called "mysterious" and "numinous." Cave artists may have had no

more hesitation over combining pictorial and nonpictorial material than do a number of modern artists. It could even be that archaic man was often satisfied with art no more highly developed than that of a young child. How can we know?

What bothers me about modern man's interpretation of archaic art is that it is so full of projected sexual and religious meanings, rather than concern for esthetic compositions per se. Is it possible to know from his art the thoughts of prehistoric man other than his graphic ideas? Is it rational to project contemporary man's mentality onto archaic art without regard to the comparative study of art as form?

Kühn writes of the "very ancient symbols that man has used from most remote ages" (Kühn, 1956, p. 155). From what we now know about child art we can say that these ancient symbols were renewed by each generation of children. The symbols of art are ancient because the co-ordinations of eye, hand, and brain which first produce them are as ancient as the human race.

Excavation in sand, prepared for the placing of driftwood in a cross arrangement, done by boys in Israel

Letters designed by an African chief in 1904 as a first attempt at an alphabet for his language. Many of these letters were discarded in his final choice of letters. More than 140 of these symbols occur in child art. (Illustration from L'écriture des Bamum, *by I. Dugast and M. D. W. Jeffreys; Cameroons, L'Institut Français D'Afrique Noire, 1950)*

16. Theories Concerning Children's Art

John Dewey wrote, "A very humble experience is capable of generating and carrying any amount of theory (or intellectual content), but a theory apart from experience cannot be grasped even as a theory" (Dewey, 1916, p. 169). He stated that "An ounce of experience is better than a ton of theory simply because it is only in experience that any theory has vital and verifiable significance. . . . Because of our education, we use words, thinking they are ideas, to dispose of questions, the disposal being in reality simply an obscuring of perception as prevents us from seeing any longer the difficulty" (p. 169).

Many theories about art are based on ounces of experience, and some theories seem to me to be based on virtually no experience. Words in these theories are used to obscure perceptions rather than to present verifiable ideas. In particular, theories about child art often are developed by individuals who did not directly study large quantities of art made by many children.

In the previous chapter I described theories about mankind's social and cultural development as reflected in art, and in the next chapter I take up the subject of child art as evidence of basic human capabilities. All theories about art can be discussed in relation to child art, and so in this chapter I discuss some influential theories about esthetics and the psychology of art in light of my own experience.

A basic question in art education is: What part does esthetics play in the feeling life of the child? Theories about art imply two sorts of

answers. Some theories separate esthetics from all other factors in the making and viewing of art, and these theories give esthetics a special, independent place in human feelings. Other theories treat esthetics as subservient to factors such as sexual conflicts. In these theories, esthetics provides a guide to feelings from sources other than art.

Roger Fry assigns a primary place to esthetics. He says, "The form of a work of art has meaning of its own and the contemplation of the form in and for itself gives rise in some people to a special emotion which does not depend upon the association of the form with anything else whatever" (Fry, 1962, p. 8). Fry also states, "The esthetic emotion is an emotion about form" (p. 9).

Fry takes pains to separate esthetic values from all others. He describes the effects of formal design:

> Now since very few people are so constituted by nature or training as to have developed the special feeling about formal design, and since everyone has accumulated a vast mass of feeling about all sorts of objects, persons, and ideas, for the greater part of mankind the associated emotions of a work of art are far stronger than the purely esthetic ones.
>
> So far does this go that they hardly notice the form, but pass at once into the world of associated emotions which that form calls up in them. [Fry, 1962, p. 8.]°

Fry also treats the relation between formal design and pictorialism in evaluations of works of art. His treatment is succinct and clear, and it deserves extended quotation:

> It so happens that these systems of formal relations, the meaning of which is apprehended by a comparatively few people in each generation, have a curious vitality and longevity, whereas those works in which appeal is made chiefly to the associated ideas of images rarely survive the generation for whose pleasure they were made. This may be because the emotions about objects change more rapidly than the emotions about form. But whatever the reason, the result is that the accumulated and inherited artistic treasure of mankind is made up almost entirely of those works in which formal design is the predominant consideration. [Fry, 1962, p. 9.]°

°By permission of the *Bulletin of Art Therapy.*

It is, of course, perfectly natural that people should always be looking for symbolism in works of art. Since most people are unable to perceive the meaning of purely formal relations, are unable to derive from them the profound satisfaction that the creator and those that understand him feel, they always look for some meaning that can be attached to the values of actual life; they always hope to translate a work of art into terms of *ideas* with which they are familiar. None the less, in proportion as an artist is pure he is opposed to all symbolism. [Fry, 1962, p. 14.]°

The relationship between formal design and pictorialism extends to the reaction of the individual viewer in front of a particular work of art:

And here let me allude to a curious phenomenon which I have frequently noticed, that even though at the first shock of a great pictorial design the subject appears to have a great deal to do with one's emotional reaction, that part of one's feeling evaporates very quickly; one soon exhausts the feelings connected by associated ideas with the figures, and what remains, what never grows less nor evaporates, are the feelings dependent on the purely formal relations. This indeed may be the explanation of that curious fact that I alluded to, the persistence throughout the ages of works in which formal perfection is attained, and the rapid disappearance and neglect which is the fate of works that make their chief appeal through the associated ideas of the images. [Fry, 1962, p. 15.]°

My observations of child art lend support to Fry and to other theorists who believe that the forms of art have sources and emotional effects of their own. In child art, the sequence of line formations appears independent of any pictorial associations, and Fry's statements seem to me a perfect description of the reaction of all young children to their own scribblings. It is an esthetic one. Fry traces the source of the reaction. He says that the pleasure derived from "recognition of order, of inevitability in relations," that is, of "pure beauty," may "get its force from arousing some very deep, very vague and immensely generalized reminiscences. It looks as though art had got access to the substratum of all the particular and specialized emotions of actual life" (Fry, 1962, p. 17). Other writers on art also have suggested that mysterious "reminiscences"

°By permission of the *Bulletin of Art Therapy.*

control the creative artist. My experience with child art leads me to believe that these reminiscences actually are esthetic patterns established by scribbling in childhood.

The search for the ultimate sources and effects of art may bypass esthetics and reach into the fields of anthropology, archaeology, or psychology, especially the psychology of early childhood. Before considering other theories in which esthetics is primary, I wish to describe some views in which it occupies a less important place.

Both Freudian and Jungian psychologists believe esthetic emotions to be secondary rather than primary. Freud and Freudian writers on art consider art to be the servant of wishes and conflicts that are basically

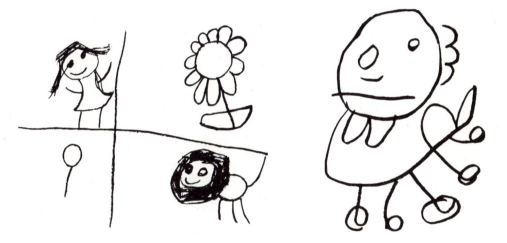

Gestalts with related structures. Despite the many different labels that might be given to these drawings—including labels that express Freudian beliefs—the drawings all possess distinct similarities of line and shape. In the same way, the other illustrations in this chapter may be viewed as manifestations of the sex drive, the collective unconscious, self-assertion, pictorial anecdote, etc. Or they may be viewed as products of the esthetic nature of the child, and the interrelations among the forms may be stressed. The evidence in this book supports the latter view, and connects the pictorial elements in child art with the abstract forms commonly made by young children throughout the world, including the forms above (four years)

sexual. Jungians hold that art expresses emotions arising from the arche-types of the collective unconscious on one level and personal emotions on another level. For example, Read, as a follower of Jung, views the child's art as an expression of both the *personal* unconscious conflicts and *collective* unconscious conflicts. Esthetics per se has not been a concern of Read in relation to child art. He says that modern adult artists who "begin with basic scribbles" are not childish; instead they "extract from the primordial confusion an archetypal form" (Read, 1960a, p. 115). It seems to me that the primordial confusion of children's scribblings is overcome by the child at about age three as he progresses in art, and that the adult who uses the Scribbles like a child may be either childlike or childish, depending on how he uses them.

The terms "personal unconscious" and "collective unconscious" must be understood to be meaningful in relation to child art.

Jung describes the collective unconscious as the timeless experiences of the human race. They are transmitted to individuals through arche-types; that is, through symbols of the various kinds of universal human experience. Each person, therefore, is more than the total of his own life's history. Each person also has unconscious attitudes, knowledge, fears, and creative capacities that are universally human. Jung denies the ego as the center of one's total being. He calls this the Self. The Self includes individual consciousness, which is personal, and individual un-consciousness, which has both personal and collective aspects.

The deep layers of the mind that Read refers to as the wellspring of art make up Jung's collective unconsciousness, which, Jung says, "can only be reached and expressed by the symbol" (Jung and Wilhelm, 1932, p. 105). Symbols are the mediators between the conscious and the un-conscious. Referring to the paleolithic sunwheel discovered in Rhodesia, he says, "Things reaching so far back in human history naturally touch upon the deepest layers of the unconscious and make it possible to grasp the latter, where conscious speech shows itself to be quite impotent" (p. 105). The mandala exists a priori as an archetype that is inherent in the unconscious and therefore has no part in the coming into being and passing away of the individual.

I had the opportunity to visit Jung in 1954. He told me then that the

Mandalas which children draw at age three are to be explained as inborn images which appear at various times in consciousness. I would now say that children's Mandalas might also be explained as images that each individual develops through scribbling experiences.

Children's Mandalas do not have religious significance, so far as I can ascertain. I believe that the adult has found the Mandala image to be an easy one to use for magical or spiritual purposes because it is a balanced esthetic form and because its origin in personal life goes back to an age when little that happened is remembered by the conscious mind. But the unconscious mind forgets nothing, we are informed. The Mandala plays a part in the early scribbling experiences of the individual, experiences which are likely to be repressed because of adults' denigrating estimate of them. If all individuals have similar experiences with the Mandala, then it may rightly be called an image of the collective unconscious. In the same way all the basic forms of art may be called archetypal. I see no more mystery in the making of Mandalas than in the making of Basic Scribbles: that the human being is predisposed to the making of Mandalas is, at least, no more of a mystery than many other aspects of human biology. As Fiedler has phrased the thought, "Art is no more extraordinary than other important human performances" (Fiedler, 1949, p. 62).

The Mandalas that children make have been seen by all of the investigators who have studied drawings, but these line formations have not been considered enough by men who have developed significant theories of child psychology. The various theoretical psychologies of childhood have come from intensive observations of children in highly artificial settings. The famous experiments set up by Jean Piaget offer children only one chance to reveal their mental processes. Though such research has its uses, the results are not fully satisfactory. More observation of commonplace behavior is needed.

Two writers who take a Freudian view of art are Anton Ehrenzweig and Ernst Kris. Ehrenzweig says that every work of art has its simultaneous appeal both to the unconscious mind and the conscious mind. Gestalt visions, he claims, is "thing" perception and is agreeable to the conscious mind. Thing-art makes "good" Gestalts which the brain has

learned to organize. Great art has not only the good Gestalts of things, but also has "hidden forms." The latter are seen only by the "depth mind," or the "unconscious mind," which has "preserved its infantile technique of perception" (Ehrenzweig, 1965, p. 31). The good Gestalt is the approved esthetic Gestalt, according to Ehrenzweig, but the hidden abstract forms of art are not really esthetic, but sexual. These hidden forms are the abstract patterns which underly the organization of thing-Gestalts, although they themselves are not the primary forms of esthetics, he claims. Instead, these abstract patterns, which can be seen only by the depth mind, are "pan-genital." Modern art, however, is now making it possible for us to see esthetic abstract forms which the conscious mind can enjoy and which no longer have primarily pan-genital significance.

As for the child, Ehrenzweig thinks he has no esthetic awareness until age five, at which time he gives up drawing the pan-genital geometric forms and the "libidinous scribblings" (Ehrenzweig, 1965, p. 178). This is the time of the Oedipal conflict (p. 169) when the child leaves the "sublimity and grace of childhood" (p. 67). Only then is he ready to develop the perception by which he sees esthetic thing-Gestalts.

It is worth our noting that only males have an Oedipus conflict. The female's Electra conflict is something quite different. Yet the scribblings of young male and female children show no differences, in my experience. From ages five to seven boys and girls draw certain subjects in somewhat different quantitites—planes and boats are more popular with boys, and humans are drawn more often by girls—but before age five work is the same for both sexes.

My experience of child art conflicts with Ehrenzweig's theory that the scribblings and structures drawn by young children are pan-genital symbols and that their appeal to the child lies in their sexual symbolism. Ehrenzweig arrives at this conclusion through Freudian theory. "I follow Freud in assuming that the esthetic pleasure transmuted a sexual (visual or acoustic) voyeurism" (Ehrenzweig, 1965, p. 258). "Man neutralized his sexual urges and guilts with esthetics" (p. 257).

Read says that Ehrenzweig "can imagine a 'pan-genital crisis when the maddened voyeur libido was deprived through the erect human gait

of the sight of the female genitals and projected a pan-genital significance into any object of the external world.' At that stage all forms acquired a sexual significance and the new esthetic principle was evolved as a kind of fig-leaf. All works of art are but species of fig leaves" (Read, 1960b, p. 91). Ehrenzweig recognizes that abstract art ante-dates pictorial art in the history of the individual and that of the human race, and that pictorial work contains hidden abstract patterns. I pre-sume that what Ehrenzweig sees as hidden Gestalts are the implied shapes and patterns of child art. It is true that they are hidden in the sense that they are not recognized by most persons, even by critics, but it is pure theory to say that the hidden Gestalts are pan-genital.

Ernst Kris says that art is primarily communication between the art-ist's id and his ego (Kris, 1962, p. 61). Art enables one to project an inner image into the outside work (p. 115) under the "protection of the es-thetic illusion" (p. 63). Kris says, "Esthetic creation is aimed at an audience: only that self-expression is esthetic which is communicated (or communicable) to others . . . what is made common to artist and au-dience is the esthetic experience itself, not a pre-existent content" (p. 254). He adds, ". . . esthetic communication requires as well, a sharing of *psychic level* between artist and viewer" (p. 255).

As for the inspired work of art, Kris says that the idea that the artist is inspired by some source outside himself not only relieves the artist of the burden of responsibility for what he communicates, but also gives the content of his work a truth which stems from an authority higher than the artist (Kris, 1962, p. 294). To be inspired in art the artist must be able to have the experience of passive receptiveness and self-regula-ted regression, and the most daring intellectual activity is needed in the creative process.

Kris says that "the graphic art of the child is to a great extent con-trolled by the primary process" (Kris, 1962, p. 178). Freud's use of the term "primary process" refers to primary energy "ready for immediate discharge" (p. 27). The adult artist, according to Kris, is able, through projecting his experiences into art, to retrieve "lost objects," a technical term which means the state of bliss of early infancy which Freud predi-cated in his writings.

(Three years)

(Three years)

(Four years)

It seems to me that the inspired artist actually utilizes childhood's self-taught esthetic forms and releases energy for art similar to that released in childhood. He does this with controls learned through great discipline, acquired with age and practice. The artist's "self-regulated regression" returns to scribblings but is not truly regressive if the purpose of the return is the utilization of scribblings' esthetic essence in an adult manner. The Scribbles and the prepictorials of child art are the *prima materia* of all art. The use to which they are put is determined by the emotional and artistic maturity of the user. Every individual possesses the images of child art, but only the artist uses them consciously and with discipline, bringing them to life as the formal aspects of his work with paint, pen, or other materials.

To conclude this discussion of Freudian and Jungian theories as they pertain to art, let me again quote Read, who says that mandalas are images of wholeness and integration, "inducing contemplation and selfless meditation" (Read, 1960b, p. 197); that the greatest works of art are images or myths of reconciliation; and that we contemplate art in order to be reconciled with ourselves and the absurdity of existence. I would like to amplify his thoughts as follows: mandalas are images of perfect balance and coherent structure; they can be enjoyed by all as esthetic experience, regardless of one's subjective state of emotion; great works of art tend to have a balanced structure that contains the four directional lines of movement found in the mandala; the esthetic experiences of art help us to eliminate from awareness some of the meaningless and unorganized visual and mental stimuli of our daily lives. Art therefore is a visual necessity for achieving mental stability.

Otto Rank is another psychoanalyst greatly interested in art. He claimed that Freud's explanation of guilt as a reaction to one's sexual will was too limited. Rank said that guilt comes from the individual's will to independence and self-reliance, which cannot be openly expressed. "The neurotic type, which we all represent to a certain extent, suffers from the fact that he cannot accept himself, cannot endure himself and will have it otherwise" (Rank, 1945, p. 275). "The creative type must constantly make good his continuous will expression and will accomplishment and he pays for this guilt toward others and himself

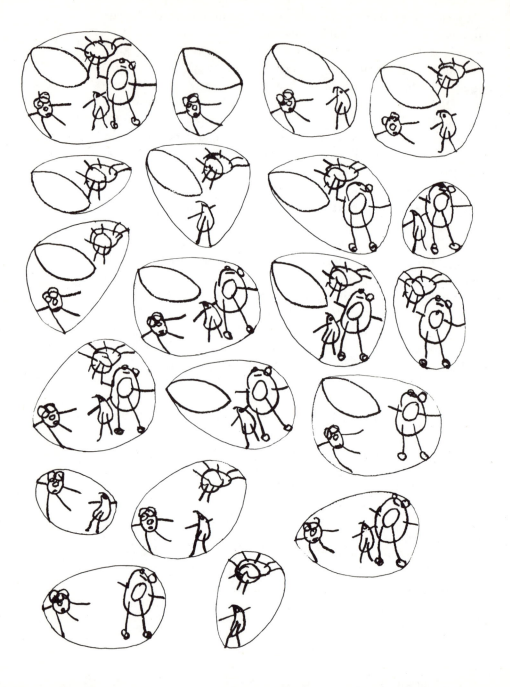

(Four years)

The drawing above consists of a Diagram, a Sun, and three
Humans with arms from the head. As a report of reality,
the drawing is distorted. As a line formation, however, the
drawing yields a rich variety of shapes that seem pleasing.
The total drawing implies an oval that falls into Placement
Patterns 2 (centered) and 9 (diagonal axis). When divided
by a Greek cross or a diagonal cross, the drawing shows even
top-bottom balance and a slight left-right imbalance. The
five parts of the drawing imply interesting shapes when the
parts are viewed in combinations, as on the facing page

with work which he gives to the others and which justifies him to himself" (p. 275). The artist is productive and accomplishes something because he has real guilt to pay for. Guilt of creative accomplishment of will makes one truly guilty, but not like the neurotic who acts guilty, knowing he has denied his own will.

Rank treats art activity not as a sublimation of sexuality, as did Freud, but rather as the full assertion of one's creativity. The artist's true guilt is his assertion of "the individual will over the will of the species represented by sexuality" (Rank, 1945, p. 276). "Creativity is not something which happens but once, it is the constant continuing expression of the individual will accomplishment, by means of which the individual seeks to overcome self-creatively the biological compulsion of the sexual instinct and the psychological compulsion to emotional surrender" (p. 276). Rank's idea that the creativity of the artist is an assertion of the individual will applies to childhood, for the art of children often causes conflicts with adult will. However, the activity of child art that I have observed is self-satisfying and noncompetitive. The individual child does not strive to distinguish himself through art or to master some sexual drive, so far as I can tell. Though Rank has good insights into childhood, he expresses no awareness that art begins in that period of life.

Many other theorists who see art as a product of nonartistic factors, including sex, social status, and religious feeling, might be noted. In general, their structures of thought do not agree with my experience of child art, and some of them present ideas that appear entirely fanciful. Let me turn, then, to several writers on art who think of forms as forms. A few quotations from each must suffice. Ernst Cassirer notes that art is "a realm not of living things but living forms. . . . In such absorption in the dynamic aspects of form consists the esthetic experience" (Cassirer, 1954, p. 194).

Clive Bell says, "To use art as a means to the emotions of life is to use a telescope for reading the news" (Bell, 1958, p. 29). As for pictorialism, he describes the artist at work: ". . . in a moment of aesthetic vision he sees objects not as a means [to art] shrouded in association, but as pure forms" (p. 45). For Bell, the viewer of art has a corresponding reaction: ". . . forms arranged and combined according to certain unknown and

(Five years)

(Five years)

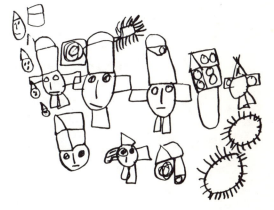

(Five years)

mysterious laws do move us in a particular way" (p. 19). The process of child art seems to me to explain the "unknown and mysterious laws," but Bell's insistence on the importance of form could be substantiated by the thousands of drawings in my collection.

Henry Focillon says that form signifies only itself and that "form is tortured to fit a meaning" (Focillon, 1942, p. 13). Forms "obey their own rules—rules that are inherent in the forms themselves, or better, in the regions of the mind where they are located and centered" (p. 10). "Form is never the catch-as-catch-can garment of subject matter" (p. 4). "The power of formal order alone authorizes the ease and spontaneity of creation" (p. 14). I think that these quotations are applicable to the life of forms in child art, and that the child's spontaneity in art is due to his inherent (archetypal) knowledge of basic forms and formal order, which his scribbling activity develops and demonstrates.

Focillon also states that the ". . . logic of the eye, with its need for balance and symmetry is not necessarily in agreement with the logic of structure" (Focillon, 1942, p. 9). "Do not these forms that live in space and in matter live first in the mind?" he asks (p. 9). In other words, do we not see only that which the mind can grasp and organize when light stimulates the retina? The artist's "vision is from within the forms, so to speak, and from within himself" (p. 2). Focillon's view of art allows a place for the work of children.

Alexander Dorner believes that form is a separate esthetic factor only for a certain period of art. Earlier, form was linked with magic and religion, and currently form must be regarded as a by-product of the dynamics of art. He writes of the evolution of art in the changing world of man's intellectual development, of the "transformation of the human mind and its concept of reality" (Dorner, 1958, p. 34). There was a period in human history when the "mental processes of the mind are confined to sensory experience, and so are its desires and creations" (p. 41). The mode of thought of this period Dorner calls the "magical."

Examples of images of the magical era are shown. The "primitive fertility signs" on pottery of 4000 B.C. which he shows (p. 48) are mandalas.

He says that the design illustrated is a "diagram of the reality created by

the later magical mind together with organized agriculture" (p. 49), and the other symbol is the diagram of the "birth of Western rational think-

ing and its vision of a three-dimensional world" (p. 56). "What we call *Art* had its origin in the rational world" (p. 62). The medieval mind de-

veloped the radial image to represent a "more spiritual vision of a unifying principle" (p. 69). Belief in the rational principle of absolute space was a form of religious activity (p. 74). The "static life principle, symbolized by space" had to "abdicate in favor of its arch-enemy, transforming energy" (p. 84). Dorner says that both art and religion split because they lost the meaning of One Truth through the mind's destruction of the idea that space is fixed (p. 101).

For Dorner, the conception of form has now been transcended by the dynamics of energy. "Both form and space have become superficial by-products" in art, for "what appeared formerly as ultimate depth [perspective] appears shallow to the contemporary mind" (Dorner, 1958, p. 113). "What now holds the world together is no longer the rigid framework of space represented by static material points, but the interpenetrative force of energetic waves, force which results in self-transformation" (p. 119).

Dorner's belief that art exists as "mutual transformations of works of art and observers" (Dorner, 1958, p. 141) is supported by the developmental sequence of child art, although the interplay of hand, eye, and brain in child art is certainly not a recent development. Dorner's drawings of the diagrammatic symbols that represent to him the stages of the evolution of art consciousness are symbols which preschool children make, and the sequential order of the symbols is the same as that in which children commonly make them. His view that form and space in

art are records of evolving, self-transforming visual and mental experience seems to me a meaningful approach in terms of the development of child art.

Claude Lévi-Strauss believes that form operates in conjunction with pictorialism: "The painter is always mid-way between design and anecdote, and his genius consists in uniting internal and external knowledge, a 'being' and a 'becoming,' in producing with his brush an object which does not exist as such and which he is nevertheless able to create on his canvas. This is a nicely balanced synthesis of one or more artificial and natural structures and one or more natural and social events. The esthetic emotion is the result of this union between the structural order and the order of events, which is brought about within a thing created by man and so, also in effect by the observer who discovers the possibility of such a union through the work of art" (Lévi-Strauss, 1966, p. 25).

In relation to child art, Lévi-Strauss would find evidence for his view in early pictorialism. However, the preceding stages of child art, in

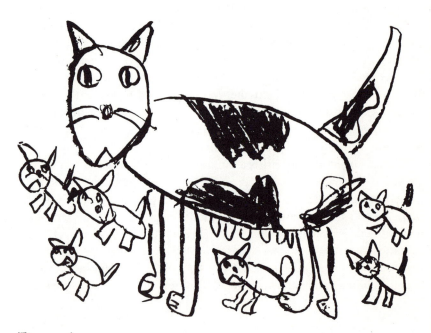

(Five years)

which Diagrams, Combines, and Aggregates appear, do not include any "natural or social events" that I can discern. The early drawings of children show form with no admixture of external knowledge.

For theorists who separate form from nonesthetic factors—whether form is viewed as a characteristic of works of art in themselves or as a component of the interaction between the artist or the viewer and art—the source of form may inhere in individuals. Florence Cane writes, "In my many years of work with children of all ages, I have become firmly convinced that the sense of design as well as the sense of form are innate" (Cane, 1951). She had success with adult artists who had become stymied in their work. She requested the artists to go back to scribbling to see what forms and ideas emerged.

Earlier spokesmen for this viewpoint were Gustaf Britsch and Franz Cizek. The latter was fondest of work of two- and three-year-olds, though few of his pupils were so young. He said, "Child art is an art which only the child can produce. There is something that the child can

(Seven years)

(Five years)

(Five years)

also perform, but that we do not call art. It is imitation, it is artificial. The child is born with creative power, but at a certain age this power begins to decline. Either mannerism or naturalism appears as a substitute for creative power . . . man begins to take nature as a criteria for his art . . . he begins to confuse art with nature. Instead of creating, the copying of nature begins" (in Viola, 1936, p. 24).

In his book on child art, R. R. Tomlinson said, "From the very beginning the child's work is inspired by a naturally ordered feeling" (Tomlinson, 1942, p. 14).

That the art of scribbling is not directly treated by many writers on art is due to their lack of familiarity with children's work and to their customary ideas about adult art. Like archaeologists, anthropologists, and art historians, writers on art theory are not used to taking child art seriously. In part, this lack of concern for child art may be traced to general attitudes toward scribbling and toward childhood. I described these attitudes in Chapter 8, but two other descriptions are worth quoting here. W. H. Missildine says: "Our traditional cultural view belittles childhood and everything about it. We tend to continue and to repeat, parrot-like, attitudes toward children—even our own—which are derogatory, belittling and the basis for later self-contempt" (Missildine, 1963, p. 33).

Bert Beverly writes, "Society, from the parents in the home, to the broadest social concepts, is made by and for adults. The child, as a child, in this scheme of living is entirely disregarded. He is expected to understand, appraise, and adjust himself to adult standards as an adult would" (Beverly, 1957, p. 34). Adults do not scribble, and most adults do not function at all in art; therefore, the child has difficulty taking seriously his artistic self-education.

The evidence of child art has been used to support diverse and conflicting theories. My experience of examining the line formations in hundreds of thousands of drawings made by young children causes me to favor theories that see esthetics as a separate study, with its basis in the biology of mankind. The child-art record connects many viewpoints, and the study of art in general would benefit if scholars gave systematic attention to the works of children.

17. The Meaning of Children's Art

What does a work of art mean? Aside from its possible pictorial significance—its representation of external reality—an art object's meaning often is said to be arbitrary. The object is said to mean whatever the viewer thinks it means, and its value depends on the viewer's judgment. Curt Ducasse says, "The critics' evaluations, then, ultimately are just as purely matters of his individual taste as are those of the unsophisticated amateur. The great difference, even when both of them have the same tastes, is . . . that the naive amateur is pleased and displeased without knowing exactly why, whereas the critic does know what specific features are responsible for his own pleasure or displeasure in a given work of art" (Ducasse, 1948, p. 120).

Pictorial meaning too may be judged differently by different individuals. For example, the symbol designed for Expo, Canada's 1967 world's fair, became controversial:

> The official symbol of Expo, which consists of eight pairs of male-like matchstick figures standing in a circle with their arms in the air, caused a great uproar. One psychiatrist charged that the symbol had definite "homosexual overtones." Tory leader John Diefenbaker inveighed against the symbol in Parliament.
>
> "Nonsense," replied the Government. "Two of these graphic designs . . . linked together symbolize brotherhood and friendship. Eight of these designs joined together to encircle the earth portray the happy dance of mankind . . ." [*National Observer*, January 30, 1967, p. 1.]

Expo's symbol

My reaction to the symbol is that its figures are more like the Trees than the Humans of child art. However, *The Book of Signs* says that the parts of this mandala mean, "Apart from family life there is friendship between men" (Koch, 1930, p. 10).

Even when there is no controversy about the pictorial meaning of an art object, the object's form will produce a variety of reactions and judgments. At least, the statements of reactions will vary. Individual responses to an art object are hard to compare because they cannot be stated directly. Clement Greenberg describes the difficulty:

> Because esthetic judgments are immediate, intuitive, undeliberate, and involuntary, they leave no room for the conscious application of standards, criteria, rules, or precepts. That qualitative principles or norms are there somewhere, in subliminal operation, is certain; otherwise esthetic judgments would be purely subjective, and that they are not is shown by the fact that the verdicts of those who care most about art and pay it the most attention converge over the course of time to form a consensus. Yet these objective qualitative principles, such as they are, remain hidden from discursive consciousness: they cannot be defined or exhibited. [Greenberg, 1967, p. 38.]

The difficulty of stating individual reactions may be traced to the nonpictorial aspects of an art object, as indicated by the quotations from Roger Fry in Chapter 16. Ducasse makes the point succinctly: ". . . the particular feelings that designs express cannot be expressed otherwise than by them" (Ducasse, 1948, p. 55).

Although the meaning of any one art object is hard to state and is open to controversy, the meaning of art objects in general does lend itself to analysis. The early chapters of this book provide such an analysis. By itself, a single drawing of a Mandala has little significance, but in the context of hundreds of thousands of drawings, the Mandala gains meaning. As a line formation, it exhibits likenesses and differences in relation to other line formations. As the product of a child of a certain age, it is unusual or commonplace in relation to the ages at which other Mandalas are made. Because the various line formations identified in my analysis tend to be made at different ages, the Mandala also can be seen

A balanced line formation of concentric ovals resting on a base of concentric rectangles (four years)

as unusual or commonplace in relation to the entire sequence of the art of children.

The classification of hundreds of thousands of drawings by line formation and by the age and name of the artist points to further meanings. What accounts for the prevalence of shapes in spontaneous child art? Why do the various line formations tend to be made in a certain sequence? My analysis supports the belief that the human eye and brain are predisposed to see over-all shapes, that this predisposition operates during the interplay of hand and eye in scribbling, that the child makes shapes with increasing purpose and clarity as he grows, and that he favors shapes that are balanced. In addition, the child's early pictorial work is strongly influenced by his previous scribbling, so that his drawings of Humans, Animals, Buildings, Vegetation, and Transportation items reflect the Diagrams, Combines, Aggregates, Mandalas, Suns, and Radials that he has made before. (Appendix A gives other continuities.)

Pictorial and nonpictorial elements combined to yield the over-all coverage of Placement Pattern 1. The house and the tree both touch the hair of the standing figure, implying an arch that, by itself, would fill Pattern 13. A Gestalt of uncertain identity fills the left part of the page, and nonpictorial scribbling is at right. Many of the shapes and arrangements of line in the drawing testify to the strong and continuing influence of early scribbling by the child (five years)

Pictorial and nonpictorial elements in Placement Pattern 1, as above. Here, the smaller parts form an L-shape around the big Aggregate (five years)

Just as my classifications point to a visually logical system in the child's development, so this system points to still other meanings, ones that go beyond the preschool classroom. What is the relation of the child's self-taught art to adult art and adult expectations? How does self-taught art compare with the art demanded in mental tests? How does it compare with the art of archaic or remote adults? What implications does it have for theories of esthetics and the psychology of art? The meanings of child art suggested by these questions have been explored briefly in previous chapters. Now I would like to go even further and talk about the meanings of child art in terms of the basic human capabilities that such art reveals.

In Chapter 1, I raised the question of whether motor pleasure or visual pleasure is primary in early scribbling, and I concluded that visual pleasure is, at least, essential. Because my analysis has treated the visual aspects of children's art, I have said very little about the motions that children make when they handle art materials. Yet the line formations in child art are the result of motion, and my analysis has implications for the study of motor activity. It is notable that Paul Klee believes movement is the essence of art: "A certain fire of becoming flares up; it is conducted through the hand, flows to the picture surface and there bursts into a spark, closing the circle whence it came, back to the eye and further back to a center of movement, of volition, of the idea. . . . The pictorial work springs from movement, it is itself fixated movement, and it is apprehended by [eye] movement" (in Read, 1960b, p. 160).

Children seem to thrive by making movements which to the adult appear to have no purpose other than pleasure. The movements of the child's body which produce an art work certainly are not made merely for the joy of movement. In fact, these movements aid in the coordination of moving and seeing. They also aid survival. To show that the movements which produce art are also of survival character, I need to outline some of the ways in which moving and seeing are related.

The infant's eye muscles produce vertical, horizontal, and diagonal movements for covering the area in which his eyes try to focus. Unless his head is able to move, that area is limited to one which his eyes can see owing to the movement produced by his eye muscles. The newborn

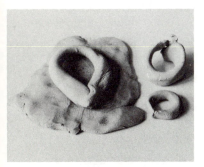
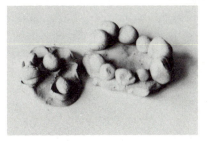

Shapes in clay. The child's motions in rolling, rounding, or twisting clay are evident in these shapes (four years)

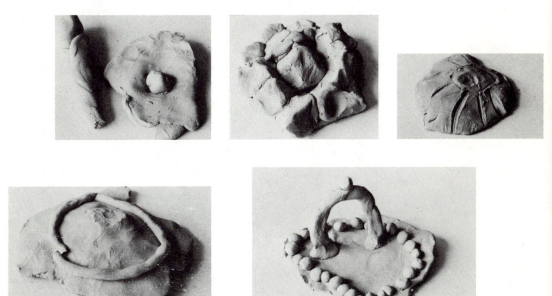

child is not capable of turning his head very freely, and when his eyes begin to focus, what they see by their up-and-down and back-and-forth movements is necessarily limited. When his head is motionless, the area seen presumably is limited to a circular field. When his head shifts position, a new area becomes the field of vision, limited again to the area which his eye movements can encompass. There is center and peripheral vision for each area. The movements of the head and the eyes thus produce a series of areas which the mind must organize. The focused or "sharp" eye moves rapidly up and down, left and right, and diagonally to organize each area. As the child learns to crawl and to walk, his survival depends upon his development of a sharp eye, unless, as in the case of a child who is blind or mentally deficient, someone else's eyes do the seeing for him.

Children in an art class held at the Phoebe A. Hearst Preschool Learning Center of the Golden Gate Kindergarten Association. No fee is charged, attendance is entirely voluntary, and children may come when they please

As the child develops his ability to walk, he deliberately moves his body, and these movements are greatly influenced by his eye movements. To bend, to lie down, to stand, or to walk, the child must use his eyes to relay stimuli to the brain, which controls the impulses that result in coordinated movement.

When the hand moves to make the scribbling gestures characteristic of early childhood, a record of the hand's movements is left on some surface, be it earth, stone, paper, or whatever. This record consists of images that can be variously described. They can be defined and classified as line formations—the approach used in this book—or as products of the movement of the child's hand and eye in vertical, horizontal, diagonal, or circular directions. As I suggested in Chapter 2, a movie camera might be used to yield a complete record of the child's hand-eye coordination and of the successive line formations he makes on a single surface. The camera could yield a record of the child's body movements, too, for as he draws he can assume vertical or horizontal postures, or he can lean or turn, and his arms and legs can flex, extend, or rotate—or make combinations of these movements.

What mental association exists between the flow of lines on a surface and the movements of the body I do not know, but I suspect that there is one. Adults, after all, commonly interpret vertical lines as "standing," diagonal lines as "leaning," and horizontal lines as "lying down." Art Gestalts seem to have physiological effects on us and seem to enable us to feel movement, even though our bodies are motionless.

Perhaps scribbling gives the child a sense of body movement that he can enjoy fully because it is "safe" in comparison with the images that he must absorb to move with safety. That is, the child can scribble directional movements with a satisfying vigor far more safely than he can move his whole body. Restricting children's movements represents a deep frustration to them, as all parents and teachers know. One of the problems of supervising children is finding safe movement outlets for their waking hours. Child art appears to allow the mind to move freely while the body remains safe in restricted movements.

The movements that produce child art may also be enjoyable because they have the characteristics of rhythm and balance observable in the

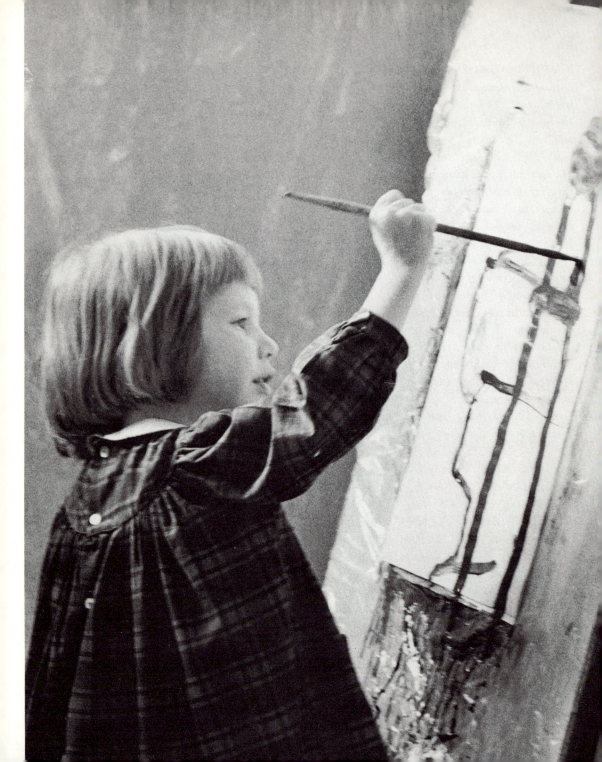

drawings themselves. The child's hand, arm, and body may move vigorously and yet with pleasant regularity. Thus the child's esthetic vision may have a counterpart in esthetic movement. Werner Wolff commented: "If aesthetics is related to rhythm and proportion, children's drawings should show a high degree of aesthetic value, because their measurements reveal a very high sense of proportion and symmetry. If aesthetics is related to a selection and configuration of expressive elements, again children's drawings should rate very high in aesthetic value" (Wolff, 1947, p. 252). I believe that the esthetic characteristics mentioned by Wolff might also be found in the children's movements as they draw. Children respond naturally to music and dance. Their movements in the graphic arts may be similar, though more restricted.

The relation between motor activity and children's drawings also is described by W. Grozinger. As mentioned in Chapter 14, he speaks of "symrhythmical" art (Grozinger, 1955, p. 113), and he states that the bilateral drawings made by children are an expression of basic aspects of feeling, rather than signs of abnormality. Grozinger's investigation leads him to stress the interconnections between the motor and sensory activities of children and the drawings that they produce. He says that the "whole body feeling participates in the process of vision" (p. 65), and he finds symmetry both in seeing and in moving.

Visual pleasure is an essential part of child art, or else children would not make markings, but motor pleasure also is essential, or else children would not produce Gestalts when similar ones abound in the world around them. (Children, unlike adults, do not want to study art Gestalts after they have made them.) Apparently, the pleasure of scribbling comes from the combination of vision and movement, and child art has meaning for both capabilities.

In previous chapters, I discussed several meanings that child art has for human intelligence. Most of these meanings were stated as negatives and differences. The visually logical system of child art represents "visual thinking," but this is not the same as rational thinking, language development, or the expression of emotional states. The Gestalts of child art may coincide with other Gestalt systems, but they differ for the most

In the act of painting, the child coordinates vision and hand movement to produce a certain arrangement of lines

(Five years) (Five years)

Abstract line formations of self-taught art

part, and the difference often is a source of confusion to the child. He may have difficulty accommodating his self-taught line formations to the conventions of language symbols (including numerals, printed letters, and cursive letters, both upper and lower case) as well as to the lines found in the drawings that parents and teachers make for children to copy; in book illustrations; in photographs, movies, and television; and in charts, graphs, diagrams, and maps.

Current intelligence tests based on child art do not recognize the differences between self-taught art and other Gestalts, and so the tests employ arbitrary standards of success and failure. A realistic use of art as a mental test would seek to interpret the child's spontaneous drawings as standard or below or above, and the interpretations would acknowledge the formidable problems of naming the structures in child art.

Recent psychological research has focused on the perceptions and learnings of infants. To measure the early operations of intelligence, psychologists present visual stimuli to the infants and then gauge the response. For example, Robert L. Fantz has shown certain graphic Gestalts to infants from one to twenty-three months of age as they lay in a viewing chamber, and he has recorded the time that each infant has looked at each Gestalt. He has found that an adult's diagrammatic sketch of a human face held the infants' interest longer than a circular

(Six years) *(Six years)*

cutout of a piece of printing or colored disks or a bull's-eye of alternating black and white circles (Fantz, 1961).

Fantz concludes that the face Gestalt was the favorite because of its likeness to "mother's face." Yet it is not clear to me from the evidence he presents that the infants perceived a female face, as opposed to a general human face, or that they perceived a face at all. When children are old enough to draw pictorials, their first faces lack age or sex characteristics, and they draw Mandalas long before they draw faces. What if the circular cutout of printing had been modified as shown to make a Mandaloid Gestalt? Would this stimulus have held the infants' attention longer than "mother's face"?

Cutout of printing like the one used in tests by Fantz

Cutout of printing modified to give a Mandaloid Gestalt

Jerome Kagan has conducted similar research. Besides measuring the duration of attention, he has recorded the infants' heart rate, which tends to *decrease* when the infants' attention is engaged. Kagan used four painted clay masks, one with normal features, one without eyes, one with no features, and one with scrambled features. In general, the scrambled face stimulated the longest fixation time, and the regular face the next longest. However, Kagan found variations of attention depending on age, sex, social environment, and culture. The cultural variations that Kagan describes were measured not with three-dimensional masks, but with "chromatic paintings of facial stimuli" (Kagan, 1968, p. 26) which

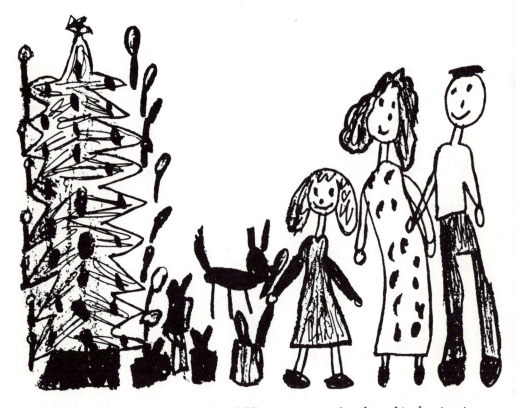

Christmas scene. As evidence of the child's perceptions of reality, this drawing is not impressive. The "candles" on the left side of the tree are upright and reasonably positioned, but those on the right are slanted, and most of them float in space. The larger female figure is drawn in a strange posture, and other distortions are present (six years)

were shown to American and to Mayan children. Kagan explains the multiple variations of attention in terms of three principles: contrast within the visual stimuli, discrepancies between the stimuli and the children's customary perceptions, and associations that the stimuli produced. The importance of the principles shifts with age.

My analysis of child art indicates that the perception of art Gestalts is different from the perception of thing Gestalts and that the development of child art is independent of associations or social environment. I wonder what would have happened if Kagan had used four masks with varying degrees of esthetic composition in his research. I also wonder

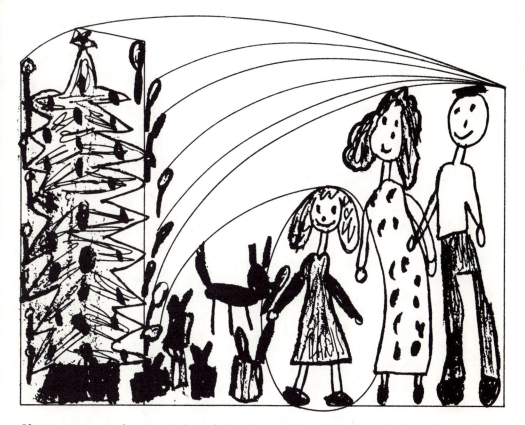

Christmas scene with some of the esthetic shapes outlined. The "candles" at right imply regular curves, and the contorted female helps to define an oval around the smaller female figure. The tree itself implies a rectangle, and all the other forms fit into a triangular shape. As a product of esthetic perceptions, the drawing is remarkably well made

why both the American and Mayan children looked longer at the paintings than American children of comparable age looked at the masks. Are two-dimensional objects—which include all the drawings made by children, of course—more compelling than three-dimensional things?

Research into the complexities of human intelligence is not simply a matter of measurements and procedures. The researchers also must decide the significance to attach to certain reactions, and this is in part a question of definition. For example, W. J. Smith talks about the meanings of "innate" and "learned" as defined by Konrad Lorenz: "Two means of dealing with sensory input provide the key to his distinction between the terms *innate* and *learned*. Both inherited information and sensory inputs are present in an individual simultaneously, but there are aspects of some responses which depend for their adaptiveness only on genetically stored information, while other aspects require modification based on information acquired during individual experience" (Smith, 1966, p. 811). For Kagan, the reactions of American and Mayan children to painted faces are significant because the differences point to variations in learning in two cultures. For Lorenz, presumably, the reactions would be significant because the similarities point to a common human inheritance. Bower (1966), Dennis (1966), Stechler et al. (1966), and others offer further examples of variations in research.

The meanings that child art has for intelligence surely go beyond the negatives and differences that I have noted. The child teaches himself art at the same time that important brain growth occurs. "The brain achieves 95 percent of its adult size relatively early, in a child of six," J. Dobbing says, "and the cerebral cortex, which contains the neuronal cell bodies, becomes increasingly infolded during early childhood" (Dobbing, 1967, p. 82). Susanne Langer states that the forms of direct perception made by the eye "are our most primitive instruments of intelligence" (Langer, 1948, p. 75). The development of the vision and movement that produce child art is likely to parallel the development of the vision and movement that help the child to survive and to learn.

Let me suggest some positive meanings that child art has for intelligence. These meanings extend beyond my analysis of line formations, but they agree with my observations of young children.

First, as I mentioned in Chapter 14, development in child art probably is a valid sign of general mental development. The child who is capable of perceiving and making Gestalts with increasing clarity may be presumed to be capable of perceiving the world around him with discrimination and purpose. The child may not perform well. He may fail to meet the expectations of the adults around him. Nevertheless, he should have intelligence in the sense of the first part of D. O. Hebb's definition: the possession of a good brain and good neural metabolism (Hebb, 1961, p. 294).

"Snow White" drawing. The original is merely an inch wider than the illustration here. (Young children produce excellent work if the paper is relatively small. Large paper seems to offer too much space to organize readily.) This drawing is balanced so that any even division of it results in a pleasing area (age unknown)

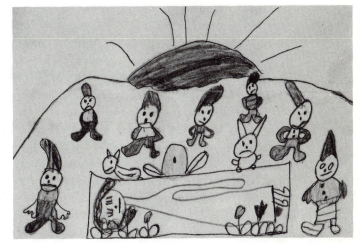

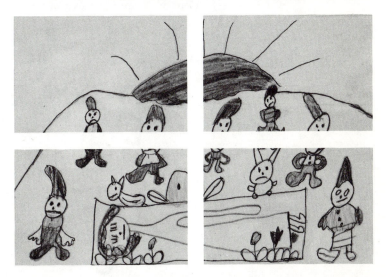

The opportunity to scribble freely has meaning for two critical operations of intelligence: reading and writing. Scribbling promotes the eye-hand coordination needed for writing, and the pleasure associated with scribbling may carry over into the more restricted movements of writing. It occurs to me that the child might enjoy learning to write language Gestalts before he learns to read. Cursive writing, which employs circular movements common in scribbling, might be easier to learn than manuscript writing. The latter has to be unlearned anyway, with all due respect to the teachings of Professor Gates. The old Spencerian method by which I learned to write I still remember as pleasurable, presumably because it was similar to scribbling.

In learning to read, the child must perceive line formations that are like the ones he has made spontaneously. Most of the letters of the English alphabet, both capitals and lower-case forms, are made by young children as art Gestalts (see Appendix B for the exceptions). In art, the letters are placed or arranged to complete a Pattern or an implied shape. In language, the letters are arranged in a certain order within words and are put into a certain left-right and top-bottom placement. As the child learns to read, he must perceive the differences between the esthetic and the linguistic positioning of letters, and as he learns to write he must put this perception to use. Each child who has scribbled a great deal will know many of the letter Gestalts when he enters school, but he needs to learn the differences between their uses for art and for language. Otherwise, he will have serious difficulties with language.

Capital letters formed by a young child, together with marks that are not language symbols (four years)

It is now generally agreed that individuals must learn to read and write in order to become responsible citizens. Literacy has even come to be viewed as a right of all humans, and public education of all the young has become an aim of modern nations. The role that child art plays in literacy thus has social and political implications. I have long cherished the idea that society's provisions for nursery education will one day be considered more important than society's role in providing college education, for one can get one's own college education, but nursery education must be the gift of adults.

A final meaning that child art has for intelligence concerns habits of self-reliance. As the child teaches himself to draw, he gains the experience of motivation from within. When he enters formal schooling, he still must be active to learn anything beyond facts by rote. As John Dewey says, the phrase "think for one's self" is a pleonasm, for "unless one does it for one's self it isn't thinking" (Dewey, 1916, p. 353).

Because child art is a spontaneous activity of normal children, it has meaning for a further basic human capability: the integration of other capabilities. Integration is not easy to investigate experimentally. The circumstances of most psychological experiments are extremely artificial, and the results of the experiments cannot be translated readily into terms of ordinary actions in commonplace surroundings. Child art provides documentation of such actions.

At the same time, child art offers a way to approach sweeping views of human behavior, views that seek to systematize the activities of all men through many centuries. Joseph Campbell presents such a view. He defines the science of Comparative Mythology as the biology, psychology, sociology, and history of the "sign-stimuli" which mankind has built for itself (Campbell, 1959, p. 41). Since many of the sign-stimuli which man makes are distributed throughout the world, Campbell raises the question of whether the patterns of these stimuli are innate. He answers that although man, like other animals, has "innate releasing mechanisms" which are biological, the sign-stimuli are not inherited. Instead, they are "imprinted" in the individual's mind by his culture. Owing to common experiences, the imprints are similar (p. 48).

The sign-stimuli serve to realize esthetic, spiritual, mystical, and reli-

Graffiti on the walls of the Louvre. The structures of spontaneous child art may be found chalked or penciled on walls throughout the world, and these structures are the same regardless of cultural differences. In particular, the balanced structures of Mandalas like those shown here have appeal that is at least as universal as the appeal of the art work within the Louvre

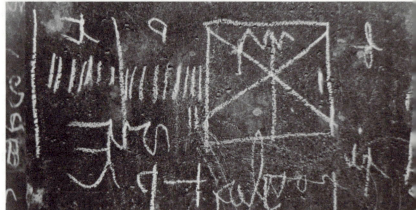

gious aspects of the myth (Campbell, 1959, p. 469), and the myth serves to engage the individual in the organized life of the culture (p. 467). Each culture maintains its own system of sign-stimuli to foster behavior suitable for that culture. For Campbell, the myth is the key to the knowledge of man's suffering and of the solutions to suffering. The human mind is "the ultimate mythogenic zone" (p. 472). Through his treatment of the myth, Campbell is able to see similarities between the integration of the individual and the integration of culture.

Certain sign-stimuli may be culturally determined in response to the unbearable aspects of adult life, as Campbell believes, but I think that all the truly universal images are traceable to child art. The conditions of adult life may explain why cultures value these images, but the source of the images is within each child, and the images appear through experiences that are esthetic rather than religious. The images—including Mandalas, Suns, and Radials—are the same for all children everywhere. Far from expressing an awareness of suffering, the images are balanced and wholesome as children draw them.

Perhaps the appeal of these images for adults lies in the sense of stabilized, balanced activity that the images convey. "Homeostasis," the word coined by J. B. Cannon to describe a condition in which all bodily functions are working together in balanced harmony, applies perfectly to spontaneous art activity (Cannon, 1939, p. 24). T. Burrow says that children create naturally, their only goal being the "natural reward accruing from the intrinsic value, social and esthetic, of the work produced (Burrow, 1949, p. 92). Read goes farther: ". . . the secret of our collective ills is to be traced to the suppression of spontaneous creative ability in the individual" (Read, 1945, p. 202).

Child art integrates movement and vision, the perception of over-all shapes and the perception of details, familiar line formations and new ones, stimulation and reaction, esthetic pleasure and muscular satisfaction. This integration is not supplied by the mere contemplation of art. To be effective, it must be experienced through one's own muscles, those of the hand as well as those that control the eye. Child art integrates not through communication from artist to viewer, but through the self-stabilization of the esthetic activity itself.

Easel paintings produced in self-taught children's art

(Four years)

(Four years)

In terms of spontaneous art, every child is a "born artist" who should be allowed to scribble without oppressive guidance in "art education." As Viola says, "the aim of art is not to produce artists, but to encourage rather than suffocate the innate creative capacities of children for art" (Viola, 1936, p. 34). The main value of spontaneous art is not the product but the doing of it.

In a society of abundance, art activity is one answer to the problem of filling leisure time more constructively. To allow children to be active in art would reduce the tensions of the aimless filling of time.

Spontaneous art can serve to integrate the functioning of adults as well as children. A hopeful aspect of life today is the upsurge of art hunger in people seeking esthetic satisfaction and not merely the intellectual sophistication of academic enjoyment. The acceptance of abstract art helps adults to feel free to make childlike—as opposed to childish—works of art. Again, the doing is more important than the product. In America today, illiteracy can be overcome in part by the

spoken information conveyed through radio and television. The "esthetic illiteracy" of many adults, caused by traditional attitudes toward spontaneous art, cannot be overcome, however, except through individual esthetic activity.

The technological society subjects us to much stimulation that cannot be integrated readily, and the price we pay for filling our world with unesthetic objects is certainly great. Many of the products we use daily are unnecessarily ugly. We do not need to become esthetes to gain the basic satisfactions of art. By respecting and participating in self-initiated art activity, we may produce more well-being in our own lives. At the same time, we may help to bridge the immense gap between our adult concerns and the mental development of children in art.

(Four years)

(Four years)

18. Classification System

The classifications presented here parallel those in my *Handbook for Microfiche*, a publication designed to accompany the 255 microfiche cards that contain some 8,000 drawings from my collection. The cards are produced by Microcard Editions, Inc., 901 26th Street N.W., Washington, D.C. 20037, and they were described briefly in the Introduction to this book.

In considering the classifications, the reader should be aware of the restricted meanings that I have given to certain words. "Horizontal," for instance, refers to a line going from one short side of the paper to the side opposite, regardless of the paper's position when the child draws on it. Similarly, "vertical" refers to a line going from one long side of the paper to the other long side. "Balance" in an arrangement of markings is in relation either to the area of the paper or to the area of the Gestalt formed by the markings, and "centeredness" designates balance in relation to the center of the paper or to the center of the Gestalt.

The "base line" of a drawing refers to the line along the bottom of the drawing in its presumed position in front of the child. "Emergent" applies to a line formation that has some characteristics of the stage of work that the child is moving toward. "Inherent" pertains to a Gestalt that may appear automatically in scribbling done with or without eye control. The child can recognize the inherent Gestalt even when he did not attempt to draw it. An "implied shape" is produced when the perimeter of a Gestalt has a regularity that would be shown by a line

drawn around the outermost parts of the Gestalt. A "build-up" is a structure of scribbled lines within an implied or outlined shape, and the structure appears to have been made one part at a time. A "fill-in," on the other hand, is scribbling within an outlined shape in which the outline seems to have been made before the scribbling.

Finally, it is worth noting that the classifications are not mutually exclusive. A single drawing might serve as an illustration of several different categories. The classifications are comprehensive, however. Any drawing may be viewed under the heading of at least one classification, and by "drawing" I mean any surface containing marks made by a human hand.

Twenty Basic Scribbles

X1 .The Basic Scribbles
X2 . Scribble Mergings

Placement Patterns

P1. Over-all Coverage
P2. .Centered
P3. .Spaced Border
P4. Vertical Half
P5. Horizontal Half
P6. .Two-sided Balance
P7. Diagonal Half
P8. Extended Diagonal Half
P9. Diagonal Axis
P10 . Two-thirds Division
P11 .Quarter Page
P12 . One-corner Fan
P13 . Two-corner Arch
P14 . Three-corner Arc
P15 . Two-corner Pyramid
P16 . Across the Paper
P17 .Base-line Fan

Emergent Diagrams

Diagrams

Combines

M5 .Mandaloid Structuring
M6 . Cross Mandalas
M7 . Cross and Square Mandalas
M8 Cross and Circle or Odd Shape Mandalas
M9 Cross and Circle and Square Mandalas
M10 .Concentric Mandalas
M11 .Little Mandalas
M12 .Imperfect Mandalas
M13 Mandalas in Placement Patterns

Suns
S1 . Pre-Sun Scribblings
S2 .Attempted Suns
S3 . Suns with Center Markings
S4 .Clear-center Suns
S5 . Sun Faces
S6 . Sun Humans
S7 .Suns in Aggregates
S8 . Suns with Loop Rays
S9 . Suns with Other Rays
S10 .Sun Designs
S11 . Enclosed Suns
S12 . Suns as Implied Diagrams
S13 . Suns in Placement Patterns

Scheme of the evolution of pictorial work from earlier drawings, beginning with the structures around the center and extending out. The scheme shows common sequences in the classifications of child art, but many other sequences are possible (author's sketch)

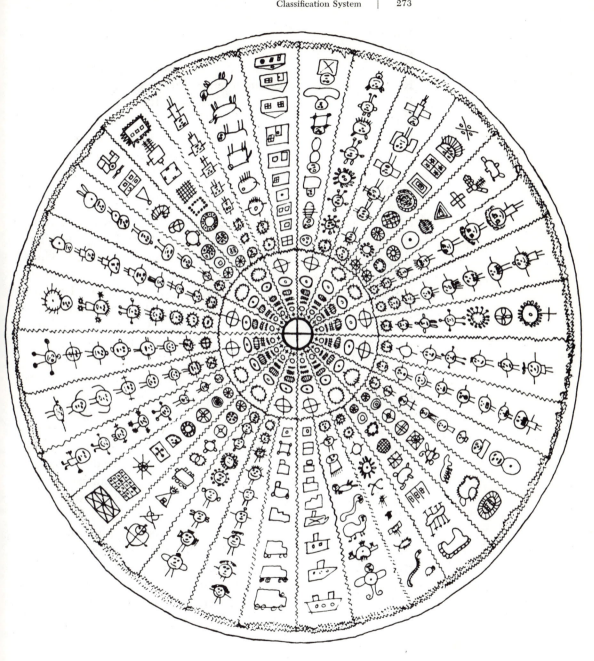

Radials

Humans

R7, Radial design (five years)

K8, horse, and rider in an implied oval (six years)

Animals

Buildings

B1 .Pre-Building Aggregates
B2 . Square-roofed Buildings
B3 . Triangular-roofed Buildings
B4 . Triangular Buildings
B5 . Other Building Aggregates
B6 .Buildings in Placement Patterns

Vegetation

V1 . Humanoid Trees
V2 .Trees
V3 . Flowers
V4 . Flowers and Trees

Transportation

T1 .Boats
T2 . Automobiles
T3 .Airplanes
T4 . Rockets
T5 . Trains
T6 .Combined Transportation Items

Joined Pictorials

J1 . Humans and Buildings
J2 .Humans and Vegetation
J3 Humans, Vegetation, and Buildings
J4 Humans and Transportation
J5 . Buildings and Vegetation
J6 Animals with Humans or Buildings
J7 .Other Joined Pictorials

Learned from Others

L1 Esthetic Use of Letters and Numbers
L2 Nonesthetic Use of Letters and Numbers
L3 . Defective Letters and Numbers

L4 . Halloween
L5 . Snowmen
L6 . Christmas
L7 . Easter
L8 . Thanksgiving
L9 . Indians
L10 . Valentines
L11 . Spacemen
L12 . Animals
L13 . Rain
L14 . Other Assigned Subjects

Formal Designs
F1 Motif Repetitions for Placement Pattern 16
F2 . Motif Repetitions for Diagram 2
F3 . Other Formal Designs

Works of Advanced Scribbling
W1 . Scribble as Design
W2 . Abstract Build-up or Fill-in
W3 . Sophisticated Scribbling
W4 . Textured Scribbling
W5 . Designs Based on Suns

Individual Work
I1 . Thematic Repetitions
I2 . Thematic Growth

The microfiche cards are arranged in several further classifications designed to show work that is advanced or behind for the child's age level and to show photographs, miscellaneous work, and points of judgment about child art. The purpose of these classifications has been met by the discussions and many illustrations in the previous chapters of this book. One further classification de-

serves to be shown: fifteen typical phosphene form groups. Phosphenes' are subjective light patterns, visible with the eyes closed. The fifteen groups illustrated here were derived from copies of 520 phosphenes as observed by 313 subjects (Kellogg, Knoll, and Kugler, 1965, p. 1129). Six investigators compared the form groups with 329 scribblings by one child, and the number of similarities they found are given in columns B through G.

The investigators concluded, ". . . we are dealing here with the activation of preformed neurone networks in the visual system," and ". . . one can perhaps hope for a satisfactory general neurological clarification of pattern- or Gestalt-recognition" (Kellogg, Knoll, and Kugler, 1965, p. 1130).

Table 1. Occurrence of 15 Typical Phosphene Form Groups (Column A, Lit. 3) in 329 Scribblings of One Single Child (Cynthia Lis, Golden Gate Nursery School)

Form groups			A	B	C	D	E	F	G
1. Arcs			95	0	0	0	0	2	3
2. Radials			75	12	3	0	3	3	3
3. Waves			68	28	22	24	19	26	28
4. Lines			59	0	5	7	3	10	10
5. Combined fig.			51	4	6	0	6	0	1
6. Circles			44	24	12	36	12	45	47
7. Multiple fig.			34	16	52	23	19	23	23
8. Odd figures			28	24	1	51	1	13	12
9. Quadrangles			18	6	2	5	2	2	2
10. Spirals			14	3	3	0	3	28	29
11. 'Poles'			13	0	0	0	0	0	0
12. Lattices			8	7	6	6	5	10	10
13. Triangles			6	0	0	0	0	1	1
14. Fingers			5	0	1	1	1	1	0
15. 'Cherries'			2	0	1	1	1	3	3
Sum of numbers of recognizable phosphene patterns (col. A) and of recognizable scribblings (cols. B to G)			520	124	114	154	75	167	172
Sum of scribbling form groups corresponding			15 (Lit. 3)	9 (R.K.)	12 (M.K.)	9 (J.K.)	12 (E.L.)	13 (H.R.)	13 (W.G.)
Percentage of scribbling form groups corresponding			100	60	80	60	80	86	86

Column A: Number of phosphenes belonging to each phosphene form group.

Columns B–G: Numbers of recognizable scribblings (out of 329) similar to each phosphene form group, according to 6 different experimenters.

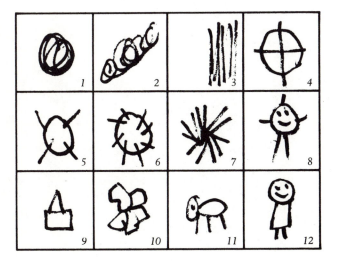

Identifications of illustrations from page 8

1. *Scribble in Placement Pattern 2*
2. *Scribble in Placement Pattern 9*
3. *Scribble in Placement Pattern 4*
4. *Mandala*
5. *Area with few rays*
6. *Sun with clear center*
7. *Radial*
8. *Human with head-top markings*
9. *"Boat" Combine*
10. *Aggregate of odd shapes*
11. *Horizontal Animal*
12. *Armless Human*

APPENDIX A The Uses of Lines and Shapes in Children's Art

Children use some of the Basic Scribbles, Diagrams, and advanced structures more often than others. By concentrating on these common line formations and the ways in which they are used, I can present an overview of child art as it develops from early scribbling into shapes, designs, and pictorial effects. The brief analysis that follows is a simplified approach to the art of young children. (I have not capitalized words like "human" here because all the subjects mentioned are those of children's art, and there is no need to distinguish these subjects from adult art or from reality.)

Diagonal Lines

Of the Scribbles that have uniform direction, these are the first to be made. Apparently, they are the easiest for the hand to produce when the drawing surface is in its usual orientation, with one edge parallel to the edge of the table in front of the child. Diagonal lines (Scribble 4 in my classification) can create top-bottom and left-right balance when they are centered, or they can destroy balance when they are shifted toward one edge of the paper. Two or more of these lines are common components of mandalas. They may also be used in the following ways:

1. Simply by themselves, which is a very common use.
2. To fill in a shape, sometimes with a radial effect.
3. To create designs.
4. To form roofs, skirts, sails, rockets, branches of trees and flowers, hats of clowns and witches, rain, smoke, snow, lines of attack for planes fighting with boats, crowns, arms and legs of humans, etc.

Vertical Lines

These lines (Scribble 2) are made frequently from the age of two. The lines produce left-right divisions, they correspond to the images of standing objects, and they are often components of mandalas. Other common uses:

1. Simply by themselves, like diagonal lines (horizontal lines are not frequently made by themselves).
2. To make parts of squares or rectangles.
3. To make designs.
4. To give height with fill-in strokes.
5. To represent vertical aspects of pictorials, especially houses, boats, trees, rain, cats, certain other animals, and legs of humans.

Horizontal Lines

Although horizontal lines (Scribble 3) are not used by themselves as commonly as diagonal or vertical lines, they appear in scribbling from the age of two. They form top-bottom divisions and they are common parts of mandalas, in addition to other uses:

1. To make parts of squares or rectangles.
2. To make designs.
3. To make sky lines, ground lines, and sea horizons.
4. To give width with fill-in strokes.
5. To represent horizontal aspects of pictorials, especially boats, houses, cars, animals, and arms of humans.

Loops

Loops, whether single (Scribble 13) or multiple (Scribble 14), are easier to make than circles or squares. Loops generally have left-right balance. They serve innumerable purposes in the art of children. Here are major ones:

1. To form rays of the sun.
2. To make designs.
3. To form torsos, arms, legs, hands, feet, hats, hair, and ears of humans.
4. To form torsos, legs, feet, ears, and tails of animals.
5. To depict wings and propellers of airplanes.

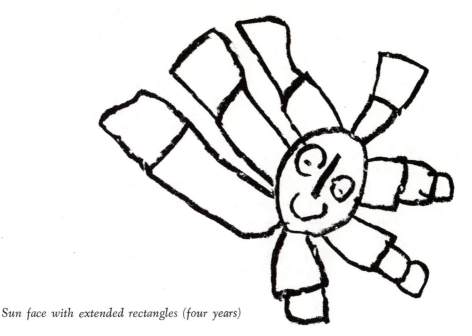

Sun face with extended rectangles (four years)

6. To make flower petals, leaves, and fruit stems.
7. To create chimneys and the smoke from chimneys.
8. To form humans, particularly sexless humans.
9. To make wheels on vehicles.

Odd Shapes

In a sense, the odd shape, which is simply a line formation that encloses any irregular area, is the easiest Diagram to make (it is Diagram 5 in my classification). It can fit any space and it is made from the age of two. However, it can be made in so many ways and with so many variations and combinations of line that it cannot be easily related to the child's development. It has two main uses:

1. To complete designs.
2. To represent a great diversity of pictorial items.

Face and a tall house (five years)

Circles and Ovals

These formations (Diagram 3) are the easiest of the regular diagrams to make. They often have over-all balance, but they lend themselves to distortion without loss of esthetic appeal. They also are esthetically satisfying in varying sizes. Besides being easier to make than squares or triangles, they provide better representation of many objects than do the straight-line forms. Circles and ovals are basic to many mandalas. Other frequent uses:

1. To give circular movement to fill-in work.
2. To make designs.
3. To achieve any effect that is not restricted to straight lines.
4. To form any parts of animals.
5. To form any parts of humans, particularly sexless humans.
6. To make hats, buttons, earrings, and shoes.
7. To make trees, flowers, fruit, rain, snow, windows, doors, smoke, houses, etc.

Greek and Diagonal Crosses

The Greek cross (Diagram 1) and the diagonal cross (Diagram 6) are inherent in early scribbling and are easy to see there. Both have over-all balance, and both are basic to the mandala. Their additional uses:

1. To make designs in dresses.
2. To make other designs.
3. To form the outlines of humans.
4. To create human torsos.
5. To make eyes, hands, and feet.

Squares and Rectangles

These line formations (which constitute Diagram 2) generally are achieved at age three. They are the last of the Diagrams to be used frequently in children's art. (The triangle is inherent in early scribbling, but it is not often made by young children.) Squares and rectangles provide width and breadth simultaneously, and they lend themselves to mandala treatment. Other uses:

1. To make designs.
2. To portray objects that look rectilinear, such as houses, boats, cars, hats, and trousers.
3. To make torsos, arms, legs, wings, etc.

Concentric Lines

Both squares and circles lend themselves to Combines and Aggregates that are concentric. These line formations, achieved at about age three, have over-all balance and mandala form. They are extraordinarily decorative. Their uses:

1. To make designs.
2. To form emblems on boats and planes.
3. To depict suns, sun humans, flowers, hands and feet, hats, fringes, eyebrows, etc.

Mandala Images and Structures

Images of the mandala are inherent in early scribbling, but the child who can purposefully make mandalas has the ability to make other structures. The mandala may combine all six Diagrams in one structure. For example, a mandala formed of a circle, a Greek cross, and a diagonal cross centered on a piece of paper also shows a triangle (a pie-shaped area), various odd shapes, and a rectangle owing to the borders of the paper itself. The mandala, with its balance and four or more directional lines, is the basis for the first drawings of humans. It may also be used in the following ways:

1. To encompass designs.
2. To form units of designs.
3. To provide over-all implied designs for drawings.

Four examples of early lettering. The letters are positioned to fall into Placement Patterns and to imply a variety of shapes (48 to 59 months)

APPENDIX **B** Dyslexia

"Dyslexia" is a word used to imply visual-cerebral difficulties in learning to read under usual methods of instruction. There is concern for the plight of children who suffer from dyslexia, and there has been substantial effort to help such children. Evidence is good that dyslexic children can be helped. A study conducted by Margaret B. Rawson concerned twenty-five dyslexic boys who attended The School in Maylan, Pennsylvania, between 1930 and 1947. Of the twenty-five, six were research scientists (including two physicians), three were college professors, one was a lawyer, one was a school principal, three were owners of middle-sized businesses, one was an "upper management" business employee, four were "middle management" business employees, three were high school teachers, one was an actor, and two were semi-skilled workers (Anonymous, 1967, p. 3).

Child art should have a significant role in the treatment of dyslexia because the English-speaking child who has difficulty in reading has already formed most of the English letters as part of spontaneous art. However, the letters in art often are made backward or upside down. Insofar as dyslexia is caused by a confusion between the use of letter Gestalts in art, where they may be turned in any way for esthetic reasons, and in language, where Gestalts must be placed in proper orientation on a line, dyslexia should be easy to cure. The cure would consist of pointing out the differences between letter Gestalts in art and in language. All of the capital letters except H, I, O, and X, which are the same when turned top to bottom or right to left, and G, Q, R, and Y, which do not occur in the spontaneous art of young children, are subject

to confusion. The lower-case letters can be confused in the same way except for o and x, plus those lower-case letters that are not made in spontaneous art: a, j, k, q, t, and u. The child who is able to scribble freely should learn to write the alphabet with relative ease because he knows the forms of most letters. What he needs to learn is their proper placement in words.

This placement is arbitrary for language and should be explained as such. To one child I said, "Letters have to be made only one way for

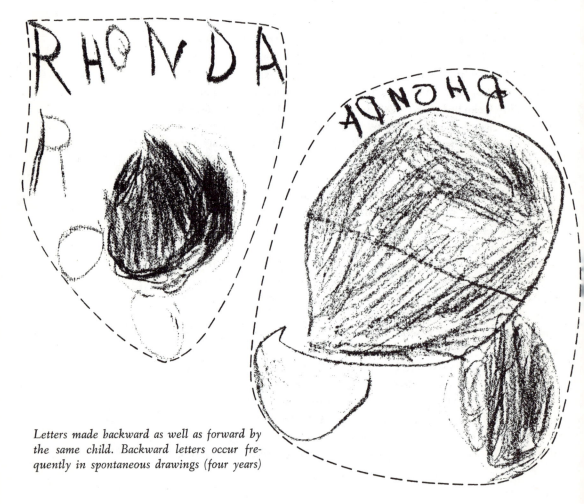

Letters made backward as well as forward by the same child. Backward letters occur frequently in spontaneous drawings (four years)

writing, but any way you like for drawing," after she had given me a drawing with two letters in her last name written backward. I made the correction for her and she rewrote her last name correctly. I asked her why she had written the letters backward and she replied that her uncle said it was because she was left-handed. I pointed out that her left hand could write either way, depending on how she decided to write.

This bright girl was being taught to write prematurely by her uncle, who obviously had heard one of the common explanations for dyslexic writing. Although the girl was too young for writing lessons, I tried to correct misplacements of letters—as I do whenever I see them in the work of four- or five-year-olds—so that they would not become fixed in her mind.

Following our talk she made the two drawings shown on the opposite page. Note that the H, O, and A are the same for correct left-right placement or for reversed writing. She made the N correctly in the reversed word, probably unintentionally; N is one of the difficult letters to learn because it is seen in art as two verticals connected by a diagonal, and a change in the diagonal makes little difference in the total image.

The motor-visual-mental processes that are utilized in art are based on Gestalt comprehension wherein left-right and top-bottom balance of lines seems a logical completion of the whole. Thus CAT can be seen as ƆVⱵ or TAC because C and Ɔ, A and Ɐ, and T and Ⱶ are Gestalts known to the young child as forms that can be placed in various orientations to complete esthetic Gestalts. When this kind of comprehension is applied to language forms, it is labeled "dyslexic" vision.

My examination of existing methods of teaching reading and writing and of correcting so-called dyslexia convinces me that adult ignorance of normal comprehension of art and letter Gestalts is a main cause of reading failures. I believe, for example, that illustrations in reading books are a handicap because they distract the eye and mind from letter and word Gestalts. The child who can learn to memorize the few words that go with pictures in first readers seems to be learning to read. However, by the third grade, when the readers have too many words to memorize, teachers discover that the child no longer recalls the words he once seemed to know. Once he fails in reading, he may easily give up

trying. I believe that word and art Gestalts should not be combined, as they are in readers, workbooks, and labels on children's drawings.

I also believe that words should not be presented in a distorted form, as they are in many workbooks. The child can most easily grasp letters and words when they are seen as whole Gestalts. When words are hyphenated into syllables for phonetic drill, though, the normal Gestalts are distorted. If letters are omitted so that, for instance, the child sees "A _ird" and writes in the b and then sees "A bird," his mind has to absorb two Gestalts for the word which will not appear in books.

If phonics and spelling are postponed until the child has a good reading vocabulary, learning to read would be simplified. Teachers would only need to know that the child can pronounce written words and comprehend their meanings.

Reading is essentially the ability to have specific mental reactions to the sight of word Gestalts. (For the blind, these mental reactions are derived from the Gestalts made by gestures—by the touch of Braille print.) The cause of reading failure too often is given as "minimal cerebral dysfunction" or "brain damage." From my study of children's art, I conclude that brain damage is too rare to be a problem in most classrooms and that the cerebral dysfunction of nonreaders is produced by the methodologies of teachers and by environmental influences. Then specialists try to treat the dysfunction by remedial methods that do not take sufficient account of the enormous ability of the average child.

By careful, individual help of teachers who detect and correct reversals in language when they first occur, children can learn that one way is correct for writing and reading but that other ways are acceptable for art. Repeated correction may be needed, for children can enjoy reversed writing. As one bright five-year-old boy said when I complained about a reversal of his name on a drawing, "I wish I could write it the way I used to."

Bibliography

Alschuler, Rose H., and La Berta W. Hattwick
 1947 *Painting and Personality.* Chicago: University of Chicago Press.

Anati, Emmanuel
 1961 *Camonica Valley.* New York: Alfred A. Knopf.

Anonymous
 1962 "A View from the Crib." *Time Magazine,* Vol. LXXIX, No. 10, March 9, p. 62.

 1963 *Masters of the Congo* (film). Belgium: The International Scientific Foundation.

 1967 "A Study of Dyslexic Boys." *Today's Child,* Vol. 15, No. 1, January, p. 3.

 n.d. *Bronze Age Pictures* (catalog for an exhibit of Swedish rock carvings). Washington, D. C.: Smithsonian Institution.

Arnheim, Rudolf
 1954 *Art and Visual Perception.* Berkeley: University of California Press.

Bader, A.
 1961 *Insania Pignens.* Basle: Ciba.

Baker, H. and Rhoda Kellogg
 1967 "A Developmental Study of Children's Drawings." *Pediatrics,* Vol. 40, No. 3, September, pp. 381-389.

Bell, Clive
 1958 *Art.* New York: Capricorn Books.

Bender, Lauretta
 1952 *Child Psychiatric Techniques.* Springfield, Illinois: Charles C. Thomas.

Beverly, Bert
 1957 *In Defense of Children.* New York: John Day Co.

Botsford, G. W.
 1911 *A History of the Ancient World.* New York: Macmillan Co.

Boulding, K. E.
 1956 *The Image: Knowledge in Life and Society*. Ann Arbor: University of Michigan Press.

Bower, T. G. R.
 1966 "Slant Perception and Shape Constancy in Infants." *Science*, Vol. 151, No. 3712, February 18, pp. 832-833.

Brain, R.
 1960 "Symbol and Image." *The Listener*, Vol. 64, March 10, pp. 443-444.

Breuil, Abbé
 1952 *Four Hundred Centuries of Cave Art*. France: Montignac Centre d'Etudes et de Documentation Préhistoriques.

Burrow, T.
 1949 *The Neurosis of Man*. New York: Harcourt, Brace and Co.

Campbell, Joseph
 1959 *Masks of God: Primitive Mythology*. New York: Viking Press.

Cane, Florence
 1951 *The Artist in Each of Us*. New York: Pantheon Books.

Cannon, Walter B.
 1939 *The Wisdom of the Body*. New York: W. W. Norton and Co.

Cassirer, Ernst
 1954 *An Essay on Man*. New York: Doubleday Anchor Books.

Cattell, Raymond Bernard
 1968 "Are I. Q. Tests Intelligent?" *Psychology Today*, Vol. 1, No. 10, March, pp. 56-62.

Covarrubias, Miguel
 1954 *The Eagle, the Jaguar, and the Serpent*. New York: Alfred A. Knopf.

Dennis, Wayne
 1966 *Group Values Through Children's Drawings*. New York: John Wiley and Sons.

Dewey, John
 1916 *Democracy and Education*. New York: Macmillan Co.

Dobbing, J.
 1967 "Growth of Brain." *Science Journal*, Vol. 3, No. 5, May, pp. 81-86.

Dorner, Alexander
 1958 *The Way Beyond Art*. New York: New York University Press.

Ducasse, Curt J.
 1948 *Art, the Critics and You*. New York: Hafner Publishing Co.

Ehrenzweig, Anton
 1965 *The Psychoanalysis of Artistic Vision and Hearing*. New York: Braziller.

Encisco, Jorge
 1963 *Design Motifs of Ancient Mexico*. New York: Dover Publications.

Eng, Helga
 1931 *The Psychology of Children's Drawings from the First Stroke to the Coloured Drawing.* London: Broadway House.

Fantz, Robert L.
 1961 "The Origin of Form Perception." *Scientific American,* Vol. 204, No. 5, May, pp. 66-72.

Fiedler, C.
 1949 *On Judging Works of Visual Art.* Translated by Henry Schaefer-Simmern. Berkeley: University of California Press.

Focillon, Henri
 1942 *The Life of Forms in Art.* New York: George Wittenborn.

Fry, Roger
 1962 "The Artist and Psychoanalysis." *Bulletin of Art Therapy,* Vol. 1, No. 4, pp. 3-18.

Gaitskell, Charles D.
 1958 *Children and Their Art.* New York: Harcourt, Brace and Co.

Gajdusek, C.
 1964 "The Composition of Musics for Man." *Pediatrics,* Vol. 34, July, p. 91.

Gesell, Arnold
 1949 "The Developmental Aspect of Child Vision." *The Journal of Pediatrics,* Vol. 35, No. 3, September, pp. 310-316.

Ghyka, Matila
 1946 *The Geometry of Art and Life.* New York: Sheed and Ward.

Giedion, Sigfried
 1962 *The Eternal Present,* Vol. 1, *The Beginnings of Art.* New York: Pantheon Books.

Goodenough, Florence L.
 1926 *Measurement of Intelligence by Drawings.* New York: Harcourt, Brace and World.

Greenberg, Clement
 1967 "Complaints of an Art Critic." *Artforum,* Vol. 6, No. 2, October.

Gregory, R. L.
 1966 *Eye and Brain.* New York: McGraw-Hill Book Co.

Griffiths, R.
 1945 *A Study of Imagination in Early Childhood; and its Function in Mental Development.* London: Kegan Paul, Trench, Trubner and Co., Ltd.

Grozinger, W.
 1955 *Scribbling, Drawing, and Painting.* New York: Frederick A. Praeger, Inc.

Hadamard, Jacques
 1945 *The Psychology of Invention in the Mathematical Field.* New York: Dover Publications.

Harris, Dale B.
 1963 *Children's Drawings as Measures of Intellectual Maturity: A Revision and Extension of the Goodenough Draw-a-Man Test.* New York: Harcourt, Brace and World, Inc.

Hebb, D. O.
 1961 *The Organization of Behavior.* New York: Science Editions, Inc.

Isaacs, J.
 1961 "The Ballet and the Critics," *The Listener,* Vol. 66, October 5, pp. 505-507.

Jacobi, J.
 1953 "The Ego and the Self in Children's Drawings," *Die Schweizerische Zeitschrift für Psychologie und ihre Anwendungen.* (Bern: Hans Huber), Vol. 12, Pt. 1.

Jones, Val, editor
 1967 *Special Education in the United States.* Springfield, Illinois: Charles C. Thomas.

Jung, C. G. and R. Wilhelm
 1932 *Secret of the Golden Flower.* New York: Harcourt, Brace and Co.

Kagan, Jerome
 1968 "The Many Faces of Response," *Psychology Today,* Vol. 1, No. 8, January, pp. 22-27, 60-61.

Kandinsky, Wassily
 1947 *Concerning the Spiritual in Art.* New York: Wittenborn, Schultz, Inc.

Kellogg, Rhoda
 1949 *Nursery School Guide.* Boston: Houghton-Mifflin (out of print).
 1953 *Babies Need Fathers, Too.* New York: Comet Press.
 1956 *Finger Painting in the Nursery School.* Author's edition (out of print).
 1958 *The How of Successful Finger Painting.* Palo Alto, California: Fearon Publishers.
 1959a "The Sense of Scribbles." *Design Magazine,* Vol. 61, No. 2, November-December.
 1959b *What Children Scribble and Why.* Palo Alto, California: National Press (out of print).
 1955 "Hour a Day Nursery Education." *Bulletin of Northern California Association for Nursery Education,* Vol. 18, No. 2, Spring.
 1967a *Rhoda Kellogg Child Art Collection* (microfiche cards showing 8,000 drawings of children ages 24-40 months). Washington, D.C.: Microcard Editions, Inc.
 1967b "Understanding Children's Art." *Psychology Today,* Vol. 1, No. 1, May, pp. 16-25.
 1968a "The Biology of Esthetics," *Anthology of Impulse, Annual Contemporary Dance 1951-1966.* Brooklyn: Dance Horizons.

1968b "Phoebe A. Hearst Pre-School Learning Center," *Special Education in the United States,* Val Jones, Editor. Springfield, Illinois: Charles C. Thomas.

in press "Learning Through Movement," *Dance—In Art and Academe,* Martin Haberman and Mrs. Tony Meisel, editors. New York: Teachers College Press of Columbia University.

_____, M. Knoll, and J. Kugler

1965 "Form Similarity between Phosphenes of Adults and Pre-School Children's Scribblings." *Nature,* Vol. 208, No. 5015, December 11, pp. 1129-1130.

_____, and Scott O'Dell

1967 *The Psychology of Children's Art.* Del Mar, California: CRM Associates for Random House.

Koch, Rudolf

1930 *The Book of Signs.* New York: Dover Publications.

Koppitz, E. M.

1968 *Psychological Evaluation of Children's Human Figure Drawings.* New York and London: Grune and Stratton, Inc.

Kris, Ernst

1962 *Psychoanalytic Explorations in Art.* New York: International Universities Press.

Kühn, Herbert

1956 *Rock Pictures of Europe.* London: Sidgwick and Jackson.

Lajoux, Jean-Dominique

1930 *Rock Paintings of South Africa.* London: Methuen and Co., Ltd.

1962 *The Rock Paintings of Tassili.* London: Thames and Hudson.

Langer, Susanne K.

1948 *Philosophy in a New Key.* New York: The New American Library.

Lantz, Beatrice

1955 *Easel Age Scale.* Los Angeles: California Test Bureau.

Lévi-Strauss, Claude

1966 *The Savage Mind.* Chicago: University of Chicago Press.

Lorenz, Konrad

1965 *Evolution and Modification of Behavior.* Chicago: University of Chicago Press.

Lowenfeld, Viktor

1954 *Your Child and His Art.* New York: The Macmillan Co.

Lowie, Robert H.

1954 *Indians of the Plains.* New York: McGraw-Hill Book Co.

McBroom, Patricia

1968 "Mining the Child's Art," *Science News,* Vol. 93, No. 4, January 27, pp. 92-93.

McFee, June K.
> 1961 *Preparation for Art.* San Francisco: Wadsworth Publishing Co.

Machover, Karen
> 1949 *Personality Projection in the Drawing of the Human Figure: A Method of Personality Investigation.* Springfield, Illinois: Charles C. Thomas.

Mellaart, James
> 1964 "A Neolithic City in Turkey." *Scientific American,* Vol. 210, April, p. 94.

Mendelowitz, Daniel M.
> 1953 *Children Are Artists.* Palo Alto, California: Stanford University Press.

Missildine, W. H.
> 1963 *Your Inner Child of the Past.* New York: Simon and Schuster.

Montessori, Maria
> 1912 *The Montessori Method.* New York: Frederick A. Stokes Co.

Morris, Desmond
> 1962 *The Biology of Art.* New York: Alfred A. Knopf.
> 1967 *The Naked Ape.* New York: McGraw-Hill Book Co.

Murray, E. R.
> 1914 *Froebel as a Pioneer in Modern Psychology.* Baltimore: Warwick and York, Inc.

Neumann, Erich
> 1955 *The Great Mother.* New York: Pantheon Books.

Parkyn, E. A.
> 1915 *Prehistoric Art.* New York: Longmans, Green and Co.

Penfield, Wilder and Lamar Roberts
> 1959 *Speech and Brain-Mechanisms.* Princeton, New Jersey: Princeton University Press.

Pequart, M., S. Pequart, and Z. Le Rouzic
> 1927 *Corpus des Signes Gravés des Monuments Mégalitheques du Morbihan.* Paris: August Picard.

Rank, Otto
> 1945 *Will Therapy, and Truth and Reality.* New York: Alfred A. Knopf.

Ray, C.
> 1958 *The Art of the Savages.* New York: Golden Griffin Books, Central Encyclopedia of Arts, Inc.

Read, Herbert
> 1934 *The Meaning of Art.* London: Penguin Books, Faber and Faber.
> 1945 *Education Through Art.* New York: Pantheon Books.
> 1960a *Art Now.* New York: Pitman Publishing Corp.
> 1960b *The Forms of Things Unknown.* London: Faber and Faber.
> 1960c "In the Sense of Abstract Art." *New York Times Magazine,* April 17.
> 1960d "Rock Paintings in South Africa." *The Listener,* February 11, p. 263.

1963 "Presidential Address to the Fourth General Assembly of the International Society for Education Through Art." Montreal: August 19, mimeographed.

1966 *The Redemption of the Robot.* New York: Trident Books.

Rensch, Bernhard
1965 "Ueber aesthetische Faktoren im Erleben hoeherer Tiere." *Naturwissenschaft und Medizin*, Vol. 2, No. 9, pp. 43-57.

Schaefer-Simmern, Henry
1948 *Unfolding of Artistic Ability: Its Basis, Processes, and Implications.* Berkeley and Los Angeles: University of California Press.

Smith, W. J.
1966 "Lorenz's Concept of the Origins of Adaptive Behavior." *Science*, Vol. 151, No. 3712, February 18, pp. 810-811.

Speed, W. J.
1967 "Early Expressionists." *Film News*, Vol. 24, No. 1, February 1, p. 13.

Stechler, G., S. Bradford, and H. Levy
1966 "Attention in the Newborn: Effect on Motility and Skin Potential." *Science*, Vol. 151, March, p. 1246.

Steward, Julian H.
1929 "Petroglyphs of California and Adjoining States." *University of California Publications in American Archaeology and Ethnology*, Vol. 24, No. 2, pp. 47-238.

Taubman, Howard
1967 "A Child's Capacity to Respond to the Arts." *San Francisco Chronicle*, November 29, p. 46.

Tomlinson, R. R.
1942 *Picture Making by Children.* Scranton, Pennsylvania: International Textbook Co.

Tucci, G.
1961 *The Theory and Practice of the Mandala.* London: Reider and Co.

Vernon, M. D.
1962 *The Psychology of Perception.* Baltimore: Penguin Books.

Viola, Wilhelm
1936 *Child Art and Franz Cizek.* New York: Reynal and Hitchcock.

Wilkinson, J. Gardner
1841 *Manners and Customs of the Ancient Egyptians.* Albemarle: John Murray.

Willcox, A. R. and H. L. Pager
1967 "The Petroglyphs of Redan, Transvaal." *Suid-Afrikaanse Tydskrif vir Wetenskap*, November, pp. 492-499.

Wolff, Werner
 1947 *Personality of the Preschool Child.* New York: Grune and Stratton, Inc.
 1948 *Island of Death.* New York: J. J. Augustine.

Wraight, Robert
 1966 *The Art Game.* New York: Simon and Schuster.

Index